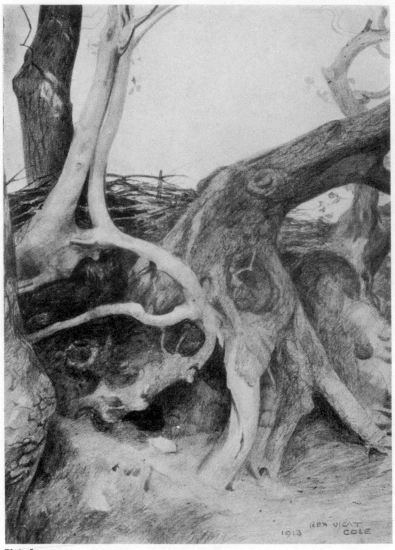

Plate I

PENCIL STUDY BY THE AUTHOR

"Trees hanging over a bank would often appear unbalanced, if it were not for the projecting roots that grip the bank surface and reach down its face.'

THE
ARTISTIC ANATOMY
OF TREES

THEIR STRUCTURE & TREATMENT IN PAINTING

ILLUSTRATED BY 50 EXAMPLES OF PICTURES FROM THE TIME
OF THE EARLY ITALIAN ARTISTS TO THE PRESENT DAY
& 165 DRAWINGS BY THE AUTHOR, SUPPLEMENTED
BY 300 DIAGRAMS IN THE TEXT

SECOND EDITION

BY

REX VICAT COLE

"Painting is jealous, and requires the whole man to herself."
MICHAEL ANGELO.

DOVER PUBLICATIONS, INC., NEW YORK

Published in Canada by General Publishing Company, Ltd., 30 Lesmill Road, Don Mills, Toronto, Ontario.

Published in the United Kingdom by Constable and Company, Ltd., 10 Orange Street, London W. C. 2.

This Dover edition, first published in 1965, is an unabridged and unaltered republication of the work first published by Seeley, Service & Co., Ltd., London, in 1915. This edition is published by special arrangement with Seeley Service & Co., Ltd.

International Standard Book Number: 0-486-21475-3

Library of Congress Catalog Card Number 65-26015

Manufactured in the United States of America

Dover Publications, Inc.
180 Varick Street
New York, N. Y. 10014

PREFACE

In teaching, as I understand it, one must assume that the student knows nothing. When one has overcome the disagreeable feeling that this assumption implies, that of being set up on one's own little pedestal, one is able to be of more use than if one attempted to dovetail bits of knowledge into those that have already been acquired. This is more particularly the case when compiling a book that has to meet the needs of students in various stages of proficiency. My standpoint, then, for which I must apologise, is that the reader knows but little of draughtsmanship, and nothing of the construction of trees.

I cannot understand the position of some who assert that an object can be painted in a convincing manner without its mechanism being understood. Would they come through the test of having to draw a yacht or a locomotive, or would they shuffle out of the difficulties by saying they only wished to give the " feeling " that impressed them ? I doubt whether the feeling alone would please the yachtsman, mechanic, or artist. At this stage I shall be accused of saying that correctness is the chief aim of the artist, when it is but a little part. Most of the greatest artists, if judged by the photographic standard, have drawn incorrectly. This is a fact I delight in, since—loving their work and yet confessing to a certain pleasure in accuracy—I find I am sufficient artist myself to recognise those finer qualities that can dispense with exactness without loss of merit. Sailors tell me that Turner's " Fighting Temeraire " could not have fought because she could not have sailed. To me she is the grandest ship ever painted, and I cannot listen to the carping of her critics. But Turner could and did draw correctly as well as grandly when he wished to do so. A love for the " Fighting Temeraire " still leaves room for delight in the exquisite drawings of craft in detail that E. W. Cooke has left us. A great artist can express his ideas without insisting on facts, a competent craftsman is unhampered by them ; but to the young student the mere imitation of form by itself presents enormous difficulties, and to him a knowledge of all he wishes to paint is indispensable. There are times when it is an encouragement to refer to the lives of the great painters and to assure oneself again that even they could not dispense with toil but

steadfastly accumulated knowledge throughout their lives. It is well to think of our Etty, with his genius already developed, plodding at the life school; and Turner poring over the mathematical laws of perspective. The notebooks of others bear witness to their desire to understand with full appreciation all they saw before they allowed themselves the licence of selection. Perhaps it will suffice to take the practical side, and wonder how anyone can spend a generous portion of his life in looking at objects with that uninquisitive intelligence which does not pry into the mysteries of construction. The knowledge of how a thing is built induces an intimate sympathy, giving us constant pleasure ; and the landscape painter must have as true a knowledge of the branch anatomy of a tree as a figure painter has of the anatomy of the human form. The young student, not knowing how a tree is constructed, is unable to express its essential forms ; he loses their vitality, and makes his tree look nondescript and lifeless.

The serious training of an art school devoted mainly to one object, the human figure, is difficult to apply out of doors to various and changing forms. It is for the student to supplement his teaching by a thorough grasp of the construction of forms, and to profit by the experience gained by others during years of observation.

This is not a book choked with dry botanical details or one giving receipts for the production of pretty sketches. It is a book for the serious student, whether amateur or professional, planned to give him facts—to help him to appreciate some of the aims of a landscape painter when dealing with trees, to save him time in his studies, and to guide him as to how to observe, so that with a sure knowledge of what lies behind appearances he can presently work out his individuality.

It has been my aim to give help of the same kind as Pollock has done in dealing with the forms of water in his charming book *Light and Water*.

Someone—I do not remember who—has said : " It is not the addition of individual circumstances, but the omission of general truth, that makes the little, the deformed, and the short-lived in art."

NOTE

IT is with considerable diffidence that I undertake the task of attempting a description of Trees from the artist's point of view. A loving acquaintance with them each year brings home to me my shortcomings in rendering them as they should be rendered in the branch of art I follow—Painting. To this is added a new terror in having to use words ; and the temptation is to relinquish the effort and say instead that only those who can feel the beauty of Trees may attempt to paint them, and that to others their significance must for ever remain a closed door. If my statements appear dogmatic or dictatorial it is not because I think I can draw trees really well ; but only because I know that a large number of people draw them worse.

ACKNOWLEDGMENT

I AM much indebted to Miss B. Fairbridge for overlooking the text. By her help many errors of grammar and punctuation were detected, and some uncouth and ill-expressed sentences reconstructed to a more palatable form.

The bibliography has been compiled for me by my friend L. Bellin Carter, F.R.S.A.

The tedious business of indexing the book has been undertaken by my wife.

By the kindly co-operation of artists and owners of pictures I have been able to reproduce the work of living painters. My thanks in this respect are especially due to David Murray, R.A., George Clausen, R.A., Sir Ernest Waterlow, R.A., Edward Stott, A.R.A., Mark Fisher, A.R.A., Adrian Stokes, A.R.A., H. Hughes-Stanton, A.R.A., J. W. North, A.R.A., Oliver Hall, R.E., and to Lady East, Sir J. Herbert Roberts, Bart., M.P

CONTENTS

PART II

THE ANATOMY OF A TREE

PART III

THE DETAILS OF TREES

LIST OF PLATES

xiii

NOTE TO THE READER

The Plates, Illustrations, and Diagrams in this volume are indicated by the use of different kinds of type thus:—

Plate XX

Illus. 20

Fig. 20

Unless the reader keeps this steadily before him, he will probably confuse the references to the various kinds of Illustration.

THE ARTISTIC ANATOMY
OF TREES

GENERAL INTRODUCTION—PAINTING
AND DRAWING

WE know that a fine picture cannot be described. Words tell us of
the masterly way in which the subject is presented, the dexterity of
the workmanship, and the excellence of the colour and drawing; but
these things, when enumerated, leave us cold and uninterested, while
any attempts to resurrect the feelings of the painter while engaged on
his task lead us to boredom. The emotion aroused by a grand picture
may be somewhat closely reproduced by a fine prose essay, by poetry,
music, or by a mood in nature herself. The higher appeal in it comes
through the intuition of the artist—*Non vi non dolo sed dono*—the
unconscious effort unacquired. The essentials for any fine work are
intuition combined with a highly developed power of expression.
But there is an intuition that in a lesser form is given to many. I
think we know it as " taste," and this taste or good feeling which starts
with a leaning to that which is best, or from a certain sympathy with
nature, can be guided and improved simultaneously with the acquiring
of the craftsmanship of painting. There are many possessing this
taste or talent who might gain a keener enjoyment if they realised
that, by training, it could be converted into a means of expression.
There are others, lacking taste, who make unfortunate excursions into
painting as an accomplishment. Their performance, instead of being
an offence, might, if they studied appearances sincerely, be of use,
and at the same time be not unpleasing. Most people can be taught
to draw with fair accuracy and to acquire some degree of competency
in painting. Our natural desire to imitate form should be accepted as
words are, merely as another method of description. In our education
drawing and writing should go hand in hand.

If drawing were universal, people would not confuse, as they now

do, mere copies of nature with works of art ; but would frankly acknow-
ledge the former as records, and judge them by the amount of interesting
information they convey. A letter is useful as transmitting informa-
tion, and a drawing can be the same. If your letter is nicely worded
and your drawing shows taste they begin to appeal to another sense,
and we say they have "style." If your intention is grand and is
expressed in fine language, and your drawing conveys a grand im-
pression, we honour them as works of art. Landscape painting is,
I fancy, but little understood even amongst the educated. It does not
surprise one that the yokel should eye a painting as a coloured topo-
graphical inventory of his countryside and praise the performance in
proportion as room is found for every well-known object, each exactly
where it should be. I know a farmer much perplexed because a paint-
ing of his farm was sold for a larger sum of money than the farm itself
soon after realised, and this though the pond, old sheds, and the very
ducks themselves were included. He wonders yet at the stupidity of
the picture-buyer, who, by a less expenditure, could have sat by the
real pond and gazed daily at his farm. Much the same attitude is
assumed by the better educated when they ask, "How do you find such
a beautiful place, and was it exactly like that ? " You must say it was
identical, blade for blade and leaf for leaf, or your reputation as an
honest man is lost. But one must not be over critical, for I have not
forgotten my disgust as a boy on discovering a certain dirty ditch
which had served as the foundation for a fine picture I had previously
seen. Latterly, people have been reading strangely involved writings
on art and ignorant criticisms of pictures. This, and their visits to
some new exhibitions of canvases daubed by people of weak intellect,
have led them to believe that all representations of nature as we know
and love her are wrong, and they are persuaded to profess admiration
only for that which no one can understand. If we consider some of
the aims that every true artist owns, we may gain a more tolerant atti-
tude towards his work, even though it does not conform to our pre-
conceived notions of what a picture should be like ; it may help us to
appreciate many of the different forms in which good art is presented
to us, and to weed out work of ability that perhaps is not immediately
understood from that which is claptrap.

Since an artist appeals to the intelligence and to the emotions, his
work can only give real pleasure to those in whom it arouses a con-
sciousness of beauty similar to his own perception. For this reason a
picture may give intense pleasure to some, while others are unable to
receive the meaning, and, for want of understanding, are apt to dub it

a worthless performance. The feeling for beauty [1] in its best sense is conveyed in so many ways—by colour, by light and shade, by line, by pattern, and by technique ; and any or all of these become the visible means for explaining the deeper feelings that influence the painter. One, or a combination of these, cannot attract everyone equally, but only those whose perceptions are most keenly excited by the particular means selected. Even to those means to which we are less sensitive we can give credit, if not love, if they are well employed. Of the various means at the disposal of a painter, colour seems to have the greatest power of attraction. As children we are interested by colours rather than by forms, and we retain this impulse throughout life—only we temper it by a new desire for a pleasing arrangement of colours.

Our instinct for colour becomes acuter, even though we have learned to see the dignity in masses of light and shade, or to appreciate the rendering or suggestion of form by lines. I fancy our minds are interested in form, but our nature is excited by colour. How few people, however, really appreciate good colour ! The majority are content with any colour, so long as a picture resembles the obvious in nature or tells a tale ; and for this they can even tolerate colours that are lifeless or discordant. Colour seems so much more elusive than form. Fine colour can only be felt, though fine shape can be described. Artists are conscious of very definite laws that govern good colouring, and yet colour is so subtle that the introduction of a new element upsets any scheme, and nearly every picture presents a new colour problem. The sense of mastery over fine colour seems to come to the painter last of all and to leave him at the first note of failing powers. How much its elusive charm is connected with the technique of painting will be felt by everyone who has used oil colours. In water colours there is less excuse for bad colouring. If the scheme is a sound one, plain washes of colour can be relied upon by their transparency for a pleasing effect, though identical colours in oils would require very deft management to prevent their becoming repulsive. Those who have not practised painting use the term " A good eye for colour," meaning that we are born with this as an unalterable gift. We must grant that there is a considerable difference in the acuteness of perception for colour amongst youngsters, just as there is a quick or slow recognition of form ; but the science of colour must be studied with even greater zeal than drawing, if a student is the least bit ambitious of fame. It would be interesting to know in what degree the difference

[1] The word " beauty " is not used in this book in the same sense as " pretty."

in appreciation of colour is due to physical causes. Simple colours have so different an effect upon people. One man I know must laugh with the exuberance of his joy—he cannot help it—when he passes a field of poppies blazing in the sun ; to another it simply gives a headache. We all know that in bad health we can only bear the sight of the most subdued and cleanest of single tints, when at other times we may delight in mixed colours of oriental splendour.

In a picture light and shade is as important as colour in awakening our consciousness to that which is grand. The power of attraction (and it is boundless) in finely spaced quantities of light and dark is to me inexplicable ; perhaps it can be explained by the sense of bulk and mystery that they convey. On first seeing a picture by Rembrandt (or better still for this purpose a good black and white reproduction) it is the effect of light and shade that makes us catch our breath in the sudden revelation of beauty long before our minds have had time to take the meaning. A simple experiment will convince you how much a picture depends for dignity upon the distribution of light and dark. Take a few commonplace objects of everyday life and arrange them exactly in the lighting of some well-known picture, in looking at which you had taken for granted that its interest lay in its subject. If you now sketch these in masses of light and dark, with your eyes somewhat closed to exclude petty details, you will find these objects acquiring an interest, and even a dignity, previously unassociated with them. If you can add to your black and white sketch a good colour arrangement, you surprise yourself into the knowledge that all objects are worthy of pictorial treatment ; and the greater doubt is born whether all people are worthy to treat them.

For an artist, everything is capable of being used as a theme—an outlet for his joy in living and seeing—and his pictures are but expressions of his own moods conveyed to us through the things he represents. For his purpose he has no better agents than colour and this spacing of light and shade.

Drawing that does not include colour can be divided into (1) drawing by masses, (2) drawing by lines. It would be foolish to attempt rigid distinctions ; but usually we find that mass drawing appeals to the deeper emotions and line drawing to the intellectual senses. This may be caused by the association and suggestion of colour that is inseparable from drawing in mass.

In mass drawing, light and shade, texture and form of objects, their colour and influence on one another, all play their part. It is the orchestration in black and white art, while other branches serve as

single instruments. Drawing in lines is for the most part used for two very different purposes—(1) as a hasty record of action or construction (also as a basis in the composing of a picture) ; (2) as a completed picture within the limitations of black and white. As an expression of action it is unrivalled. Single lines compel our undivided attention, and we feel the rhythm of the line and enter into the action of the scene immediately. The fewer the lines, the more powerfully our interest is focussed. How intensely interesting are the hurried notes of a painter showing us the essential lines and what they conveyed to him, or the completed study that we delight in, such as a Caldecott drawing and the drawings of many fine draughtsmen who have made *Punch* almost a necessity for us !

As a basis of a picture lines serve as a backbone, strengthening and connecting separate objects. The building up of a picture by lines restrains an impulsive love for colour and effect, which by themselves might make our work (though beautiful) quite unintelligible.

The second type of line drawing—I mean the one giving a completed rendering of form as well as the light and shade, which may, or may not suggest the colour of objects—is I think the least emotional of all art expressions. Having little of the dash or grand isolation of single lines, it exacts from us a more prolonged mental effort ; it has to be read, as it were, to be fully appreciated. Its charm is not spontaneous ; we read it and read it again, each time discovering a new pleasure in the evidence of searching inquiry by the painter, and recognising the mastery over materials that can bring scenes of life to us with such elemental tools as pen and paper.

The use of pattern or design is, in the minds of many, associated only with its application to work that is purely decorative. In this service we should expect it to be better appreciated than some other forms of art, for is it not a daily rule of our life to demand some order and arrangement in everything about us ? Our gardens, houses, furniture, and trappings of the room have to conform to laws of decoration, and we are familiar with, if not expert, at such making of order.

Fewer people, however, understand that design is the main basis of all pictorial art ; while others concede this to figure painting, but have not considered it in relation to landscape work. It is just this feeling for decorative design that always distinguishes the work of an artist from the mechanical imitator of nature. The side issues of whether much or little detail should be included in a landscape, or whether it should be highly realistic or not, are legitimate paths of divergence, and matters to be settled by the temperament of the painter,

or the exigencies of the particular subject; but whichever path he follows, his work, if it is to be art at all, must be moulded on and regulated by design. This is not an attempt to justify paintings where decoration is obtained at the expense of nature; we have but to refer to nature herself to satisfy our desire for pattern—it is everywhere. Sky, trees, earth, and water teem with it; our difficulty lies in selecting and making the whole scene a decoration, giving each part pattern without distortion and without mauling the face of nature.

Worship of nature, together with enthusiasm for art, are our only guides, but the love of truth should help to check excesses.

This is a most inadequate sketch of the main features that we look for in landscape art. The use of colour, light and shade, line and pattern have been touched upon, and I have intentionally placed technique last in the list of those means by which a painter can bring home to others some of the power in nature that he worships. I have placed it last, as no one possessing that reverence for nature which should be the mainspring in our desire to paint, could be content to represent her except in the best possible way of which he is capable. His self-esteem as a craftsman goads him on to overcome the difficulties in handling his tools. There is a fascination in the technical side of his art that enables a man to bring his work to completion. Without it he would stop short so soon as the excitement he experienced on first tackling his subject had subsided; and our picture galleries would be full of sketches. So engrossing is this wish to do things well that a painter in spare moments may be found exercising his ability upon the most ordinary objects, and the world is enriched by beautiful renderings of these. A young student, but newly conscious of the difficulty in technique, is apt to become enamoured of work which displays a superficial dexterity. It is fortunate for him if he fails to acquire it, or it is likely before long to become his master instead of his servant. But I cannot resist here quoting at some length what Sir Joshua Reynolds has said :

"A lively and what is called a masterly handling of the chalk or pencil,[1] are, it must be confessed, captivating qualities to young minds, and become of course the objects of their ambition. They endeavour to imitate these dazzling excellencies which they will find no great labour in attaining. After much time spent in these frivolous pursuits the difficulty will be to retreat; but it will then be too late; and there is scarce an instance of return to scrupulous labour, after the mind has been debauched and deceived by this fallacious mastery. By this

[1] He uses the word pencil where we now say brushes.

useless industry they are excluded from all power of advancing in real excellence. Whilst boys, they are arrived at their utmost perfection; they have taken the shadow for the substance, and they make the mechanical felicity the chief excellence of the art, which is only an ornament, and of the merit of which few painters themselves are judges. . . . But young men have not only this frivolous ambition of being thought masters of execution, inciting them on one hand, but also their natural sloth tempting them on the other. They are terrified at the prospect before them, of the toil required to attain exactness. The impetuosity of youth is disgusted at the slow approaches of a regular siege, and desires from mere impatience of labour to take the citadel by storm. They wish to find some shorter path to excellence, and hope to obtain the reward of eminence by other means than those which the indispensable rules of art have prescribed. They must therefore be told again and again that labour is the only price of solid fame, and that whatever their force of genius may be, there is no easy method of becoming a good Painter."

These were the words Reynolds used in 1769 in his address to the students of the Royal Academy. I doubt if any President could do better than repeat them to the present-day student.

It seems at first sight as if in these notes I had excluded the chief weapon of art—Composition; but the word composition is likely to be misunderstood as applying to some worn-out conventions of prettiness instead of being understood as it should be—to mean arrangement. Composition, then, means arrangement of colour, of light and shade, of individual objects and the arrangement of each separate part, so that, though retaining interest of its own it is still subservient to the main scheme on which the picture is planned. Selection and arrangement are the life-blood of a picture. Anyone who neglects them is no artist. No artist could neglect them.

My intention thus far has been to combat the too prevalent idea that any pleasing subject in landscape, if exactly copied, will make a good picture. A mean copy of form and colour that misses the essence of the scene is less interesting than a photograph, for the lens gives more form and detail, and you are dull if you cannot find something in the photograph to think about, but the lens does not give us art. A simple copy of a scene, if it is done with correctness, may by chance recall some associations of nature that will be supplied by those who will see the study; but it is the business of the artist to give pleasure and to instruct, and not to rely upon the more subtle perceptions of others.

A painter should be able to make a good picture of any subject, but it is done, not by a literal statement of formations, but by work which shows his appreciation of the nature of the scene—its dignity, or repose, the desolation of it, or its association with human beings. Perhaps its individuality must be insisted upon ; or lost in a larger idea that is suggested by a mood of nature, the heat of the day, the softness of the spring air, or the gales of autumn. The difference between the exactly copied landscape that shows no appreciation and one that has a meaning to back it, is the same as between a guide-book and a Walter Scott novel. There is no need to force a pretended significance of something that is absent, or to presume any drastic alterations. It is better that you should try and see how much good is there ; and by seeing it you will almost unconsciously emphasize it, and by a legitimate exaggeration influence others to see it also.

To sum up these notes then, a landscape picture must be a decoration for a wall, its colours arranged on a harmonious scheme and applied with surfaces of pleasing qualities, its pattern of light and dark a grand one. The individual parts must be interesting each in its place, and must help to build up the beauty of the whole. Above all, the sentiment must be strongly stamped upon it. This is the picture an artist aims for, and his aim being high, if he fails there will still remain something beyond the commonplace in his work. The means he uses have been touched upon chiefly in the hope that some of the time spent on the neatness of pretty sketches may be devoted to thought and higher ideals.

Those who are not in the profession may retort that they are not giving up their lives to painting, and if such excellencies are demanded they would be debarred from an engaging pastime. This need not be so, for sketches, however slight, if they show some insight into nature, and the aim of the performer has been consistently adhered to, are worthy of respect, and the more successful of these will give great pleasure.

Turning from picture-making to work that is frankly a record of things seen and understood, we come to a branch of art inseparable from education. While looking at a photograph we learn just that much which we should have learned by looking at the object itself, though perhaps in a more convenient form.

If we examine a drawing we see the object itself through the brain of the draughtsman. His knowledge has already emphasized the important points for study by a previous separation of the trivial and

accidental from the essential form belonging to the type. We make use of his brain, in addition to our own, and when we refer to the object again we can add new knowledge with greater ease. There is also a charm in such drawings that comes from their appreciation of truth and beauty.

It is the idea suggested by nature and art that an artist has to paint; an intelligently truthful copy of selected parts of nature enables him to do so.

PART I

TREES CONSIDERED IN RELATION TO PAINTING

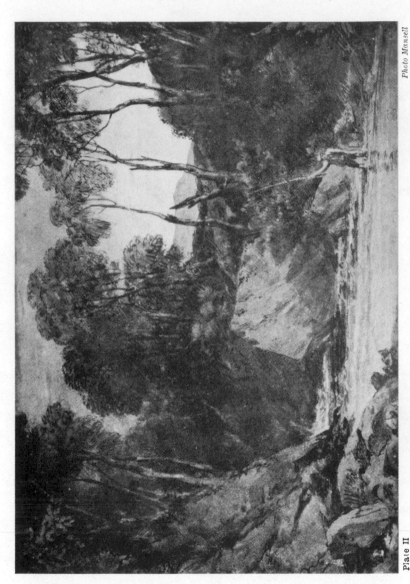

BLAIR ATHOL (LIBER STUDIORUM). J. M. W. TURNER, R.A.

Plate II

CHAPTER I

THÉODORE ROUSSEAU was able, in the painting of a single tree, to impress us with the greatness of nature—with her very soul, if one may use the expression. In looking at his tree we are not disturbed by wondering whether it is an Oak or an Ash or botanically correct. We are content to look at it and come away, feeling that we have seen something grand and without a wish to analyse it. Sometimes out of doors we may see a tree which will excite the same feeling ; but genius is given to few, and any attempt to depict on canvas the feeling we experience, unless it is backed up by a knowledge of construction, results in flabbiness—as is too often seen in the imitators of Corot. We cannot see with other men's eyes, but we can study what they look for. By some our tree will be shown to us as a mere outline, but even that alone can express the severity or rhythm of its lines—lines that would give us pleasure in anything, but here give us the grace, dignity, or strength, as it may be, of the particular tree. Others will wish us to appreciate the tree as a bulk, and will accentuate its statuesque quality in which all details are submerged. Others, again, will find out wonderful shapes, and through them will appeal to our love of pattern, successfully as they extract its complete structure and intricacy of detail,

Constable painted his leaves with the real light of the sky upon them, and they had a rugged homeliness about them free from all convention.

Turner, with a larger view, and strengthened with his absolute knowledge of their construction, used trees at will, weaving magnificent compositions with them as in his " Cephalus and Procris " and " Near Blair Athol " of the Liber Studiorum (Plate II). He utilised them for every device at the command of art ; in one place as bits of light or dark, in another as links between single forms ; here as a piece of delicate leaf tracery like lace work seen against the sky, there as massed spaces

29

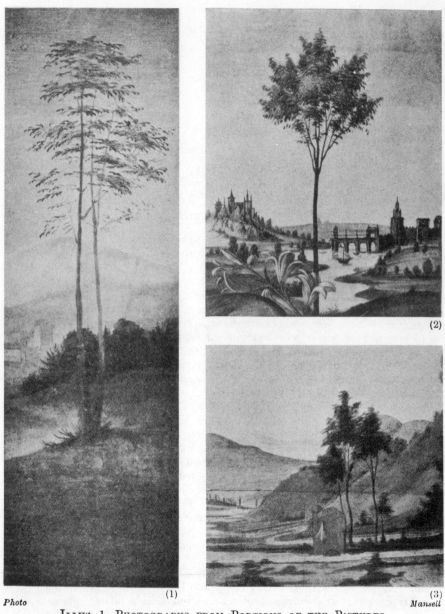

(1)

(2)

(3)

ILLUS. 1. PHOTOGRAPHS FROM PORTIONS OF THE PICTURES

(1) VIRGIN AND CHILD AND THE INFANT ST. JOHN—Fra Bartolomeo

(2) L'ANNUNZIAZIONE—Botticelli (3) VENUS AND CUPIDS—Sellaio

of heavy foliage leading into the gloom. Sometimes his tree was a
portrait, at others a specimen of the type—often a type evolved from
many species—simply a tree—but nevertheless a possible tree.
Whether it was the subtle undulations of the foliage or the severity of
the lines of the trunks, he had a use for them. To him nothing came
amiss ; his sunlight shimmered on the leaves or poured through them
in broad shafts of light ;
his branches stretched
out from the trunk
mixing in the blue of
the sky : no detail was
too trivial to make note
of, not even the seams
or the roughness of the
bark or the single leaves
and twigs that he drew
so well.[1]

From Titian and Pa-
tinier, the Fathers of
landscape painting, to
Cecil Lawson, we recall
the names of those who
have treated trees each
in his own individual
way. Titian, Giorgione,
Rubens, Claude, Rem-
brandt, Poussin, Salva-
tor Rosa, Hobbema,
Wilson, Gainsborough,
Crome, Girtin, Turner,
Constable, Cotman, Cox,
Corot, Creswick, Diaz,
Troyon, Müller, Rous-
seau, Daubigny, Monti-
celli, Cecil Lawson. To

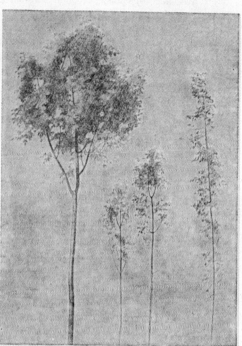

ILLUS. 2. A SKETCH OF SOME YOUNG TREES

Notice the likeness between the one on the left and
Botticelli's tree

discuss adequately their points of view and their methods would require
another book by another pen, but just to name them seems to brighten
our minds and stir us to effort.

But our list should start with the Primitive Italians with their
precise and delightful little trees painted in such an ingenuous way

[1] Turner's delicate drawings of still life on a minute scale that have been
brought to light recently seem to have astonished some people who had over-
looked his refined vignettes for book illustration.

with an infinite loving care. Their desire for an art, as something separate and different from ordinary life, seems to have guided them in the selection of just those trees that would satisfy it completely. Their trees were not, as some suppose, thought out formally, but were truthful copies of such as we find in our own copses to-day in the young trees that have been spared after the cropping of the underwood.

Here are three of them sketched the other day—just such as might have been taken as models in the fifteenth century, when they would have been beautifully painted ; leaf after leaf standing out dark against a sweet clear sky. Their appreciation of delicacy, and the nice disposition of the little blocks of foliage up the stem might well be followed, instead of the formality in untruthful ugliness that is conjured up by some of our illustrators to-day. Another form is a compact and dense little tree covered with separate leaves as in the background of " The Virgin adoring the Infant Christ " by Lorenzo di Credi (Illus. 3). They are delightful, though in truth they resemble shrubs. These are the chief forms of trees that are associated with the paintings of that period, but that other aspects were also used then is evident from Giovanni Bellini's painting of a wood in the picture, " The Death of St. Peter, Martyr." The same exactness in copying the leaves is there, but the wood has depth, and the trunks give out branches on all sides, some towards us, others receding into the wood. The same veneration of nature even in her details is shown in the realistic painting of a lemon tree in the picture, " The Madonna, Infant Christ, and St. Anne," by Girolamo dai Libri, in the National Gallery.

The work of some painters becomes more interesting if we remember when it was that they lived. Here is a list of those we mention :

A LIST OF ARTISTS MENTIONED IN THE TEXT

Popular Name	Name in Full	Nation	Date
Bellini	Giovanni Bellini	It., Ven.	*1428–1516
Sellaio	Jacopo del Sellaio	It., Flor.	1446–1493
Credi	Lorenzo di Andrea d'Oderigo Credi	It., Flor.	1457–1537
Fra Bartolomeo	Bartolomeo di Pagholo del Fattorino	It., Flor.	1472–1517
Girolamo dai Libri		It., Verona	1475–1546
Giorgione (also called Barbarelli del Castel-Franco)		It., Ven.	1477–1510
Titian	Tiziano Vecellio	It., Ven.	*1477–1576
Franciabigio (also known as Francesco or Francia Bigio)	Francesco di Christofano	It., Flor.	1482–1524
Patinier	Joachim Patinier	Dutch	1485–1525
Carracci	Annibale Carracci	It., Bolog.	*1560–1609
Rubens	Sir Peter Paul Rubens	Flemish	1577–1640
Guercino	Giovanni Francesco Barbieri	It., Bolog.	1591–1666
Poussin	Nicolas Poussin	French	1594–1665
Claude Lorrain	Claude Gellée	French	1600–1682
Neer	Aart van der Neer	Dutch	1603–1677
Rembrandt	Rembrandt Harmensz van Ryn	Dutch	1606–1669
Both	Jan (or Johannes) Both	Dutch	*1610–1652

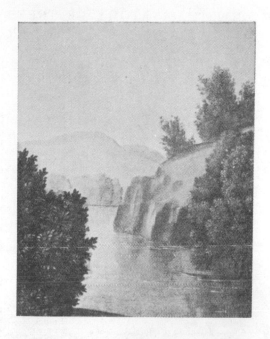

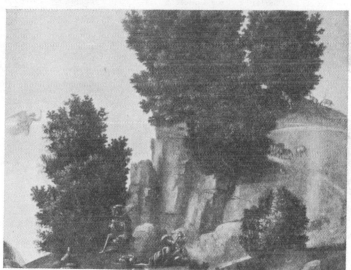

ILLUS. 3. TREES IN "THE VIRGIN ADORING THE INFANT CHRIST," BY CREDI

A List of Artists Mentioned in the Text—(*continued.*)

Popular Name	Name in Full	Nation	Date
Poussin . . .	Gaspard Dughet	French	1613–1675
Rosa . . .	Salvatore Rosa	It. Neap.	1615–1673
Bourdon. . .	Sébastien Bourdon	French	1616–1671
Wynants . .	Jan Wynants	Dutch	*1620–1682
Pynacker . .	Adam Pynacker	Dutch	1622–1673
Ruysdael . .	Jacob van Ruisdael	Dutch	*1628–1682
Hobbema . .	Meindert Hobbema	Dutch	1638–1709
Watteau . .	Antoine Watteau . . .	French	1684–1721
Pater . . .	Jean-Baptiste-Joseph Pater . .	French	1696–1736
Boucher . .	François Boucher	French	1703–1770
Wilson . . .	Richard Wilson, R.A.	English	1714–1782
Gainsborough .	Thomas Gainsborough, R.A. . .	English	1727–1788
Fragonard . .	Jean Honoré Fragonard . . .	French	1732–1806
Crome (" Old ") .	John Crome	English	1768–1821
Girtin . . .	Thomas Girtin	English	1773–1802
Turner . . .	Joseph Mallord William Turner, R.A.	English	1775–1851
Constable . .	John Constable, R.A.	English	1776–1837
Cotman . .	John Sell Cotman	English	1782–1842
Cox . . .	David Cox	English	1783–1859
De Wint . .	Peter De Wint	English	1784–1849
Nasmyth . .	Patrick Nasmyth	Scotch	1787–1831
Linnell . . .	John Linnell	English	1792–1882
Corot . . .	Jean Baptiste Camille Corot . .	French	1796–1875
Diaz . . .	Narcisse Virgile Diaz de la Péna .	French	1808–1876
Troyon . . .	Constant Troyon	French	1810–1865
Creswick . .	Thomas Creswick, R.A. . . .	English	1811–1869
Müller . .	William John Müller	English	1812–1845
Dupré . . .	Jules Dupré	French	1812–1889
Rousseau . .	Pierre Etienne Théodore Rousseau .	French	1812–1867
Daubigny . .	Charles François Daubigny . .	French	1817–1878
Monticelli . .	Adolphe Monticelli	French	1824–1886
Foster . . .	Myles Birket Foster, R.W.S. . .	English	1825–1899
Haden . . .	Sir Francis Seymour Haden, P.R.E. .	English	1818–1910
Millais . . .	Sir John Everett Millais, Bart., P.R.A.	English	1829–1896
Leighton (Frederic)	Lord Leighton, P.R.A. . . .	English	1830–1896
Cole . . .	George Vicat Cole, R.A. . . .	English	1833–1893
Walker . . .	Frederick Walker, A.R.A. . . .	English	1840–1875
East . . .	Sir Alfred East, R.A., P.R.B.A. .	English	1849–1913
Lawson . . .	Cecil Lawson	English	1851–1882
Forbes . . .	Elizabeth Stanhope Forbes, A.R.W.S.	English	1859–1912
Pickering . .	J. L. Pickering, R.O.I., R.B.A. . .	English	1912
Birch . . .	S. J. Lamorna Birch, A.R.W.S. .	English	
Brickdale . .	Eleanor Fortescue Brickdale, A.R.W.S.	English	
Cowper . . .	F. Cadogan Cowper, A.R.A., R.W.S..	English	
Clausen . .	George Clausen, R.A., R.W.S. . .	English	
Davis . . .	H. W. B. Davis, R.A.	English	
Fisher . . .	Mark Fisher, A.R.A.	English	
Hall . . .	Oliver Hall, R.E.	English	
Harpignies . .	Henri Harpignies	French	
Monet . . .	Claude Monet.	French	
Murray . . .	David Murray, R.A., A.R.S.A., A.R.W.S.	English	
Parsons . .	Alfred Parsons, R.A., P.R.W.S. . .	English	
Rackham . .	Arthur Rackham	English	
Stanton . .	H. Hughes Stanton, A.R.A. . .	English	
Stokes . . .	Adrian Stokes, A.R.A. . . .	English	
Shaw . . .	Byam Shaw, A.R.W.S. . . .	English	
Steer . . .	P. Wilson Steer	English	

* Dates uncertain.

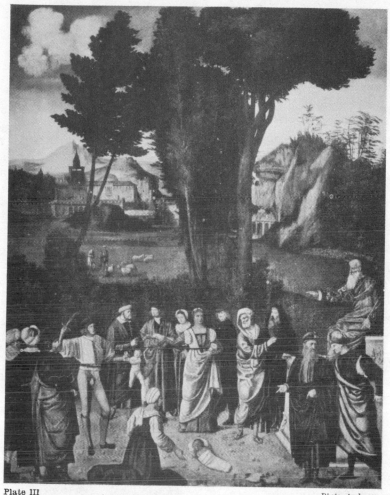

Plate III

JUDGMENT OF SOLOMON. GIORGIONE (UFFIZI GALLERY)

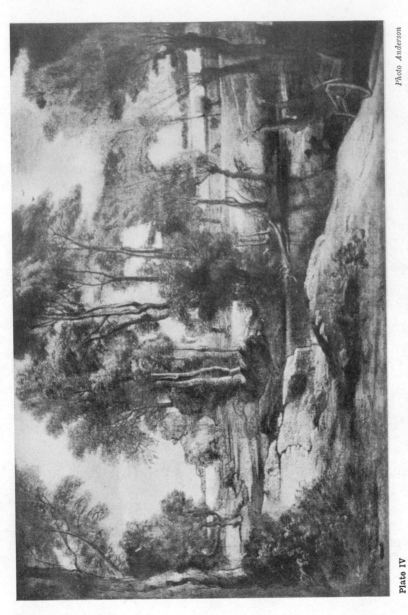

Plate IV

LANDSCAPE. RUBENS (NATIONAL GALLERY)

Notice how modern this beautiful landscape looks, and the shapes of the sky spaces.

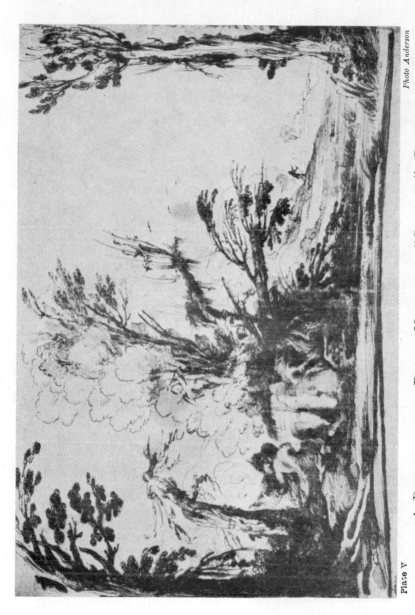

Plate V

A Drawing in the British Museum by "Guercino" (Barbieri)

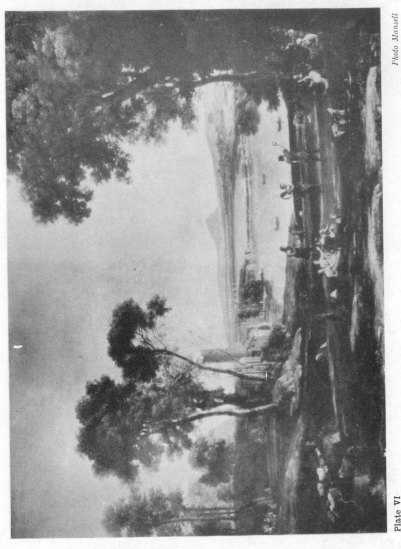

Plate VI

MARRIAGE OF ISAAC AND REBECCA. CLAUDE LORRAINE (NATIONAL GALLERY)

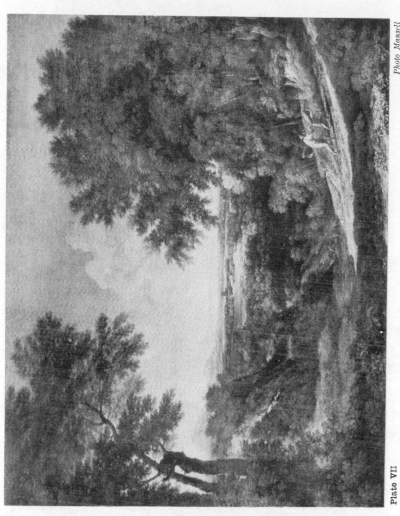

Photo Mansell

Plate VII

LANDSCAPE WITH FIGURES. GASPARD POUSSIN (NATIONAL GALLERY)

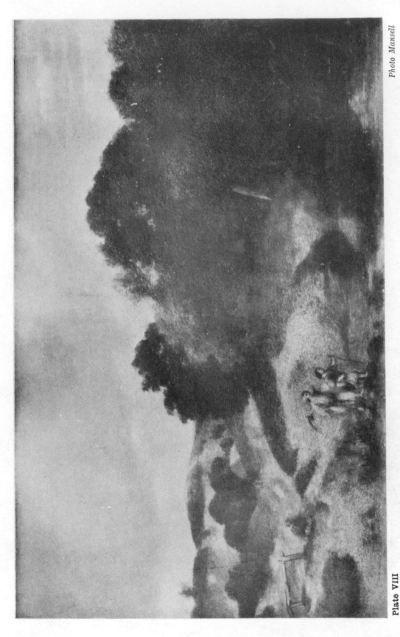

Plate VIII

TOBIT AND THE ANGEL. REMBRANDT (OR SCHOOL OF) (NATIONAL GALLERY)

The treatment of this subject by Rembrandt and Salvatore should be compared as an extreme example of the predominating influence of temperament.

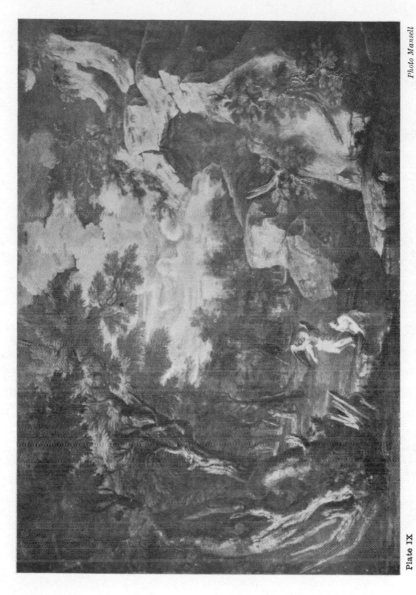

Plate IX

TOBIT AND THE ANGEL. SALVATORE ROSA (NATIONAL GALLERY)

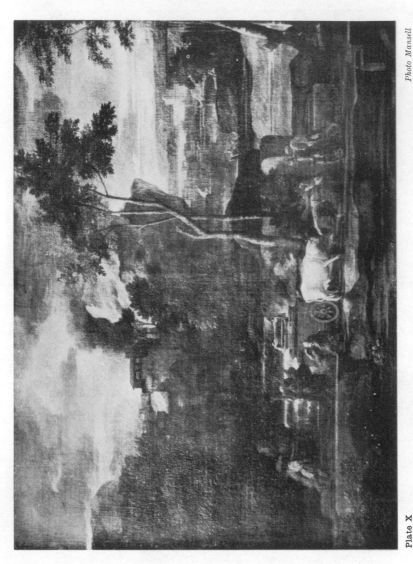

Plate X

THE RETURN OF THE ARK FROM CAPTIVITY. SEBASTIEN BOURDON (NATIONAL GALLERY)

In this reproduction the lower part of the picture has unfortunately been cut off and this has damaged the composition.

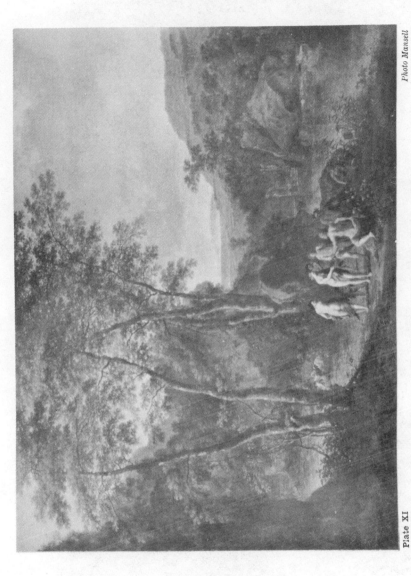

Plate XI

JUDGMENT OF PARIS. JAN BOTH (NATIONAL GALLERY)

The figures were painted by Cornelis Poelenburg.

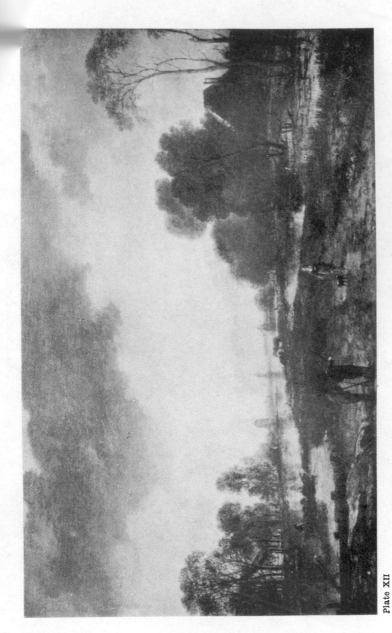

Plate XII

A River Scene, Afternoon. Van der Neer (Wallace Collection)

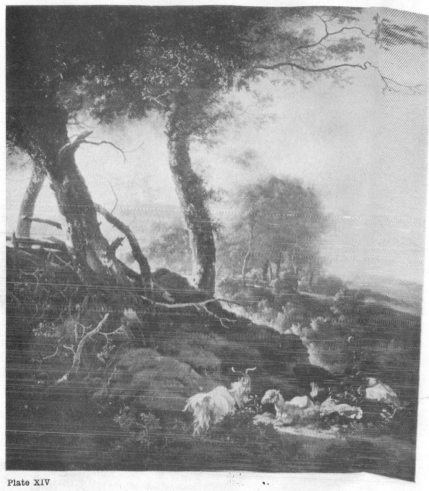

LANDSCAPE WITH ANIMALS. ADAM PYNACKER
(WALLACE COLLECTION)

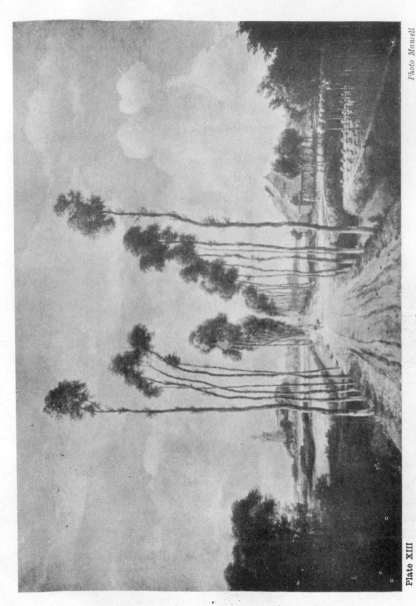

Plate XIII THE AVENUE, MIDDELHARNIS, HOLLAND. HOBBEMA (NATIONAL GALLERY)

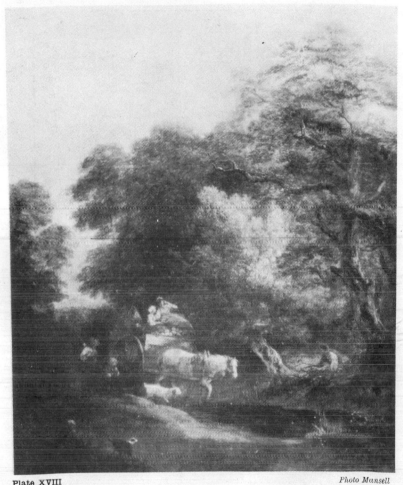

THE MARKET CART. GAINSBOROUGH (NATIONAL GALLERY)

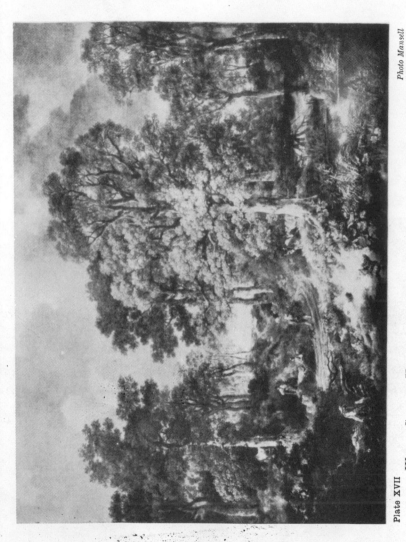

Plate XVII

WOOD SCENE, VILLAGE OF CORNARD, SUFFOLK. GAINSBOROUGH
(NATIONAL GALLERY)

An early work. Compare with plate XVIII.

With Titian and Giorgione (1477) (Plate III), began the modern view of landscape—massed trees rounded and lit by the sky, the formation of land shown by shadows, sprays, and trunks introduced into the foreground, and detail lost and found, just as we think of it now.

Was not Rubens (a hundred years later) one of the first of the figure painters to paint pure landscape (Plate IV) as well as to use it as a background? His study of the " Boar Hunt " in the British Museum is marvellously expressive ; it should be noticed how he uses the fulness of the contours on the fallen trunk to explain its foreshortening ; how dexterous is his use of shadows on the upright stem, and how extreme his accuracy in the branch formations, and in the emphasis and loss of line on the stem. The drawing is full of facts and is minutely copied, yet it expresses the greatest energy and life.

Twenty years later Nicolas Poussin, the great Frenchman, was painting his romantic scenes. We must take his trees as belonging to his subject if we are to enjoy them ; they do not bear peering into as literal statements ; nor can I think that his selection of the smaller forms shows the judgment and instinct for the beautiful displayed by Claude a few years later (Illus. 4).

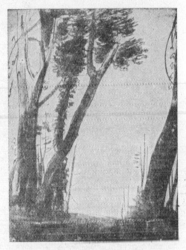

ILLUS. 4. SEPIA STUDY BY CLAUDE, IN THE BRITISH MUSEUM

There is no need to look for something to displease one (how Ruskin hurts us at times by doing so), and there is nothing to criticise in Claude and but little in Poussin, but everything to admire, if we enter into the bigness of the view as they did and as they intended us to do.

Claude was the first painter to show the grandeur of trees ; in his pictures, by their height and dignity, they commanded the landscape ; by their fulness and exquisite design, they created a setting of richness and romance that not even the artificiality of his ruins and palaces could destroy (Plate VI, Illus. 4, 5). Claude and Turner are set apart from all other landscape painters by their genius endowing them with an understanding of nature in her deepest and most varied moods. Claude, in his pictures such as " The Flight into Egypt," " Egeria and

her Nymphs," and "Landscape with Figures" (Illus. 5) (Dresden Gallery), has designed trees of simple and noble proportions that essentially belong to the tranquility of the scenes. In the "Village Dance" (Louvre) he makes use of another type full of busy forms that would be disquieting were it not for the dancers underneath them, while in his etching, "Dance under the Trees," there is a lightness and movement in the stems and foliage that we are unaccustomed to in his

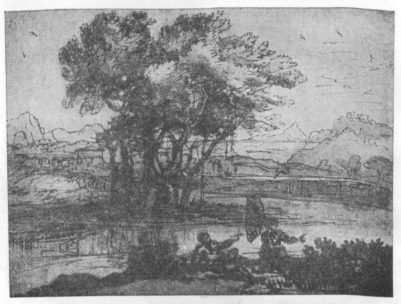

ILLUS. 5. A DRAWING BY CLAUDE, IN THE BRITISH MUSEUM

paintings　His drawings [1] (in the British Museum) reveal his great and varied sense of composition and an intense love of nature ; they and his pictures record his mastery in drawing trees.

How grandly—but with what an individual view—landscape was treated at this same time, by the Frenchman Nicholas Poussin and "Le Guaspre" (Plate VII), by Bourdon, and Claude (1600–1682) ; by the Italians Salvator Rosa (Plate IX) and Guercino (Plate V) ; by the Dutch Van der Neer, Rembrandt, and Jan Both ; and a few years later by Wynants, Pynacker, and Hobbema (1638–1709). We place their

[1] A little book at the modest price of 6d. is published by Gowans & Gray, containing sixty photographic reproductions of these drawings.

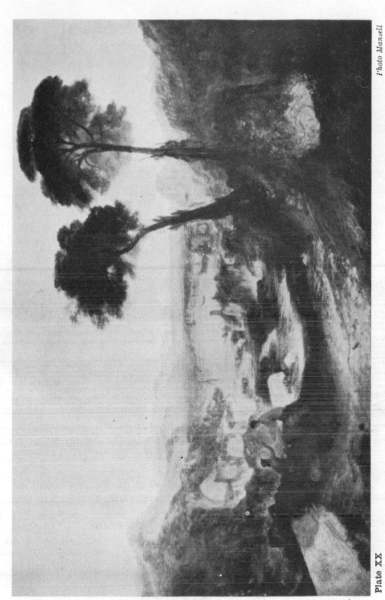

Plate XX

The Bay of Baiæ, Apollo and the Sibyl. J. M. W. Turner, r.a.

(National Gallery)

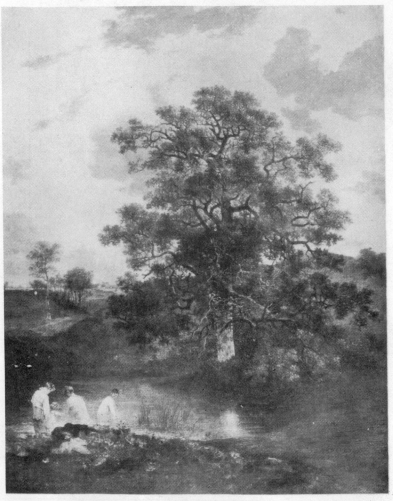

Plate XIX *Photo Mansell*

THE PORRINGLAND OAK. JOHN CROME (NATIONAL GALLERY)

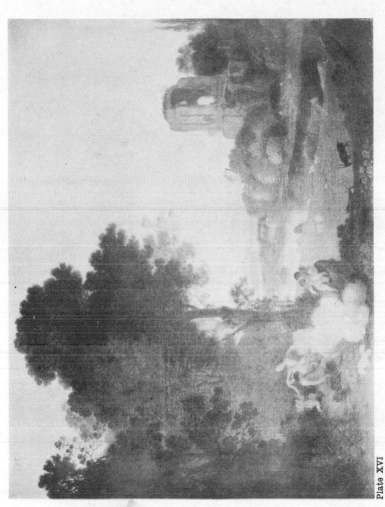

Plate XVI

LANDSCAPE WITH VENUS AND ADONIS. RICHARD WILSON, R.A.
(VICTORIA AND ALBERT MUSEUM)

The figures were painted by J. B. Cipriani, R.A. (B. 1727, D. 1785).

Plate XV

I. Les Champs-Élysées. Antoine Watteau

II. Fête in a Park. Jean Baptiste Joseph Pater
(Wallace Collection)

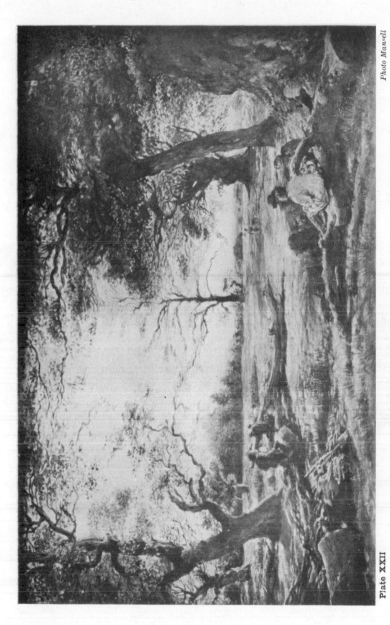

Plate XXII

Wood Cutters. John Linnell (Tate Gallery)

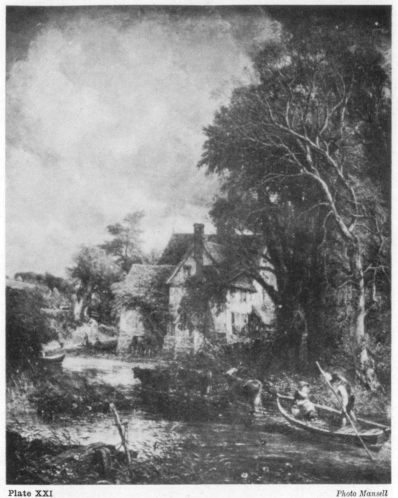

THE VALLEY FARM. JOHN CONSTABLE, R.A.
(NATIONAL GALLERY)

Plate XXIII Souvenir de La Morte Fontaine. Corot (Louvre)

Plate XXIV

LA BAIGNEUSE. DIAZ (VICTORIA AND ALBERT MUSEUM)

names together as an aid in remembering when they lived, the giants to whom we pay homage—Claude, the Poussins, Rembrandt, and Hobbema, with the lesser men whom we should nevertheless study and respect.

Gaspard Poussin shares with his brother-in-law and master Nicholas that great view of nature that sees romance and not merely botanical facts in trees.

Rembrandt's trees [1] are chiefly known in England by his grand etchings in the British Museum. The picture " Tobit and the Angel " (Plate VIII) was, I think, formerly attributed to him, though now catalogued under " school of Rembrandt." It is instructive to compare it side by side with Salvator's version of the same subject. In the former there is an unaffected simplicity and peace secured by the quiet massive shapes of the trees, the ground, and the pose of the guiding angel. Salvator's picture is the very essence of hustle caused by the tortuous shapes of trees, sky, and rocks. Each line conveys the greatest sense of energy and disturbance, and all add in the making of a fantasy as far remote from quiet everyday scenes as the other picture is in complete agreement with them.

Bourdon's imaginative picture, " The Return of the Ark " (Plate X), is composed of as many upright and level lines as Salvator's picture has twisted ones ; the vertical tree trunks contribute largely to the austere effect. Sir Joshua, in his lectures, cited this picture as an example of poetry in landscape.

Van der Neer studied his trees with discerning observation and sympathy. In his poetic river scene (Plate XII) (No. 152, National Gallery) the trees are conspicuous for the varied treatment of their outlines and definition ; the boughs are full of incidence. Compared with his trees those of Jan Wynants seem lifeless and somewhat mechanical, though not tainted with the excessively laboured detail shown by Ruisdael. Jan Both (Plate XI) made his trees elegant, and they belong to a pleasing Arcadia quite his own. If their foliage is somewhat flimsy from a want of construction, they are always free from being matter-of-fact. In Both's etchings his fancy seems to tell with greater force, and his tree tops are less given to straying.

Poussin, Claude, and Rembrandt took a large view of trees; Hobbema saw them in detail, but his elaboration was subservient to the motif and quaintness of the scene, and was uplifted from mechanical device by his fidelity and veneration (Plate XIII).

Ruisdael—judging from the number of examples in the National

[1] There is a landscape by Rembrandt in the Wallace Collection and another " Diana bathing " in the National Gallery, but trees do not occupy an important position in either of them.

Gallery—is considered also great, but to me his elaboration is unredeemed by the genius of Hobbema : however, I am not a connoisseur. The picture by Adam Pynacker, of which we give an illustration (Plate XIV), is in the Wallace Collection. It is interesting for his close view of the trunks and for the strong effect of sunlight that was characteristic of his work. There is another example in the same collection, but he is not represented in the National Gallery.

Figure students would be well advised to study the relation trees bear as backgrounds to figures ; and such a study might begin with Watteau and his pupil and imitator, Jean Baptiste Pater. The examples of their work reproduced here side by side show clearly how the elegance of the figures is echoed in the trees, and the important part the latter play in the distribution of the light and shade. You will notice that the dark and light groups of figures are repeated by the corresponding darks of the trees and light patches of the sky. By this arrangement the principal figures, though they occupy only one-third of the height of the canvas, are not dwarfed by the foliage above them. Fragonard, in " The Swing," allots less than half the height of the canvas to the figures of the swinging girl and the man at her feet. He gives to the bough above them the suggestion of movement. Watteau invariably made his trees as dainty as his figures, and there was no break in the continuity of the scheme (Plate XV). We see a corresponding relationship between figures and their surroundings in the decorations by Boucher. Millais made a similar use of the severe lines of the Lombardy Poplars in his " Vale of Rest."

In 1714 was born Richard Wilson, a " chiel amang chiels," and the first of the great English landscape painters—well worthy to take his place after Claude, with the same large view of nature and a lovely quality of paint (Plate XVI).

A few years after his death came Gainsborough, in some of whose pictures the fronded trees seem as a new creation—not literal enough to be labelled, yet compelling us to feel and enter into the homely romance or solemnity of his scene. But not always so, for his oaks in the " Village of Cornard " (Plate XVII), painted when he was but twenty-six years old, are as literally accurate as his later trees were romantic. I doubt if trees have ever been made more impressive than in his picture, " The Watering Place."

Crome, the founder of the Norwich School, was about twenty years old when Gainsborough died. He and Cotman often painted pictures for the sake of the trees alone, and their work is distinguished by a simplicity and a big decorative conception of nature ; theirs was the decoration existing in nature generally, not the flat pattern of the modern decorator (Plate XIX).

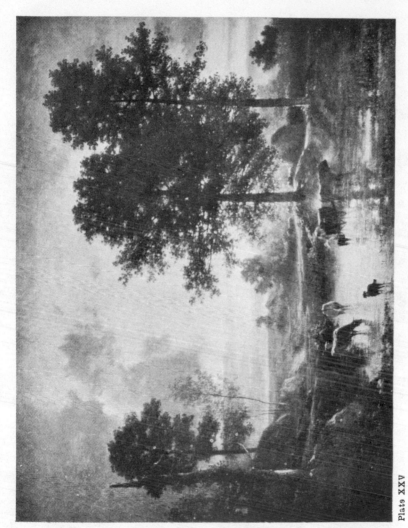

Watering Cattle. Troyon (Wallace Collection)

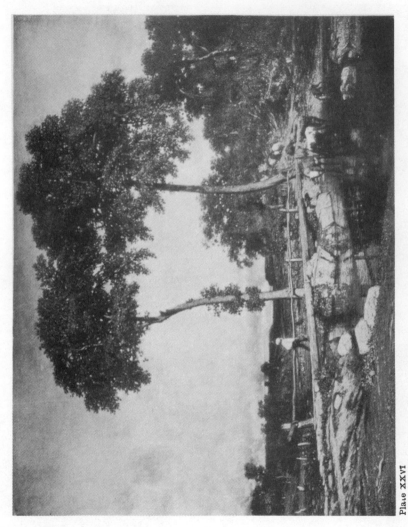

Plate XXVI

CROSSING THE BRIDGE. JULES DUPRÉ (WALLACE COLLECTION)

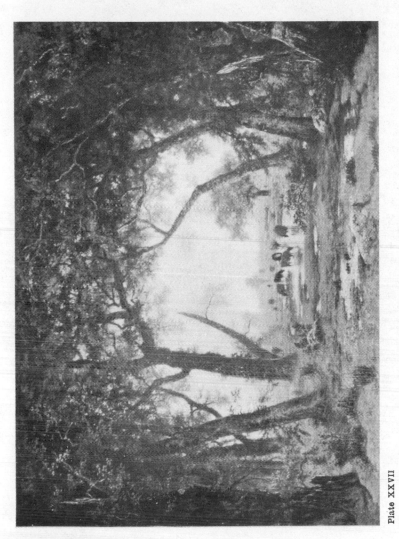

Plate XXVII

A GLADE IN THE FOREST OF FONTAINEBLEAU. ROUSSEAU (WALLACE COLLECTION)

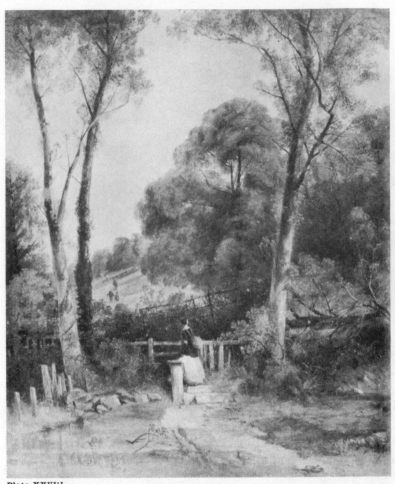

The Pathway to the Village Church
Thomas Creswick, r.a. (Tate Gallery)

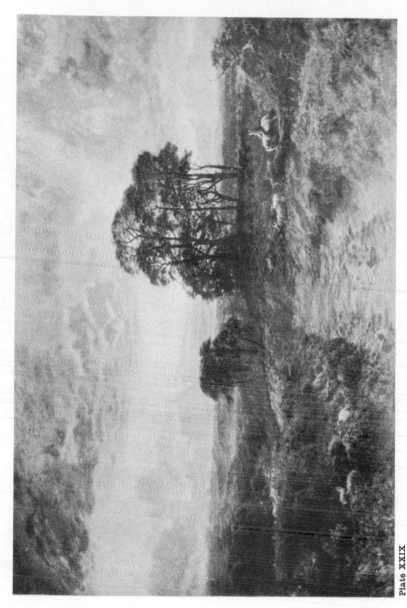

Plate XXIX

A PAUSE IN THE STORM AT SUNSET. VICAT COLE, R.A.

Painted in the year 1867.

Champions of landscape came in quick succession. From 1714 (Wilson) to 1792 we have Gainsborough, Crome, Girtin, Turner, Constable, Cotman, De Wint, Cox, Nasmyth, and Linnell. Among these we have spoken of Turner ; Girtin, even with his few years of life, may almost be classed with him.

With Constable began the open-air pictures and the faithful study of nature by men who painted the things around them without affectation. He had no fear in presenting nature in her own colours ; and his adoration of the homely English scenery is seen in everything he did. " I love every stile, and stump, and lane in the village ; as long as I am able to hold a brush I shall never cease to paint them." His trees were not painted to convey an outside meaning, but because he loved each one of them. He had no use for a set type of tree ; he wanted each one, from the humble Elder bush that holds a conspicuous place in his " Hay Wain," to the towering trees in the " Valley Farm " [1] (Plate XXI). His was the inspiration that guided the judgment of the French Romanticists.

David Cox saw the freshness of the land and liked trees best when swaying to the wind ; in depicting their movement he has never been surpassed. Nasmyth, the first of the Scotch landscapists, followed Hobbema in his love for detail. Linnell could choose a picture from the heart of the forest, and his oaks, felled trees, and woodmen make up a typical English wood and scene.

It is difficult to believe that Creswick completely understood the structure of a tree, but we cannot deny that in many of his pictures they have the power to charm (Plate XXVIII, p. 39).

Müller, who was only thirty-three when he died, painted the " Eel bucks at Goring," and if he had lived for Constable's sixty-one years, might have outrivalled him in dash and brilliancy.

From 1796 to 1834 were born the great men forming the French romantic school headed by Corot and ended by Monticelli—men who, like Crome and Cotman, painted trees for their own sake, not as incidents in a picture. Corot painted the poetry of atmosphere and discovered pathos in the Willow. He had an exquisite appreciation of the subtle undulations in lines. Diaz could make a few trees the centre and the beginning and the end of a picture that holds our undivided attention (Plate XXIV). Good landscapes did not end with Linnell (Plate XXII) and Monticelli. Cecil Lawson was inspired by the true love of nature, and viewed her in a big way ; his art was convincing

[1] Students should examine his elaborate and accurate studies of trees in the Victoria and Albert Museum. These pencil drawings of form, seen side by side with the dashing sketch of the " Jumping Horse," show the two phases that are characteristic of a great artist.

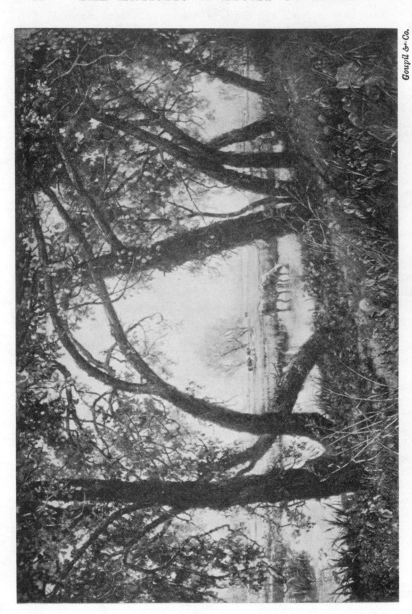

Goupil & Co.

ILLUS. 6. CECIL LAWSON'S MARSH LANDS

The photograph from which this was made does not do justice to this beautiful painting

THE WINTER SUN. J. W. NORTH, A.R.A. (TATE GALLERY, CHANTREY BEQUEST)

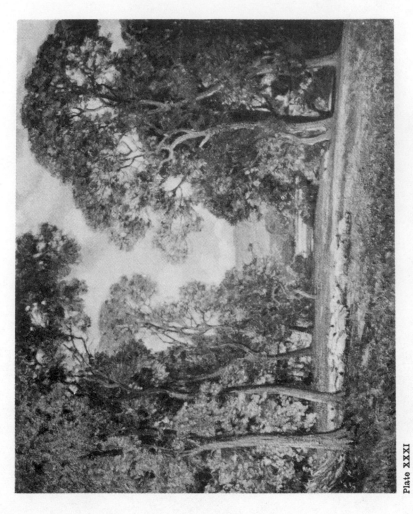

Plate XXXI

Under the Wold. Sir Alfred East, R.A., P.R.B.A.

and refined (Illus. 6). With him lived a set of painters distinguished
by their love of nature and the picturesque. Selection of types was,
with them, all important. My father, G. Vicat Cole, R.A., was con-
spicuous for his loving fidelity to nature. His refined drawing
exhibited a complete mastery of the forms of trees that he studied
and loved so well (Illus. 7; Plate XXIX).

No one can pass by that period without paying homage to the men

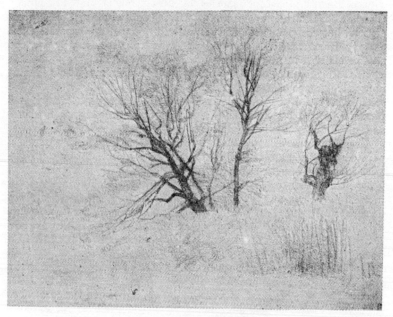

ILLUS. 7. PENCIL STUDY, BY VICAT COLE, R.A.

who made a reverential study of the smaller forms of nature. Millais,
Fred Walker, and North proved the belief which François Millet held—
that all objects in nature, however insignificant, are worthy of the toil
and talent of an artist. Millais found a meaning in the plants of the
hedgerow and painted them with consummate skill. The trees of his
later period were drawn with the confidence of a great artist, but do not
show the temperament of the true landscape painter. His landscapes
seem to me to be masterly studies of strips of country. Was it not
that his joy in seeing the open country compelled him to paint them
after the restraint of life in a town ?

Fred Walker applied a fresh and searching vision to the objects he painted at close quarters. We have only to look at the Hazel bush in his " Spring " [1] to understand the link between his mind and nature. The exquisite refinement in the work of J. W. North came as a revelation of artistic discernment (Illus. 8, p. 43; Plate XXX). Leighton has left us some perfect pencil drawings of tree forms.

Trees for book illustrations were drawn with all the feeling that typical English landscape inspires by Birket Foster (how my superior friends will raise their eyebrows !). His was not a conception of great aspects, but the sincerity and sympathy of his pictures separate them entirely from that which is vulgar or mean. Incidentally we can admire his skill in the grouping of children.

We recognise in the etchings of Seymour Hayden his gift of planning impressive groups of trees.

The beautiful pen and ink and " wash " illustrations of trees and plants by Alfred Parsons, like his water-colour studies, show a refined and gifted understanding of natural forms.

Trees have never at one and the same time been better or worse painted than they are at the present day. The old masters were content to treat them in a big way and to implicitly follow tradition. They painted one or two types of trees only. Some amongst the modern men draw every sort of tree, and how well and faithfully they do so is seen in the work of Adrian Stokes, Mark Fisher, Sir E. Waterlow (Plate XXXIII, p. 44), Hughes-Stanton, P. Wilson Steer, Arnesby Brown, Lamorna Birch, H. W. B. Davis, the late J. L. Pickering, and Elizabeth Stanhope Forbes, amongst others.

It is difficult to speak of contemporary painters without being considered a prig, but fine work of the present must be included with that of the past, and my admiration is not limited to the few names I choose. There is abundant evidence in our galleries of extensive study combined with a real appreciation of trees ; though unfortunately these examples hang side by side with pictures in which a conscious and forced straining for the grand effect has resulted in the utmost indifference to all that makes a tree a beautiful and a living thing.

We appreciate in George Clausen's work that nicety of balance between the realism that is necessary to convey the artist's love of natural forms and the requirements of art that ennoble them (Plate XXXII).

David Murray shows us the charm of rhythmic lines in stems and branches, and in Oliver Hall's work there is an educated sensitiveness and discrimination in the selection and following of lines—particularly in his etchings (Plate XXXIX).

[1] In the Victoria and Albert Museum.

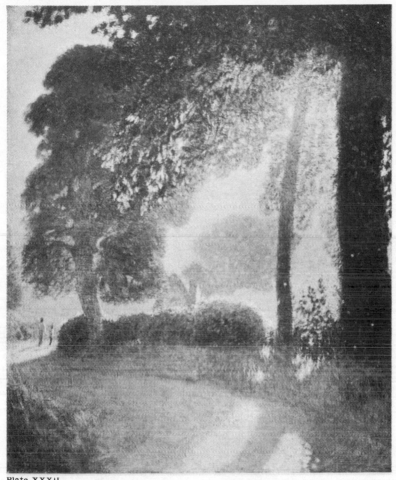

Plate XXXII

THE ROAD. G. CLAUSEN, R.A.

Alfred East made the pattern in trees his own ; they are set in an atmosphere of poetry, and we feel their dignity and reserve.

Men, who find beauty even in the lowliest of Nature's handicraft —in the buds, and twigs, and forms of plants among other things— stand apart from the followers of the modern creed of ugliness, and we

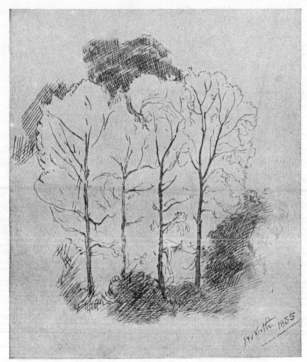

ILLUS. 8. PEN AND INK STUDY OF TREES WITH SUN-
LIGHT THROUGH THE FOLIAGE, BY J. W. NORTH,
A.R.A., SKETCHED IN 1855

are indebted to such painters as Cadogan Cowper, Byam Shaw, and Eleanor Brickdale for their influence.

With Arthur Rackham we enter into the world of Elves and Pixies suggested by the grotesque forms of the roots and saplings of the hedge-row.

Of the work of the living French landscape painters I know too little ;

some evidently paint their trees with care and fidelity ; others, in their search for means of expressing light and air, sacrifice all form for a galaxy of colour; this is chiefly so amongst the followers of Monet. Despite the want of structure that immediately separates their painting from actuality, they often possess a charm, though there seems to me an anachronism in wishing to obtain in a picture the effect of real light on an impossible tree. If we no longer call it a tree, but just something surrounded by beautiful colour, we can enjoy the abstract charm that is inherent to colour without form.

The fine work of Harpignies speaks for itself ; students should study it whenever they have the opportunity.

A figure painter interests us in his figures by quite distinct methods. If he gives us a figure that is a searching portrait of an individual with its beauty and its blemishes, it excites our sympathy from being a part of the everyday life we share in common. We recognise the effect of toil, pleasure, or what not as something personal and intimate that we know of. Harold Speed, in his most interesting book on drawing,[1] points out how well Degas could utilise this aspect, and many painters whom we know as realists have used its full power. But a painter dealing with some subjects must make sure we shall not think of his figures as individuals. Instead of being personal, his figures must convey a larger outside sentiment that we do not associate with a naturalistic study from one figure. A photograph of a woman's figure, however fine it were, would not represent Eve—we require something more abstract. Pictures by the early Italians, Fra Angelico and Botticelli, for example, owe much of their charm to the aloofness from personal life that the figures show.

We have something of the same distinction in landscape. The painting of a tree may be such an appreciative bit of naturalism that we enter into its existence, as it were. We admire its vigour of life, are astounded at its prodigal abundance of leaf and seed and the defiance of the laws of gravitation shown in those huge horizontal limbs. We recall its encounters with storms, sympathise with its fresh start in life, and marvel at the almost human ingenuity that its parts display while seeking light and air. I think this is how Nasmyth saw his oaks and wished us to see them.

But there is the larger standpoint in which the tree does not interest us so pertinently for itself, but becomes a unit in the sentiment of the scene. Claude's trees seem to me so—just beautiful masses full of the atmosphere of the day.

When we are with nature all formulas and precepts must be left behind. If we go out to paint in a set manner we are conscious of

[1] *The Practice and Theory of Drawing.* Seeley. 10*s.* 6*d.* nett.

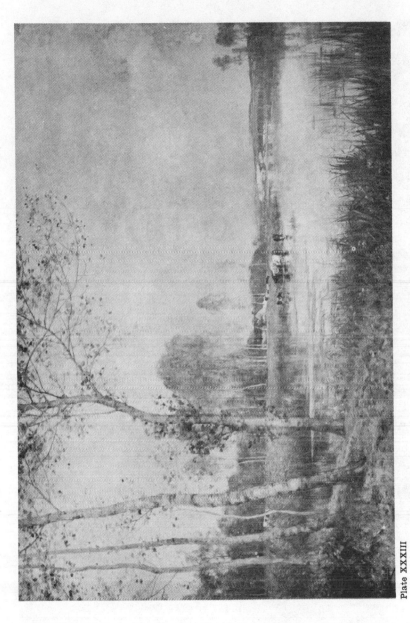

Plate XXXIII

In the Mellow Autumn Light. Sir E. A. Waterlow, R.A.

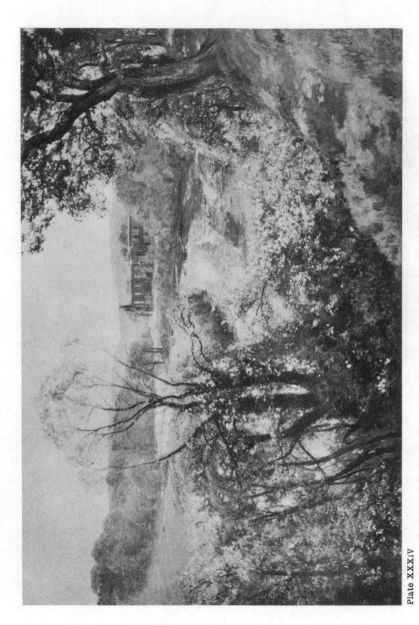

Plate XXXIV

BOLTON ABBEY. DAVID MURRAY, R.A.

ourselves rather than of nature ; our picture will show that we are learned or ignorant, dexterous or clumsy, but it will not show that which should have incited us to paint it. Away from nature, we can reason where our art has failed, and apply those laws that have guided better men before us. Probably we shall evolve trees that retain the character of those we studied, but something from our general store of observation and appreciation will be added ; then they become our own ; we shall have found something in them that the casual observer missed, something that redeems them from the commonplace, and transmutes the commonplace into poetry.

In quick studies painted outside there is a certain naïve envelopment and " life " that is generally absent in the thought-out work of the studio. The very accidents of paint due to haste may become gems, and the sketch escape that dull correctness that suggests an intellectual outlook,but dried-up impulses on the part of the painter. But elaborate studies out of doors are also necessary ; unfortunately we experience a disappointment when painting them, that comes from a too conscientious effort to do justice to our trees. While studying the tree, piece by piece, we lose the feeling of greatness with which it first impressed us ; and the difficulty is to regain that environment without falling into slovenliness. If the type to which it belongs is familiar to us, we start our work with more confidence and freedom in the handling of our materials, and finish by retaining something of the spirit of it as a living tree. It is for this that a knowledge of construction is required, not for a display of learning by the accuracy with which we imitate its branches and leaves. But we cannot neglect branches and leaves ; their form and distribution, though individual, never departs entirely from the type of the species.

The outlines of branches against the sky are not very troublesome to draw if care is expended on their construction and pattern ; but everyone knows how difficult it is to set them in their right relation to the sky. They seem distinct against it and yet they are enveloped by it. Against a very bright sky their edges become lost, consequently their thickness is reduced so much that the smaller ones appear as indistinct threads, and the twigs are but a film or are entirely lost. David Murray makes good use of this truth in his delicate lines of stems seen against the sky, in compositions where tree groups come near the centre of his picture (Plate XXXIV, p. 45). If the same space were occupied by harsh dark lines for twigs and sharp-edged branches, the sky would lose its light and be divided into spaces on either side of the trees, and the arrangement would be spoilt. Turner showed us the same appearance in the receding branches of his Italian Stone Pines (Plate XX), and applied the law (that slender forms seen against

the light appear more slender) to the rigging of ships seen against the sunset. There are little pictures of Mauve, with tree drawing of great daintiness obtained by the same means. Corot knew exactly where to lose and where to emphasize a form ; his paint is delightfully suave, and looks as if it cost him no effort. This has deceived his imitators who—shirking his experience of hard toil—have even tried to paint their oaks in a similar way, when they had but to refer to Crome for guidance in observation.

It is the fashion to extol the Old Masters at the expense of modern men (it always has been—Goethe in the year seventeen hundred and something complained of it, and in 1770 Reynolds mentions it ; and the sale prices of spurious, bad, and good pictures by the Old Masters to-day prove it) ; but I would suggest that those who paint should learn how to observe—by the study of other men's works, old masters or new— and it is with this object in view that I have chosen a few outstanding names amongst those who have shown us what a tree is like.

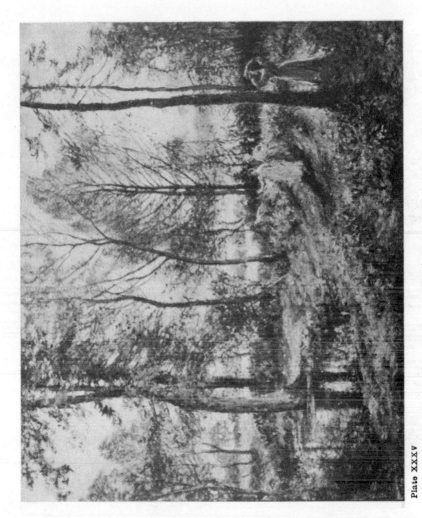

THE PCOL IN THE WOOD. MARK FISHER, A.R.A.

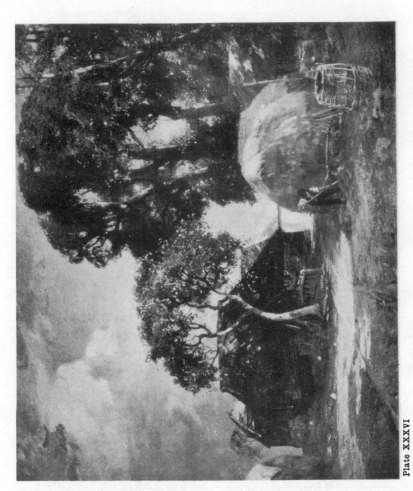

Plate XXXVI

The Hill Farm. Rex Vicat Cole

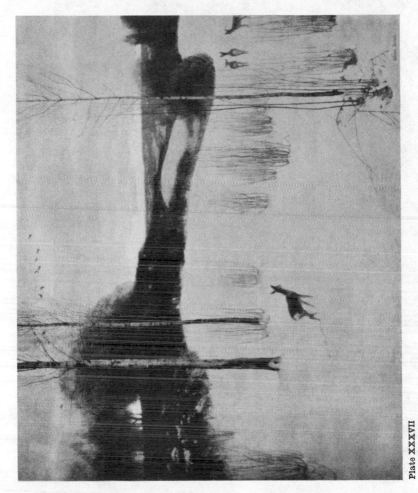

Plate XXXVII DAWN IN WINTER. ADRIAN STOKES, A.R.A.

Plate XXXVIII

FORT ST. ANDRÉ, VILLENEUVE-LES-AVIGNON. H. HUGHES STANTON, A.R.A.

CHAPTER II

Balance.—We know how much a standing figure depends for its dignity
upon its balance—how the relative position of the neck and feet is
gauged by an imaginary vertical line. So
it is with a tree ; in a well-poised trunk
the larger limbs, and the foliage they
carry, appear to be balanced without
effort. When a vertical trunk bears limbs
that spread equidistant on all sides, the
balance is too obvious to require com-
ment, unless we like to point to an upright
Spruce, Cypress, or Lombardy Poplar as an

Fig. 1

Fig 1a

Fig. 2

extreme example. The balance I wish to
call attention to is when the trunk leans
or curves, but still supports the weight of
foliage and boughs directly over its base ;
or when the deviation of the line is exces-
sive in one direction (Fig. 2). We know
that the roots of a tree ensure stability,
so that the exact balance of the human
figure is not essential, but " it requires an artful pencil," as Gilpin
says, to draw possible lines in a leaning tree ; these should not
suggest an imminent upheaval. On the other hand, one sometimes

47

comes across young trees nearly bowed to the ground, and they form[1] a charming feature of the woodlands when the copse has been cut.

Fig. 3

In these we recognise the suppleness of the slim stem, not a want of stability, as the cause for these graceful curves. Trees hanging over a bank would often appear unbalanced, if it were not for the projecting roots that grip the bank surface and reach down its face. We seem to be more assured if we can see the mechanism that ties to the ground any upright form that is out of the vertical. I wonder if, whilst standing under a builder's crane, we should not watch its evolutions with more pleasure if we could see some counteracting weight to balance the stone swinging overhead? Often we see trees which seem not to have a true balance. To see them so in nature is one thing, to live with them in a picture is another—and undesirable. To give them an insecure appearance in our drawings, and to be unaware of having done so, is inexcusable. On sloping ground trunks often lean slightly to the high side and look best so. They suggest the nice "rake to aft" of a ship's mast. No fault can be found with those that are upright, but

Fig. 4

much with those that lean downhills, as Fig. 4 explains. We are fond of trees overhanging a path, and great use can be made of these in pictures. They do not appear to lack balance, which may be partly due to the fact that most of the heavy boughs spring from the upper side. In forests there are parts suggesting weird imaginings—trees half fallen lean against their fellows, crossing and interlacing, with snapped boughs hanging; among them are young stems twisted and contorted and intertwined by creepers; ferns have found a footing among uprooted trunks; grey lichens tuft the boughs.

Fig. 5

Here the want of balance is what we look for, and would be the keynote

[1] One cannot mention these young trees without thinking of J. W. North's picture in the Chantrey Bequest Collection that shows so refined an insight into the subtle charm of the woodlands (see illustration, Plate XXX).

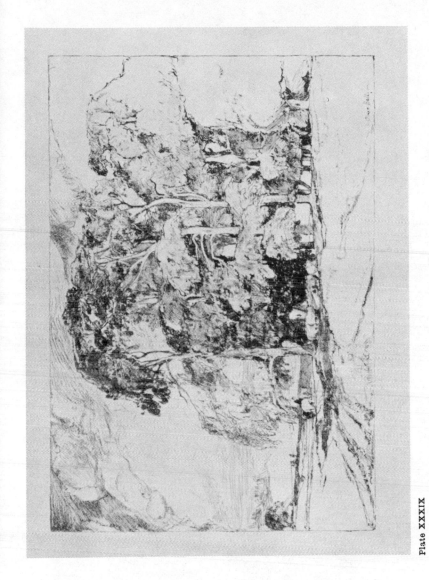

Plate XXXIX Lithographic Study of Sycamore Trees. Oliver Hall, R.E.

of your picture. The seduction of abandonment comes in, and the uneasiness of watching objects of undecided poise has no place.

When the roots show above ground they serve as it were for a stand, and the trunk holds itself the better for them. If the bole is imbedded in the soil, it appears not to spring from it, but to have been shoved into it like the flowersticks in our garden. The value of these lines, which connect the bole with the ground, is as considerable for displaying a nicety of poise. The truth of this is brought home to us in the case of a forest carpeted with tall bracken hiding such connections. We miss the firmness that the solid contours of the ground would naturally give in connection with the boles. We miss the dark shadows which connect the trunks ; we lose the sharp-edged patches of light that accentuate the forms we seek. Rank undergrowth, however, need not be shunned when choosing a subject, for the very want of definite forms is of inestimable value in contributing to the mystery of the woodlands. Rising unseen from it, the grey stems flecked with sunlight lose all connection with solid earth and become part of that world which the fairies inhabit.

Fig. 6

(2) *Single trees.*—It is impossible to combine in the painting of one tree or one group of trees all the pleasures that a painter would like to command. Think of them—beauty of line, mass, pattern. Think of what this leads you to—the value of parallel lines, of vertical or horizontal lines, of curves contrasted with straight lengths, of angles compared with curves, of long curves with short twists, of variety in the direction and size of objects, of the importance of contrast of dark with light, or of the charm of half tones without dark, or of modelled forms against flat ones ; and still you are leaving out colour and design. To attempt all of these in the painting of one group would be to court failure ; it is better to study those qualities that we associate with masses and those usually found in single objects ; so that our selection in our picture shall make an unconfused statement that by its directness may be understood. In both we must look for the silhouette seen against the sky or background, and for the variety of large and small, distinct and indistinct shapes.

A tree standing by itself chiefly attracts our attention to the pattern formed throughout its parts. If the foliage is slight, the line of the main stem can be traced from the ground to its dispersal in a haze of twigs at the apex. The balance, the curves, the straight lines that mark its course become our chief concern, and the sparse foliage with its uncompetitive and indefinite forms acts as a foil to display the lines of the stem and its ramifications ; we have, in fact, the essential charm that belongs to the winter period with the exquisite tracery of

foliage added to it. If the foliage is more compact, attention turns to the branch system, and a combined pattern of leafage and boughs must be sought for. The flat field of dainty foliage is changed to one capable of receiving strong light and shade ; fulness and weight take the place of delicacy. 'Any single object by its isolation attracts attention—

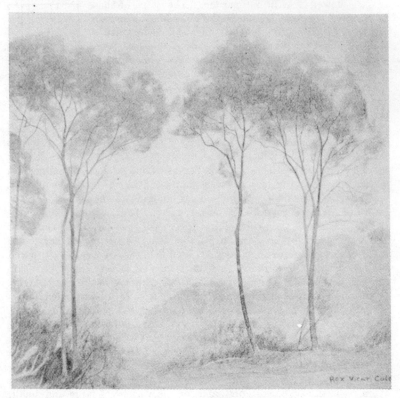

ILLUS. 9. STUDY OF YOUNG ASH TREES TO SHOW THE LINES OF THE STEMS

a little bush on a bare hill top is a landmark for half the county. We focus it more exactly than we would larger masses, and generally expect a greater exactness and finesse of representation. Single trees may be the *motif* of a picture ; they may serve to carry on a mass into other parts of the scene by connecting their outlines ; or they may serve to duplicate a solitary light or dark (Fig. 7). Often their graceful

poise is used to tell just as a line in contrast to heavy forms or as a link between them ; or the single tree is placed in front of a group (Fig. 8) with the object of breaking up an over-massive shape—a purpose served so often by a bare sunlit branch in Constable's work.

(3) *Trees in masses.*—Massed trees afford an opportunity for strength of colour and simplicity of tone. A large space covered with one depth of colour is impressive, and need not be frittered away into bits of light and dark or oddments of colour. That would be to substitute prettiness for dignity. The depth of tone on an object having only one colour should be varied, but within a limited range. This is best understood by supposing your tones on the palette to be arranged in order from light to dark, and that a

Fig. 7

section of the light middle-tones, or dark ones, only is used. Or put it this way—that tints from the left, right, or centre of the scale be used

Fig. 8

but not from both ends (Fig. 9). If your mass is a dark one and you include the paler tints, you defeat your object, which should be to show its bulk and strength. The idea of bigness is helped by some severity in the outline—a gimped edge (Fig. 10) is not conducive to grandeur ! Massed trees at times look spotty and detached, especially when viewed from a height or from far off—it may be well to paint them at another time when they throw long shadows over their neighbours, or when the light is behind them, or a cloud shadow passes and their details are lost in the flat space of tone, or when the shafts of light stream across the foliage, making a new spacing of light and shade. We have all, spellbound, watched the shafts of sunlit mist of the morning streaming through the elms.

Fig. 9

(4) *Trees seen in groups—Composition.*—The man who can really paint groups of trees needs no teaching except that which is self-imposed, for to paint a group is to be able to compose, and to be able to compose is to be able to arrange things so that they convey to others that which nature meant to you. We may pass a group of trees daily ; suddenly we rush off to paint them ; we always knew they were fine, but could

not explain why. Now the reason has come to us, and a sketch painted
while we are white-hot is likely to affect some amongst those who see it
with the feeling we had. But we cannot always wait for impulses, how-
ever, and must analyse why we like or dislike arrangements of form or
colour ; probably in this lies the chief training in our art,
and it continues throughout our lives. The first thing to
decide is, whether we paint our picture for the group or
whether the group helps us to paint our picture. If the
group is the reason for the existence of the picture, we
must see that the other groups are subservient to it, and
yet interesting in themselves. Joshua Reynolds says :
" In a composition, when the objects are scattered and
divided into many equal parts, the eye is perplexed and fatigued from
not knowing where to rest—where to find the principal action, or which
is the principal figure ; for where all are making equal pretensions to
notice, all are in equal danger of neglect." You have only to substitute
" Group of trees " for " Figure " and you have the best advice to start
on. He continues later : " On the other hand, absolute unity, that is,
a large work consisting of one group or mass of light only, would be as
defective as a heroic poem without episode, or any collateral incidents
to recreate the mind with the variety which it always requires."

Fig. 10

Handbooks offering trite receipts for composing have in many
cases been followed too implicitly, their readers becoming adepts at
turning out pretty pictures suitable for Christmas cards. There are
definite rules founded on the practice of the masters of painting who
have each discovered some law that governs Truth and Beauty. My
advice on composition would be this :—Choose a group of trees that
you admire, then ask yourself why you admire it. Visit it in the early
morning before the mists rise ; it is just a flat silhouette of one depth of
tone ; it looks immense ; the flat pattern it makes against the back-
ground holds our attention. Look at it an hour later ; the low sun
lights up the trunks and the sprays of projecting foliage ; you can see
the individual leaves and every branchlet ; the flat disc has become a
rounded mass split up into sections of rich darks, half-tones, and bright
lights, honeycombed throughout with shapes. At midday the details
are less conspicuous ; the general effect is quieter and not so divided
into dark and lights. Seen in the evening against the light, it has
still greater unity, but without the flatness of the early morning. Now
you can decide why you like the group. Perhaps it was the silhouette
it formed ; it may have been the shape of the trunks against the foliage
and the lighting of the ground beneath them ; or was it the large masses
of foliage with their feeling of fulness as they take the colour of the
sky ? Choose your time of day, and for many days study the groups

until you have a truthful painting of it—truthful in the sense that you have looked for those forms or effects which you had decided upon as the chief attraction, and that you have drawn and painted them as well as you possibly can. Find out how much each form contributes to this central idea ; do not shirk those parts that seem to weaken it, but try not to elaborate them into undue prominence. Indoors take some clean canvases (using charcoal), place your group on each in different positions. Add the second group, and see what effect it has on the principal one, and shift it continuously until the two groups give the impression you are trying for. Then ask yourself why the arrangement is the best. Now add other objects to the picture, considering each one as belonging to some group already there. Think of them as black, grey, or white objects, and remember that it is easier to add another to a group if it and the group are of the same tone. This exercise, if carried out with every subject you sketch, will lead you to study intelligently the great painters, and to formulate schemes for distributing objects in those places where they shall be of value to the group to which they are attached. Here, again, we should read Reynolds, though we must understand " ornaments " to mean " details." " It appears to be the same right turn of mind which enables a man to acquire the truth, or the ust idea of what is right, in the ornaments, as in the more staple principles of Art. It has still the same centre of perfection, though it is the centre of a smaller circle."

Quite a good elementary idea of arranging groups can be had by arranging a number of toy trees until they look best (Figs. 11 and 12). Elaborate schemes can be worked out by making drawings of the toys and by introducing light and shade (Fig. 13).

Fig. 11 Fig. 12 Fig. 13

Learn how to compose by viewing everything as if it had to be painted ; see how painters of repute have arranged and do arrange groups, and remember your Reynolds :—" Nor whilst I recommend studying the art from artists, can I be supposed to mean that nature is to be neglected ; I take this study in aid, and not in exclusion, of the others. Nature is, and must be, the fountain which alone is inexhaustible, and from which all excellences must originally flow."

Jean-François Millet, at the request of a friend, at times wrote

down his belief. I reproduce a part of it (from *Scribner's Magazine*, 1880), for it is not only delightful to read, but may be taken as a model for guidance :

" We should accustom ourselves to receive from Nature all our impressions, whatever they may be and whatever temperament we may have. We should be saturated and impregnated with her, and think what she wishes and makes us think. Truly she is rich enough to supply us all. And whence should we draw, if not from the fountain-head ? Why for ever urge, as a supreme aim to be reached, that which the great minds have already discovered in her, because they have mined her with constancy and labour, as Palissy says ? But, nevertheless, they have no right to set up for mankind for ever one example. By that means the productions of one man would become the type and the aim of all the productions of the future.

" Men of genius are gifted with a sort of divining-rod ; some discover in nature this, others that, according to their kind of scent. Their productions assure you that he who finds is formed to find ; but it is funny to see how, when the treasure is unearthed, people come for ages to scratch at that one hole. The point is to know where to look for truffles. A dog who has not scent will be but a poor hunter if he can only run at sight of another who scents the game, and who, of course, must always be the first. And if we only hunt through imitativeness, we cannot run with much spirit, for it is impossible to be enthusiastic about nothing. Finally, men of genius have the mission to show, out of the riches of Nature, only that which they are permitted to take away, and to show them to those who would not have suspected their presence nor ever found them, as they have not the necessary faculties. They serve as translator and interpreter to those who cannot understand her language. They can say, like Palissy : ' You see these things in my cabinet.' They, too, may say : ' If you give yourself up to Nature, as we have done, she will let you take away of these treasures according to your powers. You need only intelligence and good-will.'

" An enormous vanity or an enormous folly alone can make certain men believe that they can rectify the pretended lack of taste or the errors of Nature. On what authority do they lean ? We can understand that, with them who do not love her and who do not trust her, she does not let herself be understood, and retires into her shell. She must be constrained and reserved with them. And, of course, they say : ' The grapes are green. Since we cannot reach them, let us speak ill of them.' We might here apply the words of the prophet : ' Deus resistit superbis, sed gratiam dat humilibus.'

" Nature gives herself to those who take the trouble to court her, but she wishes to be loved exclusively. We love certain works only

because they proceed from her. Every other work is pedantic and heavy.

"We can start from any point and arrive at the sublime, and all is proper to be expressed, provided our aim is high enough. Then what you love with the greatest passion and power becomes a beauty of your own, which imposes itself upon others. Let each bring his own. An impression demands expression, and especially requires that which is capable of showing it most clearly and strongly. The whole arsenal of Nature has ever been at the command of strong men, and their genius has made them take, not the things which are conventionally called the most beautiful, but those which suited best their places.

"For example, in its own time and place, has not everything its position ? Who shall dare to say that a potato is inferior to a pomegranate ? "

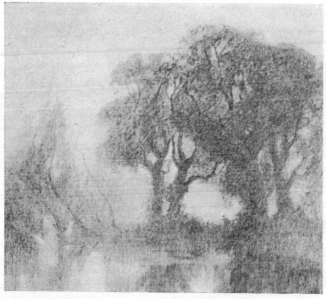

ILLUS. 10. THIS SKETCH SHOWS HOW FIG. 12 COULD BE USED
—THE TREES ARE MERELY REVERSED AND ELABORATED

CHAPTER III

Balance of dark spaces with light.—If it is difficult to represent trees, it is much more difficult to place them in the right position on the canvas. The difficulty is due to the necessity of balancing all the parts so as to produce an agreeable whole. It is the appreciation of balance in a good picture that distinguishes it from a bad. In its complete meaning, balance embraces colour, line, light, and shade—the balance of warm and cold colours, of straight and curved lines, of light and dark and grey spaces. The greater part of an artist's time and thought is occupied with these problems.

Fig. 14

Fig. 15

The balance of light and dark spaces only is here touched on in its relation to the painting of trees. The first difficulty before a student is to see nature as spaces of light and dark, not as a number of separate objects independent of their surroundings. A tree might be this shape (Fig. 14), but if there is a shadow under it, it becomes for the purpose of a picture this shape (Fig. 15), and we see that the shadow is as important as the tree in forming this dark space. A couple of trees might be distinct in lighting (Fig. 16), or they might, from similarity of tone, be used as one form (Fig. 17). It is of the utmost importance to realise this, so I will press the point further. Here are two trees, a piece of ground, and a figure (Fig. 18), but under a uniform lighting they become one form, and it is the space of grey between them that attracts attention (Fig. 18). Take another example : in Fig. 19*a* the trees are by the water side, but the wind destroys their reflection ; in Fig. 19*b* the water is still, and the space of dark (19*b*) is twice as long as before. Again (Figs. 22, 23, 24), there are three trees, but they make different spaces. Nature provides the spaces

56

Plate XL

A STUDY IN OILS BY VICAT COLE, R.A.

Example of forms being continued by shadows.

of light and dark by cloud-shadows, by reflection, by pale and dark coloured objects, by rain clouds and clear skies. The labour of man adds to our choice crops of different hues, pale cornfields, dark herbage, and tilled ground.

Fig. 16

The spaces are there if we seek them, but are very rarely arranged ready for use, or are seen for a moment only, under a passing effect of light. They have to be balanced to become acceptable. If they happen to be more or less arranged, they must be transferred to the canvas on an appropriate scale or they lose their vitality. A balance in exactly equal proportions between dark and light masses is too formal to be pleasing; but a total want of balance is even more disquieting—a fact that beginners should note, as they too often err in placing their principal objects in out-of-the-way corners of their canvas, having heard they should not be quite in the centre. There is a quaintness and unaffectedness in the formality of nearly equally spaced light and dark that should be recognised. The charm of Hobbema's Avenue (see Plate XIII, p. 35) owes something to this as well as to the receding straight lines. The well-worn plan of a diagonal division of dark and light with a small strong dark in the light and small lights in the dark seems as fresh and pleasing as ever, and we turn to it in Corot's "Souvenir de Morte-Fontaine" (Plate XXIII) as if it were something new. When the principal objects form a dark pattern against the background our efforts are mainly directed to disposing them well; after that, in placing the smaller forms such as detached pieces of foliage, and in elaborating the interest of their outline. If the objects are strongly lit, more attention must be paid to the individual parts. The shapes of masses of foliage must be selected with a view to a good design, the character of this being determined by the habit of growth of the tree.

Fig. 17

Fig. 18

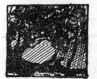

(a) Fig. 19 (b)

Fig. 20 Fig. 21

Two examples of even spacing that should be avoided

It is a matter for compromise between appearance and art. There will be truth as well

as beauty in an intelligent rendering of these selected forms which a literal statement of appearances overlooking the main design cannot

Fig. 22

Fig. 23

Fig. 24

Figs. 25–26

Examples of a too equal and a too unequal arrangement

give. The value of interesting spaces of dark and light is nowhere better seen than in those pictures where a number of tree trunks play an important part. The interior of a pine wood under ordinary lighting is insufferably dreary; the parallel lines of the trunks, with but little variety of intervals, are as wearisome as the bare hop poles of Kent, though the pines might make a background for a funeral procession. Lit by the setting sun, the stems become spaced by light and shade; some are caught by the golden light, others sink into uniform greyness, patches of foliage tell, dark and sharp, between. So we get intervals of light, dark, and middle tones, and our duty is to choose each tone, not for its value independently, but for its influence over other tones throughout the design. It is not necessary that a picture should always be divided into large masses of light and dark. A sparkling effect of considerable beauty is obtained by patches of alternating light and dark, a theme that has been exploited with success by modern painters (see illustration, Plate XLII). The pictorial possibilities of this spotted arrangement is no new discovery; figure-painters employed it long ago, but its application to landscape seems an innovation, to the credit chiefly of Monet and his followers. The fascination of sunlit ground splashed with a chequered shade from trees should convince even the stereotyped painter, who follows the old routine, that nature presents many different faces that could be utilised for the pleasure of those shut up in towns. I can never see large stems cutting across a landscape without feeling again the grandeur and notion of space they convey; but this impression is more often gained from the intervals between the trunks than from the trunks themselves. The greatness of a colonnade seen in perspective is always felt; and something of this architectural sense of dignity is seen in the stems. It is a good plan, when drawing, to shape the largest forms first, and this

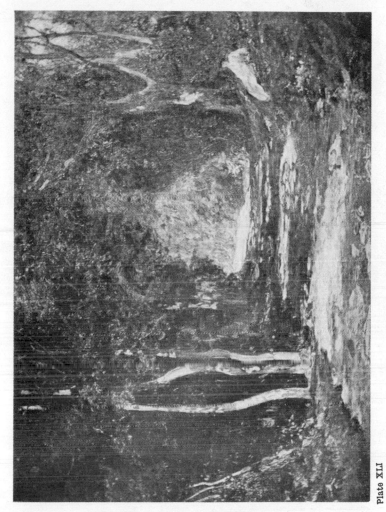

Plate XLI

Study of Broken Sunlight by R. V. C.

method applied to a row of trees ensures strict attention being given to the spaces between the trees. Draw the spaces first, then redraw the

Fig. 27

Fig. 28

trunks left between (Figs. 27 and 28). Turner's " Liber Studiorum " should open the road to the study of balance in dark and light masses. The drawing " Near Blair Athol " is perhaps the finest.

Balance of large and small objects.—There is an arrangement amateurs are fond of. It consists of some trees (Fig. 29), equal in size, surrounded by large tracts of country—a most difficult plan in which to interest anyone. The unvaried and small scale of the trees makes them unimportant, and gives them that little, far-off look of figures on a stage when seen from the gallery; the spectator loses the perspective that decides the size of objects. That this is a serious loss will be understood if a distant tree is looked at through a telescope and compared with one seen near at hand ; both may be drawn the same size, but there is no foreshortening in the one seen through the telescope. W. L. Wyllie, in his artistic book on perspective, gives examples of boats seen near and far off, and the study of this work will suggest many applications of the laws of nature to the drawing of trees. But this type of picture has other faults ; these small trees, if not arranged, suggest a strip of landscape chosen at random, and copied indifferently well. If they are arranged, from the large spaces that surround them they seem to be the only trees in the country (Fig. 30); this would

Fig. 29

Fig. 30

Fig. 31

not be the case if they were cut off (Fig. 31) by the edges of the picture. The value of variety in the size of objects cannot be overstated, and

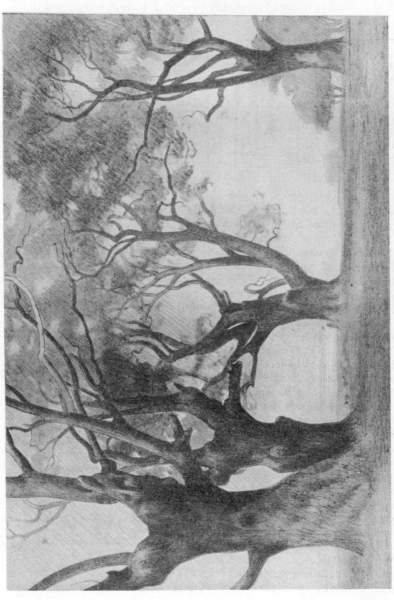

ILLUS. 11. SKETCH OF A SUBJECT IN WHICH THE METHOD OF DRAWING THE SPACES BETWEEN THE TREES INSTEAD OF THE TREES THEMSELVES MIGHT WELL BE EMPLOYED

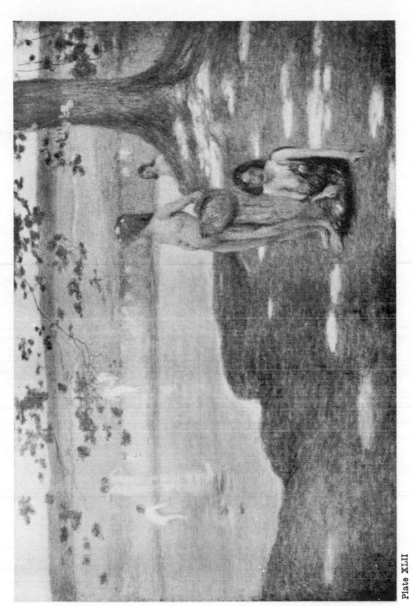

Plate XLII

A SUMMER IDYLL. E. STOTT, A.R.A.
An example of balance obtained by varied lighting.

the illusion that makes a twig in the foreground look as large as a whole
tree in the distance should be utilised to the utmost, though the absurd
distortion of the camera should be avoided. Again,
if we refer to the "Liber," we see how often Turner
allowed his trees to be cut off—he liked to be nearly
under them, and the trunks seemed to him immense,
stretching up we do not know how far into the sky ;
behind the trunks there is a speck for a tree, evi-
dently miles away ; on one side of the picture there
is half a tree, on the other side just a spray. This is the

Fig. 32

sort of landscape you can walk into among the trees, instead of having
that horrid space to get over before you reach the footlights. Every
able painter knows the use of variety in the size of masses, and uses it.
One thinks of Briton Riviere's picture of the great bank of clouds and

Fig. 33

the tiny figure below with outstretched arms ;
of fine landscape in which mere dots for trees
and a strip of ground support great skies. Turner,
with much daring, in one drawing, " Mill near the
Grande Chartreuse," has run great stems through
the height of the picture so that they are cut
off both by the top and bottom margin ; but
see how they take us right up to the crags and
rushing water—we get intimate with the scene

immediately. With many objects differing in size (Fig. 32, 33), it would
seem impossible to get a nice balance, if it were not that a small separate
object is so effective that it balances a large object that is not isolated
(see Illus. 12 of Corot's " Macbeth and the Witches"). Differences
of surface often help a small object to hold its own against larger ones.
For instance, a large mass of indistinct Willows will
be balanced by a small tuft of sharply defined Rushes.
There are times when the size of a thing is settled for
us ; but we wish to make it appear larger or smaller.
Let us suppose that you have a tree trunk that does
not give the impression of great girth as you wish it
to do ; add the line of a sapling beside it (Fig. 34), and
it takes its full size directly. If a form seems too
large, devise some way of dividing it into sections by
lines, if you cannot lessen it by the easier method

Fig. 34

of splitting it up into different tones of light and dark. The object
of dividing a space to reduce its length will be seen by comparing a
bare Larch stem and an Ash (that has boughs), both having the same
heights. Looking at the Larch you run your eye up and down, and
arrive at no conclusion as to its height—it merely seems terribly tall.

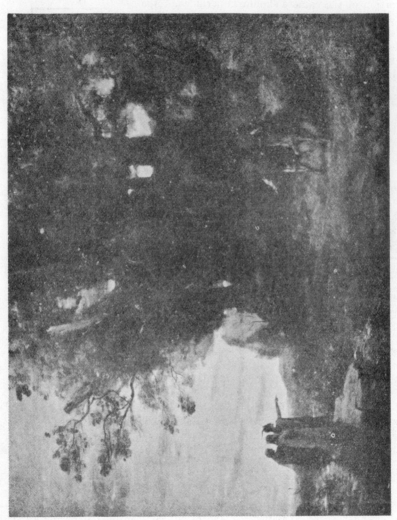

ILLUS. 12. MACBETH AND THE WITCHES. COROT
Example of small isolated objects balancing large masses

Run your eye along the Ash and it pauses at the first branch, then at the next, and you can guess the length of each section. The mystery of its unknown height is gone ; it is a thing you can measure, and therefore think less of.

(2) *Weight of masses and delicacy.*—The principal consideration, if we leave out colour, in composing a picture is without doubt the

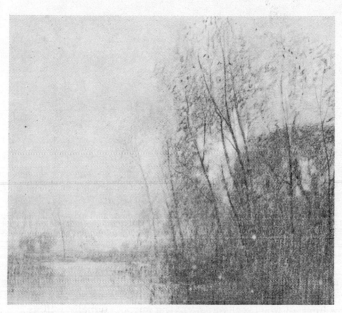

ILLUS. 13. SKETCH EXEMPLIFYING MASSES VEILED BY LIGHTER FORMS

balance of large forms with small, and the balance of dark forms with grey and white ; but we must not overlook the importance of comparing decided masses with indefinite ones, and in landscape this requires particular attention. We hear a picture summed up by those who do not paint as " so nice and soft," " horribly hard," as if it were Teddy Bears or other absurdities that were talked of. Generally a picture should have both qualities, though one of them may predominate. The charm and use of indefinite forms compared with solid masses is well seen in the bulk of tree foliage bordering the sky apertures. These, however, must be taken in detail presently. Another example is when a tree of massed foliage and one thinly clad stand the one in front of the other (Illus. 13). It is a case where the

outline of the massed one may either be used to contrast sharply with the delicate forms of the other, or the delicate forms may be a means of lessening the abruptness of the massed form by blurring it, as it were, into the sky. A great space of indefinite form can be balanced by a small distinct one. This we notice when a dabchick swims in front of

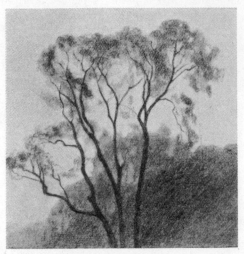

ILLUS. 14. SMALL FORMS SEEN AGAINST A FLAT BACKGROUND

a great bed of Withies. Some would say this happens because the dabchick is alive and lively, therefore more interesting than the Withies, but a lump of wood really answers the purpose equally well.

(3) *Trees seen near and far off.*—A distant tree, rendered flat in tone by the atmosphere, is recognised by the pattern it makes against the sky or the background. The main shape, unconfused by any detail of foliage, stands out clearly as an oblong, a semicircle, a cone, or whatever form of outline may distinguish its species. Marked differences in the construction of the outline become apparent. The Elm with a border of straight lines (Fig. 35) can be distinguished at a great distance from a Beech with undecided edges of loose sprays. A Lombardy Poplar acts as a sentinel among the squat forms of the Oaks (Figs. 36, 37, 38), and is as valuable in the picture as a church spire would be.

Fig. 35

Fig. 36

There is no edge to the Larch wood—just a haze ; against it the upright lines of the trunks show as faint streaks of grey here and there.

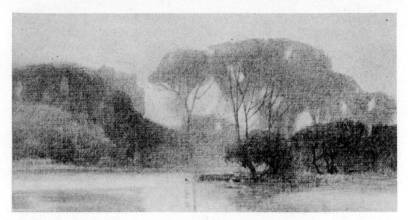

ILLUS. 15

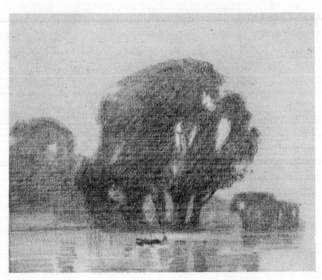

ILLUS. 16

TWO PENCIL DRAWINGS TO EXPLAIN THE VARIETY IN THE
OUTLINES OF SILHOUETTES

We cannot distinguish each tree, nor do we wish to, but the inexhaustible variety caused by the density or thinness of the foliage, the sharpness or want of definition in the outline, and the varied shapes of the silhouettes should be looked for, and made interesting. It is not enough to represent them by a number of monotonous dots which serve no purpose in the picture. Look out for groups of trees on the sky-line; they are sometimes architectural in design, and as useful as a feudal castle would be (Fig. 39). You can find straight lines or undulating ones in the woods that line the hill, just whichever you want, with here and there spots of light. Perhaps the sky rim of the wood is

Fig. 37 Fig. 38 Fig. 39

fuzzy, and the earth line tells with a sharp edge in the gaps between the trunks, or it may be that some young trees just like the toy ones that are sold with Noah's Ark stand in a row on the hill top, or line some division between the fields; they serve as a reaction from forms that are too pompous, and they show the scale of the country.

From my window I see tops of trees beyond the hill-line suggesting the unseen land beyond. Plantations stretch from this side of the hill to the other, disappearing in graduated steps behind it; other woods run down the gullies or pass over the high ground into the hollows, fixing all the contours and undulations of the hill; all these facts give variety, and help in the portraiture of a particular district. They give the artist the chance of securing accents of light and dark; though these are more often obtained by passing clouds that throw an indigo shadow over parts, in strong contrast to the glow of a sunlit field or the blue haze of the distance.

In the middle distance the local colour of the trees begins to show through the atmosphere. The lighter green of an Ash or Lime is distinguished from that of the darker Sycamore, Elm or Oak, and the Pinewoods make a startling patch of dark. The silver tones of the Willows and Poplars flicker in the sunlight or gleam quite white against the sky as a breeze passes, and the little Whitebeam, or the Wayfaring Tree, becomes as important as half the woodlands. In the very distant trees a point of difference is seen only in the outline of the foliage against the background. With these closer to hand it can be seen in the middle of the tree as well. We cannot mistake the thin layers and detached spiked sprays of the Beech; the heavier layers and drooping curves of the Lime; the tufted foliage of the Oak with its star-shaped projections;

the massed sharp-edged foliage of the Sycamore and Plane ; the Poplar
made up of dotted leaves, or the blurred edges of the Willows. The
shadows between the foliage may alone betray the species ; in some

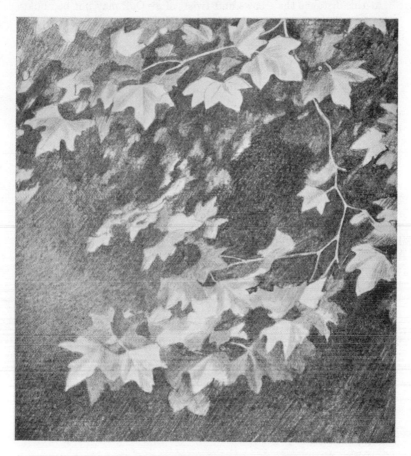

ILLUS. 17. PATTERNS FORMED BY FOLIAGE
(Pencil drawing of Plane leaves)

they are sharp and dark, in others faint and confused, massed or de-
tached, forming lines consistently in one direction or another. Whether
the shadow is easy to find as in an Elm, or impossible to follow as in a
Poplar, is an important point in depicting the character of the tree ;

and perhaps still more important in an artist's search for variety. The direction of the chief branches can be followed, and in places the junction of branch with bough explains its method of growth.

At this distance the elbows and twists of an Oak may not be unlike those of a Walnut, and yet a subtle difference maintained throughout prevents our confusing one with the other. The same habit of observation enables us to distinguish them as it helps us to appreciate the suave lines of Willow branches which lack something of the spring in the lissome lines of a Birch.

The trees close at hand are unmistakable. It is no longer a matter of giving a main character, but one for consideration of individual traits, of recognising how the tree in all its parts conforms to the ways of its fellows in the species, and in what way it asserts its independence. We note how much its appearance is due to some stronger influence, perhaps of a prevailing wind, and the picturesque qualities that storms or position have endowed it with. The suitability with the locality or the sentiment of the subject might be considered. Attention becomes focussed also on smaller matters, such as the technical treatment of twigs and leaves against the sky or the amount of definition in the foliage. A single leaf may look as large as a distant tree, a bunch of leaves may balance a hill-side. The treatment of near trees is not one to dictate upon. They can be painted for themselves, with the delight to be found in every detail insisted upon, and the country used as a background for displaying them ; or they may be thought to be out of focus, as it were, if the eye is on more interesting objects behind them, and can be treated just as a mass of tone and colour. If the painter's belief is a sincere one and humble one he may choose his way—his own views should be respected, and he stands or falls by the way he presents his views.

Plate XLIII

THE INTRICACY OF DETAIL. DRAWING BY R. V. C.

CHAPTER IV

THERE is nothing in landscape so difficult to paint well as tree forms against the sky, except the sky itself. When painting a sky an artist can never lose sight of the limitations of his materials ; he knows how far off white paint is from light, and he is content to obtain some truths of atmosphere, and having done so as well as he can, to leave it at that. With a tree, he is confronted at every turn with his shortcomings as an artist and craftsman. He must make it lit by the light of the sky he has painted. He wishes to make it decorative, but fears to convert it to a flat pattern. He would like to show how beautiful it is in every detail, but must keep it grand and effective as a whole. He despises himself if he cannot show the character of its species, but he knows this is not his chief object in painting it. It may be well to consider the stumbling-blocks separately.

The edges.—If you look attentively at a small spray jutting out from the outline of a tree, you notice how great a variety there is in the definition of the leaves. Probably the majority will be in a more or less horizontal position, some will be hanging, others turned upwards or tilted this way and that ; single ones in places are noticeable, some cross one another, others are clustered ; and the sky breaks in at intervals. Focus your sight on the spray for a minute, and it seems clearly defined ; then pass your eyes rapidly to the edge of your canvas, and that seems much more definite. Now half close your eyes ; the whole spray looks less defined than before, and sharp only in places. The first most obvious fact has been learned—that no part of it is quite sharply defined, and that there is a great variety in the intensity of definitiveness. Leaves are either glossy, hairy, or granular, so that they are able to catch or reflect the colour of the sky. On most trees they are sufficiently transparent to allow a strong light to pass through them when they are detached ; most of them have a notched or indented margin, and they are connected by a thin stalk to slight twigs. Here we have the reasons for the lack of sharpness. Most leaves take a horizontal or partly drooping position, the best one for reflecting the sky to us, and their natural colour is modified by the paler grey or blue of the atmos-

phere. At the margin of a tree most of the leaves are seen foreshortened,
and the light passing on either side makes them all but invisible. The
tips of others that belong to the far side are seen, adding to the
blurred effect. Some hang in a vertical position and are much more
distinct, and usually darker, from being the lowest and in the shade of
the bunch above them. Though by comparison distinct, their gimped

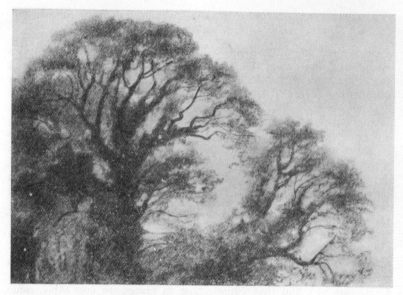

ILLUS. 18. THE TOP OF AN ELM TREE

edges and transparency of blade prevent the effect being presented
that would be noticed in a disc of metal with an entire edge, both
being of the same size. The slightness of the stalk makes it invisible,
and the twig only helps to veil the sky. Where the sky breaks through
the foliage the patch of light is bordered by countless leaves, some fore-
shortened, the tips of others overlapping the mass, some in shadow,
others in light—all helping to make an uneven blurred margin to the
light. So indistinct is the margin that the small lights appear as globes,
as if the in-and-out edges of the surrounding foliage were insufficient to
stop the rays of light. That this is actually the case may be proved by
the simple experiment of cutting a hole, with a fine frilled edge, out of
a piece of paper, and holding it in front of a very strong light. The

dazzling light of the sky prevents us from recognising any colour in those leaves that encircle it.

All this teaches us the important fact that the extreme margins of holes in foliage through which the sky is seen are diffused and colourless. They are not sharp, dark, or bright coloured. In the centre of each foliage-clump we find the local colour of the leaves showing strongly, though still influenced by the sky. In the centre of the largest masses we find the strongest colour, because the surrounding leaves form a background for its display ; they also cut off the light of the sky that would render our eyes insensitive to colour near it. We have said that the small sky gaps appear like globes, and might add that at times they resemble globes with a light inside them, giving the illusion of the light hanging among the leaves. The question whether it is legitimate to imitate such an effect in a picture (since it would be understood only by the few) I will leave to the regular writers on art to discuss if they care to ; and I will add the problem of whether flat land seen from a height should be made to look as if it were a horizontal plane as we know it to be, or one inclined upwards as it appears to be. To return to our tree, one should delight in the brilliancy of the colour where the sun shines through the leaves, and test the greyness of the surrounding foliage by this strong note.

A scrutiny of one tree, then, shows us that the extreme edge is made up of rather indefinite forms, some in clusters, others in larger groups, and here and there a single leaf, or small tuft more sharp or dark than the rest, the whole less coloured than the bulk of the tree ; that the sky spaces between the foliage have a colourless indefinite rim and in places strongly resemble the colour of the sky ; that these spaces of light are often screened by an indistinguishable veil of small leaves and twigs, and for this reason seem darker than the open sky ; that the small sky spaces usually appear as circular lights with diffused edges, the strongest light being in the centre ; that the local colour of the leaves is strongest in the centre of the larger groups. We should also note that the upper or lower edges of these groups will be sharp or indistinct according to which of them projects in front of the surrounding masses—a feature of importance in the portraiture of a particular species, as it explains the formation of the branches. It seems superfluous to add that there will be an enormous difference in the comparative sharpness throughout a tree bearing small leaves, say an Elm, and one with large leaves like a Sycamore ; or that narrow leaves, such as the Willows bear, will bar the light less effectively than the broad leaves of an Alder. (See Figs. 19–26.) No one will require to be told that widely spaced leaves (Black Poplar) will make a less massive effect than leaves so near together (Oak). On leafless trees we observe somewhat similar effects.

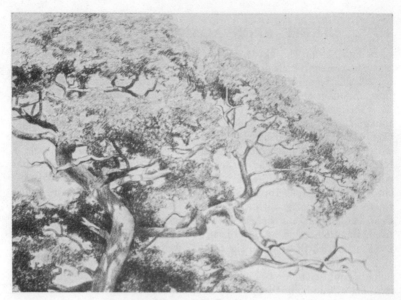

ILLUS. 19. OAK

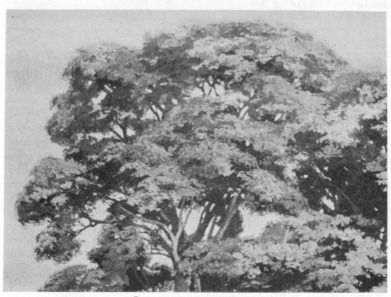

ILLUS. 20. SYCAMORE

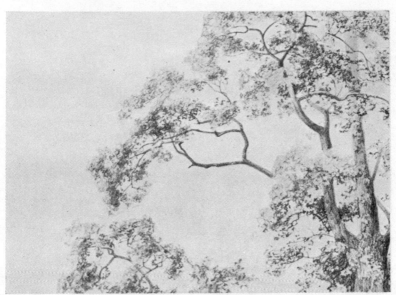

ILLUS. 21. ALDER

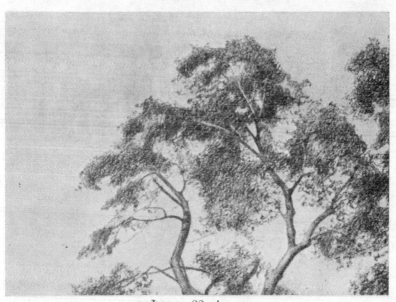

ILLUS. 22. ASPEN

ILLUS. 23. WILLOW

ILLUS. 24. YEW

ILLUS. 25. COMPARE THE HANG OF THE LEAVES AND THE LONG
STALKS OF THE BLACK POPLAR WITH THOSE OF THE PLANE

ILLUS. 26. BLACK POPLAR

The border is constructed of little twigs that are insufficiently large—-
or insufficiently massed to obstruct the light. They produce the ap-
pearance of a haze scarcely differing from the colour of the sky. Inside
this border is a closer network. It is dense enough to allow the delicate
colouring of the twigs to be seen, but still only acts as an indistinct veil,
and against it the exquisite lines of the larger boughs can be clearly
traced. The round forms of the sky openings, which are so noticeable
among the foliage in summer time, are replaced by irregular shapes.
These for the most part are determined by the spaces between the
larger boughs, though trees with thick twigs (Horse Chestnut), or with
numerous twigs matted together, may have sky apertures bounded by
the twigs themselves. The openings between foliage help to explain the
direction of the boughs and the plan they are built upon. They may
be the natural gaps between the larger forms, or they may be due to
accident. In either case they offer opportunities for construction in
the limbs that border or cross them.

The shape and position of these openings, varied as they are in each
individual tree, yet conform to certain limitations imposed by the
habit of the species, and we instinctively recognise them as belonging
to a particular species, even before we study the methods of growth
that cause them. If you think of the direction taken by the long
straggling boughs of a Beech and the hang of the foliage, you would
not expect the lights seen through the tree to be shaped or disposed
like those seen through an Oak ; nor more they are, yet I have seen
sketches where you could not tell one from the other. In whatever
way the openings are arranged, it is our business as artists not to miss
the rhythm of the lines that connect them, or to overlook the decorative
qualities in the disposition of the lights and darks. For this purpose
we may consider them as a flat pattern of light and dark, though we
should not paint them so, except in the far distance, or under some
special effect of lighting (Figs. 40, 41).

At the beginning of a picture it is a good plan to construct these
patterns clearly, in fact to draw the mass of the tree by them, giving
particular attention to their relative importance in size, clearness, and
position. The placing of them is a very important part of composition—
one that Corot knew so well. If you look at his trees, the lights through
them seem absolutely right, very pleasing, and by no means artificial ;
they seem just to have come there without an effort on his part. If
you examine them carefully you will find they are all beautifully and
exactly placed, probably on a preconceived pattern, certainly with a
definite intention. These lights should not be copied separately until
the connection between them has been observed. They may be
actually connected by small lights forming an unbroken chain, or more

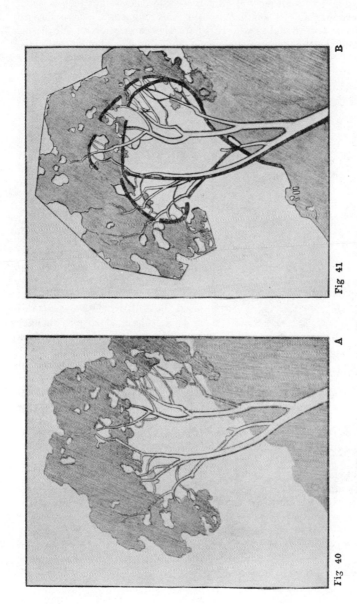

Fig 40 A Fig 41 B

(A) Diagram showing the Variety in the Sky Apertures

(B) The Heavy Black Lines show the General Shapes to be first looked for

likely there will be breaks where the foliage intervenes, and the flow of one large light to another will only be felt by the weight of the larger ones overpowering the smaller. Often a strong edge, where massed foliage ends at the light, will carry on the connection to the strong edge in the next light ; and the emphasis of this line, though really dis-

ILLUS. 27. TO SHOW HOW AN OUT-
LINE CONTINUES THOUGH IN-
TERRUPTED

connected, will prevent the space being cut up into meaningless sec tions of light and dark (Fig. 40).

Just as we should look for definite patterns in some places, in others we should avoid them ; or rather we should avoid making those darks and lights that at times resolve themselves into set patterns against our will. The absolute want of pattern is a charming feature in some trees (a half-grown Ash for example) and delightful in a picture. There is a unity in grey or dark spots of unequal size, but of equal value interspersed with the sky, that should be sought for and used both by itself, and also as a background to display boughs and other defined forms. Mark Fisher has shown us how useful this even distribution of light and dark is, though he has ap- plied it more to the glitter of light on foliage. Decoration in trees is, I think, over-insisted upon at the present day by some professional artists; the trees seem to be de- signed entirely for decoration, and to have become a flat pattern. When looking at some pictures, one feels that the painter's love for open country and rustic scenery has been shelved for a display in the dexterous management of shapes.

Clausen, in his lectures on painting, puts my meaning better. " One often sees trees painted that look all cut out at the edges, like trees on a stage, and when we look at the edges of a tree against the sky, we see that they look cut out, too ; but if we look at the tree as a whole—as a great dome, spreading up and rounding into the sky, with the light showing on it and through it—if we realise this, we can get a little nearer to our tree." However, I believe

amateurs are not aware of the necessity at all of looking for decorative forms ; so this description of trees seen against the sky should suffice as a basis for closer observation. Familiarity will not in this pursuit breed contempt, but reverence ; and casual representation will be replaced in time by free handling, acquired by appreciative knowledge and self-confidence.

CHAPTER V

THE OUTLINE OF A TREE

MY intention in the last chapter was to show that the edge of a tree
can be made interesting in a picture by an appreciative rendering of the

Fig. 42

variety that is to be seen in the tone, colour, and com-
parative size and definition of the leaves or twigs of
which it is composed. It will be understood that the
edge is not defined by an uninterrupted line (Fig. 42).
To save misunderstanding, we must consider the word
" line " in this connection to mean something which
does not exist in nature, but which nevertheless repre-
sents to our mind the extremity of one object or
group of objects, or a division between different
tones and colours. The word is nearly always used
in this sense in connection with pictures, and does
not imply the existence of the actual form so
neatly described as "length without breadth."
The first thing to notice in a tree is that the lines
representing its boundaries are not fashioned after

Fig. 43

Fig. 44

the manner of a scallop (Figs. 43, 44), but of straight
lines, curved lines, long and short, and every variety
of line. The Cyma recta, and reversa, the cavetto and
ovolo of architecture are all there, and many others yet
untabulated.

If you trace without thought a map of England
jumping in and out round the promontories and dipping
into every estuary and little bay, you are apt to make a most wobbly
caricature of our island. If, on the other hand, you draw only the chief
curves and straight lines, noting how they differ from one another, you
will get an exaggerated but most unmistakable likeness (Figs. 45, 46).

If you gave yourself the trouble of making this experiment, you
would learn some most important factors in drawing that cannot be
neglected when constructing the outline of a tree. To be precise, you
would learn (1) that the chief curves or straight lines are often carried
across a break ; in other words, the main lines are not of necessity
continuous, but are picked up by one form after another. (2) That

82

there is a great choice as to which line you may consider to be the chief one. (3) That the distinguishing feature of the line must be insisted on, and not spoilt by trivial interruptions. (4) That its value will depend upon the contrast it forms to some other line, and that its value is enhanced if its direction is repeated by another form close by. (5) That a number of similar lines near one another are more effective than dissimilar lines. (6) That lines become wearisome unless there is some slight variation in their course. (7) That straight lines are more austere than curved lines, and help to suggest restraint, dignity, and strength. That slightly curved lines suggest delicacy and grace, while circular ones suggest weight and something of a coarse exuberance.

Fig. 45

Perhaps it was an exaggeration to say that all these things can be found out by our map, but they certainly can be seen in trees, and we must apply them—

Fig. 46

(1) The chief lines need not be unbroken. They may follow the rim of separate objects or different tones. If you bear this in mind when drawing a tree (Fig. 47) you will not overlook the main line (Fig. 48), and you will notice that it is carried across the still larger space to the top of the small tree. If you neglected these main lines, the various objects, tones, and colours of the scene would be no longer knit together, but would become separate objects, disconnected tones, and unattached colours, thus making a sort of inventory that catalogues the number of objects, tones, and colours visible, but conveys no sense of unity, breadth, or arrangement. In this Fig. we have considered the chief lines as if they must be fashioned by the outline of the tree. Usually this is so, but quite often the lines of composition exist between different tones instead of emphasizing the outline. Suppose that (Fig. 49) one side of our tree were sunlit and the rest in shade, our composing line would then border the shadow instead of the tree outline, and our tree would present a new aspect. The lines need not be continuous in one direction ; they may reverse the curve, and by this means (Figs. 50, 51, 52) continue, the direction of other curves. In some compositions the flow and interchange of curves will be an outstanding

Fig. 47

Fig. 48

feature ; when they are apparent in nature it is well to begin the sketch by a statement of them first, and later on to fill in the different forms by which they are created.

Fig. 49

The continuity of lines seen in some pictures is so strictly adhered to, that the whole subject—though made up of more or less separate objects—might be traced without the necessity of once lifting the pencil from it. A composition of this sort might easily be too suave, and some straight lines become a necessity to prevent its degenerating into insipidity. Sequence in the arrangement of the lines that bound the sky apertures will act as a guard against over-spottiness—an appearance that may unwittingly be caused by a very slight deviation from continuous lines to snappy ones. The oft repeated breaks in the outline of a young Fir (Fig. 53) are displeasing, but far more so when the dentated edge is emphasized by a harsh outline ; for in nature the line would in some places be lost, in others be continued by some interior form, or be made less apparent by its connection with the light or dark of the sky or objects in the background.

(2) That there is a great choice as to which line you may consider the chief one.

The same scene in nature would not convey the same impression as the day passes. Not only would the sentiment connected with the morning, midday, and evening be different, but the constructive lines would appear under a new guise. The same lines still construct the outline of trees

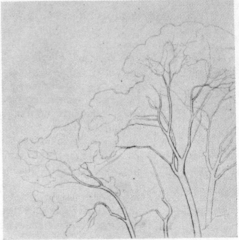

Fig. 50.—THE GROUP REFERRED TO IN FIGS. 51, 52

and land, but new effects of lighting crop up, and that which was formerly a main line on one group becomes insignificant, and is to be found on some groups or set of objects. The most simple illustration (Figs. 54, 55) of this would be a scene where a group of trees on sloping ground cuts across a receding row behind them, thus forming two diagonal

lines. With the sun on the right or left respectively we get the near or the farther trees in shadow, and the one more important than the

Fig. 51 Fig 52

TWO DIAGRAMS OF THE SAME GROUP OF TREES SHOWING THE DIFFERENT COURSES THE MAIN LINES COULD PURSUE (see Fig. 50)

other contains the main line. Any doubts as to the necessity of selecting carefully the main lines should be brushed aside once and for all by this diagram of a scene (Fig. 54) that a child could copy and that an artist could make four different compositions of, even though he traced and kept to the child's outline. In landscape there are many lines to choose from. Our difficulty is not so much to plan as to select them. From continual association a painter stores in his memory a number of effects, and some accidental line or effect in the scene before him may call one of these almost unconsciously into use ; he adds his own sentiment to the one suggested

Fig. 53

by the scene, and looks for those lines that will enable him to carry out the idea. The scene becomes gay, austere, frivolous or

Fig. 54 Fig. 55

morose ; though the painter has used the actual lines that were before him. It is just the bewildering prodigality of form that makes a tree or a thicket so difficult to paint well. We must choose the main lines and preserve them during our painting ; but this is not sufficient. The same process of selection has to be carried on throughout the canvas. Every group or part,

however insignificant it may appear, has its main lines; and these must be arranged and controlled to take their proper place in relation to the lines of the principal groups. Each part becomes a centre of more or less interest, and the lines that compose it must be right, one with the other, and the aggregate must not compete with a more important group. What a beautiful thing a hedge is, for instance, or a clump of bramble! Millais, Fred Walker, and North could make it an important feature of a picture, and my father, by an exquisite selection, could make it satisfying in the place it took in his picture. The brambles perhaps give the chief line of dark, the wild roses one of light; the tops of grasses or the roadway provide the straight lines, and the bryony the curves; but the relative value of each must be given and preserved, else it becomes an aggressive tangle of items, ugly in itself and harmful to the important parts of the landscape.

(3) The distinguishing feature of the line must be insisted on, and not spoilt by trivial interruptions. There is an instrument designed for giving an enlarged outline of a drawing; a pointer at one end is guided over the lines of the drawing, a pencil at the other end repeats on an enlarged scale the object traced; and the discrepancies between the original and the enlarged version are usually amazing. One need not rub in the moral, but, remember, before drawing a line to get a clear understanding of its direction and the course it is to pursue from start to finish, then draw the line without letting the accidents embarrass you. The confidence gained by the preliminary investigation will give a "live" feeling to the line that is missed by the enlarging machine. Some lines on a tree are so uncertain that they can be used or misused without any great departure from accuracy, and can be made to mean very different things. The in-and-out edge of foliage is a case in point. It might be drawn like this (Fig. 58) or like that (Fig. 59). The two forms on paper look so different that you jump to the conclusion that no intelligent person could so misrepresent lines; but you would be surprised how easy it is to miss just that straight bit that makes the curve look so buxom.

Fig. 56

Fig. 57

(4) The value of a line will depend upon the contrast it forms to some other line; and its value is enhanced if its direction is repeated by another form closely. The last example is sufficient as an instance of contrast giving interest to a line. We may add that the liveliness of the sky line can be missed by inattention to the numerous

though small forms that often define it. Quite ordinary trees assume
an importance that is disproportionate to any excellency of form they
may possess when outlined against the sky. Sometimes
it is because they make a break in the long lines formed
by the hills, and often because an arresting difference is
noticeable between them and the hill line—a difference
that is more convincing if the hill is repeated by others
behind it. The interest culminates if the level line of the
horizon is there to act as a foil and to set off the delicate
undulations in the flatness of the hills. The Fig. here given
(61) must not be taken as an example of good lines collected
together. They are merely different lines chosen at random
to suggest variety. The repetition of curved lines is usually
confined to lines of rather simple form, as the repetition
of very intricate lines is apt to be ineffective and lead to
confusion.

Fig. 58

Fig. 59

(5) A number of similar lines near one another are more effective
than dissimilar lines.

Again our examples rather overlap, but we can break off to a new
application. In a Beech tree or a Lime you notice the lower branches

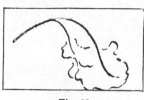

Fig. 60

are built on a recurved plan, giving a
springing curve of much delicacy and ease.
It is difficult sometimes to fix on a line
for the extremities of their foliage that
shall be sufficiently characteristic of their
growth without being disconcerting in its
jaggedness. The continued breaks are
inharmonious, and attract unnecessary
attention. The branches, however, in their
simplicity of form, repeat one another in harmonic cadence, and
those outlines of the leaves can be sought that aid in the construction
of a form that has unity. If all
the branches were dissimilar in
build instead of being varied on
a similar construction they would
not have united power, and the
jagged edges of the foliage would
assume an importance in the

Fig. 61

picture that could not be condoned, though it might be a literal state-
ment of fact.

(6) Lines become wearisome unless there is some slight variation
in their course.

Monotony is one of the most useful agents we have, but it must be a

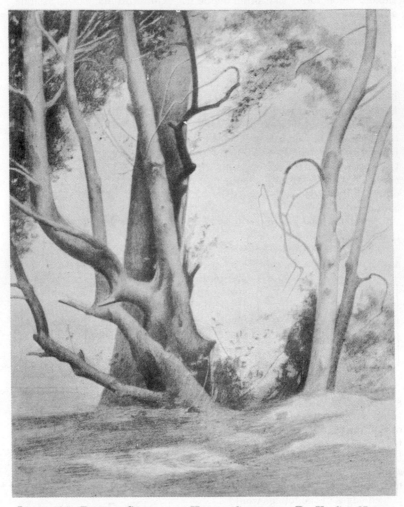

ILLUS. 28. PENCIL STUDY OF HOLLY STEMS BY R. V. C.—NOTICE
THE VARIETY IN THE LINES THEMSELVES IN SPITE OF THE
FREQUENCY WITH WHICH SIMILAR CURVES AND STRAIGHT
PIECES RECUR

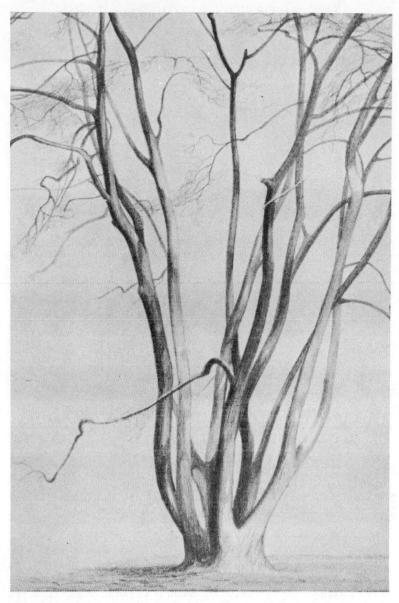

Illus. 29. Example of Variety in Curves (Field Maple)

qualified monotony. Parallel ruled lines are monotonous and weari-
some to look at. Parallel lines drawn by hand are also monotonous,
but restful rather than dreary. The circle of the compass does not

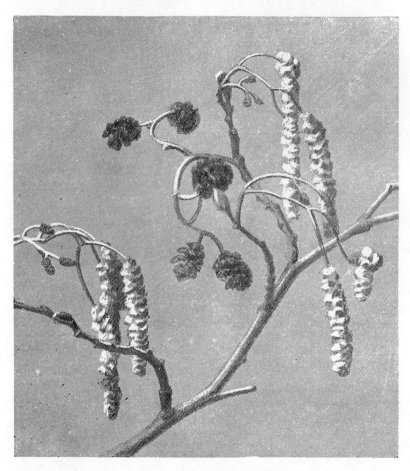

ILLUS. 30. THIS DRAWING OF A TWIG OF ALDER BEARING CATKINS IS
A GOOD EXAMPLE OF THE REPETITION TO BE FOUND IN FORM

invite scrutiny—the circle of a full moon is full of incident. It is just
the little accidents in the passage of a line—whether curved or straight
—that make it so personal and living, and keep it from the slur of

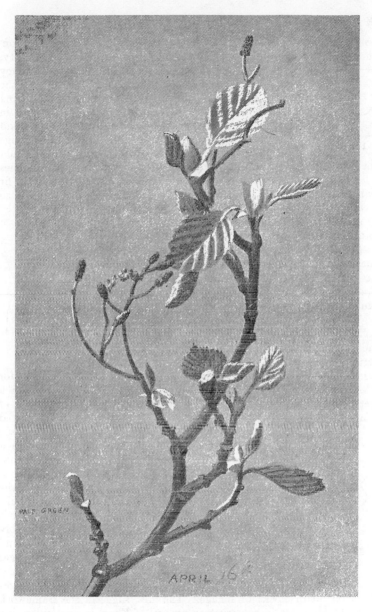

ILLUS. 31. A TWIG OF ALDER

Notice how often the same curves are repeated

looking machine made. We seem to have a horror of absolute precision.
The lines of foliage often follow one another with beautiful regularity,

but there is an independence and ease in the way they
fall into place, and endless variety is caused by the
different angles we view them from. The hanging
branchlets of a Larch differ from one another only in
details, and yet they can afford pleasure for an odd
hour ; three minutes' contemplation of a mantel fringe
would satiate most people ! Regularity in lines should

Fig. 62

not be avoided, but the intermixing of regular and much-varied ones
should be undertaken with discretion. The precise lines of a fir
plantation may easily be a blot on the forest—and more easily so
in a sketch—if the slight deviation of their lines
is missed or their character over-emphasized by
total isolation.

(7) Straight lines are more austere than curved
lines, and help to suggest restraint, dignity, and
strength. Curved lines give delicacy and grace,
circular ones suggest weight and even a coarse
exuberance.

The severity of a Larch wood is undeniable.
Column follows after column with no relief. Even
the early architects found the austerity of many
vertical lines unbearable ; after they had secured

Fig. 63

dignity and a feeling of strength they yielded to the desire for
relaxation by the addition of varied ornament. Straight lines in a
picture are of inestimable value. A straight line is the backbone of
a landscape. The composition of a picture is regulated and completed

by the straight lines of the frame. All curves are
moulded on straight lines. Curved lines require a
straight one to steady them. It is by straight lines that
we estimate the curves of others (Fig. 62). The outline of
a tree is made up of many straight lines. Sometimes the
straight lines are so short that the curve—though built
on them—seems independent (Fig. 63) ; in these cases it
is a good plan to look for lengths that could possibly
be fashioned with straight pieces, and it will be found
that the comparative length of these straight pieces
determine the character of the curve. Sometimes

Fig. 64.—ELM
TREE

three or four straight lines only would be needed to cut the edges
of all the main blocks of foliage. The idea suggests the framework
which builders use in constructing an arch. Elms, in particular, are
outlined by straight-cut edges, and are by them conspicuous among the

rounder and more uneven tops of the Oaks, though these also have straight pieces. These long lines connecting one clump of foliage with another are repeated by shorter straight lines here and there on the boundary of the foliage (Figs. 65 and 66). The restraint and dignity

Fig. 65.

Fig. 66

TWO DIAGRAMS TO SHOW THE STRAIGHT LINES ON THE
MARGIN OF TREES

of straight lines compared with a wavy outline can be appreciated even in a diagram ; there is no need for an essay ; and the strength in the rectangular limb of an Oak will be seen without having to read a disquisition. The dignity of a Lombardy Poplar is

missed in the suave lines many young trees assume. The trees we call graceful and delicate are those with the curved lines; the more subtle the curves the greater the exposition of grace. The Birch, the young Ash, the Osier and the Willow share in the charm that delicate curves can give; but the two latter are more conspicuous for the refined lines of the stem and branches than for any definite curves in the arrangement of the foliage such as we find on Birch and Ash. Full curves, as they approach the form of a circle, have to be used with more caution than slight curves. Exaggeration in the roundness of a curve very soon gives a look of grossness, and students will remember their early difficulty of making a muscular man look muscular in their drawing and not podgy.

The outline of some trees approaches somewhat nearly to the segment of a circle. You will come across an Oak or Thorn tree of

Fig. 67

this habit; but as a rule there is the straight line of the lower branches to steady the half circle, and this is sometimes repeated by the line of the ground and accentuated by the perpendicular of the trunk—not a very promising form to have to tackle. Good compositions have been obtained without the expedient of hiding the circle, but by drawing attention to it and making it the centre of other circles, the concentric character being carried out by cloud forms above, and by fallen trees, groups of figures, rock formations, lines of shadows and the like in the foreground. One would not wish to neglect the use of full vigorous curves that miss the tameness of the geometrical circle; for they are the very embodiment of movement, life, and excitement. Wind-driven clouds with their fulness of form bellying like a sail to leeward and concave to windward teach us this; and vigour of growth is often expressed by similar lines in foliage, and is infinitely preferable to the look of meanness assumed in a circular line pared down to gentility.

CHAPTER VI

LINES OF THE BRANCHES—CURVES—STRAIGHT LINES AND ELBOWS

INVESTIGATION of the effect of lines to be sought for among the foliage leads us to make a rough comparison of the lines we find in the branches of a tree. A somewhat detailed exposition of the branch anatomy belonging to different species is reserved for the third portion of the book; so, in this chapter, lines will be considered generally with the view of finding out why they are interesting or dull, and what influence one has upon the appearance of another.

Fig. 68

The full value of a line is usually obtained when it is used in conjunction with another or others. The influence of one line upon another is surprising. The straightness of one displays the curve of another, the pronounced curve of a third makes the one of slighter curve seem nearly straight, while the elbow on a fourth is so marked that it tricks one into the belief that the full curve of its companion is slight.

Fig. 69

If lines were placed in this order, so that the fullest curve was farthest removed from the straight line (Fig. 69), their difference would not attract the considerable attention that it would if they were side by side (Fig. 70); the degrees that lead the eye step by step would be passed without much sensation, and the fulness of the curves would be unappreciated. A similar absence of sensational effect is produced by tones of light and dark—when black lies farthest

Fig. 70

Fig. 71

away from white, and is joined to it by a gradation in sequence of the half-tones in the greys. Unity in the picture might be obtained by some such device in arranging lines, if that were practicable; but it is better done by nature. Unity is gained in nature by the consistent adherence to a certain type of line in all the

95

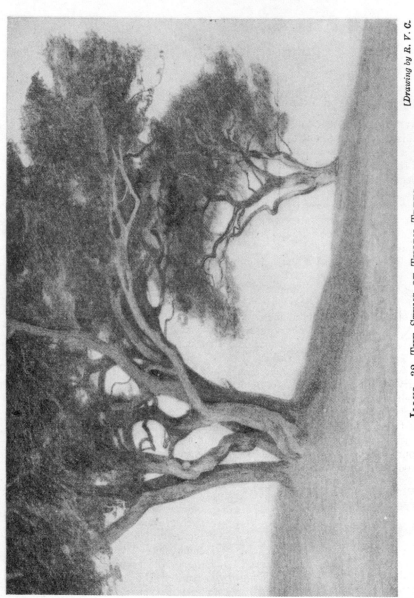

ILLUS. 32. THE STEMS OF THORN TREES

Note their variety in form

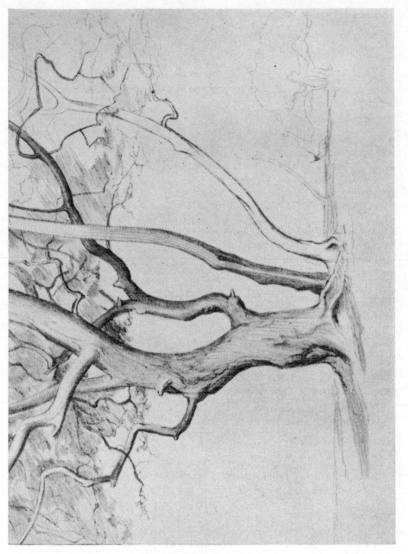

ILLUS. 33. COMPARISON OF LINES—THORN STEMS

ILLUS. 34. THE TOP OF A YOUNG WHITE POPLAR—COMPARE THE ANGLES WITH THOSE OF A BLACK THORN OPPOSITE

individual trees of a species. On one the branches form lines that are set one with another at a small angle, on another the angle is larger. Other species exhibit slight curves, or full curves, or the boughs form elbows. One type of line is retained by each; every

ILLUS. 35. THE ANGLES OF A BRANCH OF BLACK THORN

branch takes its place in the scheme governed by the prevailing angle, curve, or straight line that distinguishes it, and a harmony exists that could not be if each bough and twig had a law to itself. Though every twig is formed on the plan of its neighbour, and every bough is but a

twig grown old, yet endless variety is obtained by our different point of view of each. We have only to compare the foreshortened view of

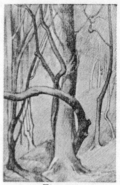

a branch heading towards us and that of another receding, to appreciate how inexhaustible a difference new aspects give. But boughs are not machine made—they live—and each asserts the right to wander from the given path, or (Fig. 72) is pushed out of it by others. Age, also, rounds the angles, and robs a bough of many parts ; and the branches have that variety which belongs to a living thing, in addition to the change in appearance caused by the laws of perspective. If we wished to obtain the most startling effect, we should take the most dissimilar lines (Fig. 74) we could find and place them side by side ; they would hardly make a pleasing whole, as each

Fig. 72

line would be for itself and each would catch our eye separately ; we should merely look from one to another in amazement or dismay. A line to be seen to advantage should be next to one of a more neutral form, so that the interest in the one is augmented by the want of interest in the other ; the line selected to play the part of chaperon would probably be of some form nearly approaching that of a straight line.

We more often wish to make an assembly of lines form an agreeable whole than to use them for the display of an individual. This can be carried out in the tree by the grouping of many varied lines that conform to a definite type. The repetition of a form, whether it is beautiful or ugly, produces one sensation, but if different types are

Fig. 73.—Repetition in the direction of lines as shown in a young Oak tree

used together the result is complex and discordant. In Fig. 74 three
types only are included so as to convince, but
not to injure, the reader. It is often difficult
to analyse lines and to determine in cold blood
when variety in one type is ended and a new
type is begun. We wish to avoid monotony
by shunning exact repetition, as we try to obtain
unity by not allowing too great a divergence. If
we refer to our trees again we notice a certain
laxity that verges on the adoption of a new
type; the branches of an Elm perhaps will in
parts lose their identity and mimic the Oak boughs, while the more

Fig. 74.—Three types of branches on one tree

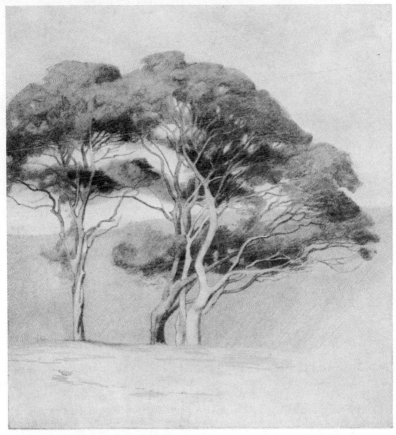

ILLUS. 36. PENCIL STUDY OF THORN TREES BY R. V. C.

uncertain Hornbeam takes the dual character of Beech and Elm ; but if we look more carefully, we find here and there a loyal following of the predestined form, and this of so unmistakable a nature as to counterbalance other eccentricities. It is this recurring note that

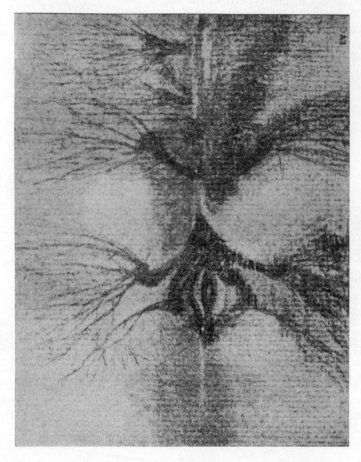

ILLUS. 37. CHARCOAL SKETCH OF POLLARD WILLOWS

gives unity to the lines of our picture. Lines that flow in one direction only, act in unison as a single line, helping to accentuate the feeling that would be conveyed by the single line. A line full of energy might be exploited better by itself or in contrast to quiet lines ; but if the sensation of repose, quietude, and vastness can be rendered by lines

of little variety, the same notion can be best insisted upon by a collection of similar lines. Those that are straight or slightly curved would, from being the least animate, form the better part of such a composition. Many groups of lines that are parallel, or nearly so, can be used in a picture; they appear antagonistic only when the groups cross or are unbalanced. For instance, the shoots on a Pollard Willow radiate in curved lines from the apex of the trunk. There is

Fig. 75

a spring in their curve that is delightful, and varied repetition adds to their charm; remembering this, we might group the Pollards with success, when neglect of the cause of their charm would create a clashing of lines—a sort of Willow warfare that would lead to calamity.

The selection of lines is so integral a part of composition that it would be wise in spare moments to practise arrangements with any objects at hand; ten minutes spent with a box of matches will explain the most obvious effects of one line on another (a matter to be considered daily out of doors) better than would the wading through and digesting of pages of written treatise, though the latter has the advantage of stimulating ideas. Compare A, where the matches follow the

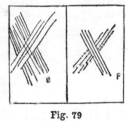

Fig. 76 Fig. 77 Fig. 78 Fig. 79

same course but are not equally spaced, with B, where they cross anyhow; we prefer A, but, if it is too orderly for your purpose, try a slight or greater angle of divergence, C and D. Now compare C and D with E, where the lines are equal in length. Make them quite equal and equidistant from the crossing, and they become impossible F. A literal copy of a bough is often unpleasant to look at; the removal of one branch brings about an improvement that might lead to success if emphasis is given to certain lines and not to all equally. Branches are often so beautiful in form that they lure us on, line by line, to a detailed representation that misses the very thing we set out to draw;

it is then that we benefit by the habit of considering all objects, whether trivial or not, with a view to their artistic possibilities. The removal of one line or the placing of a stronger accent on another will often

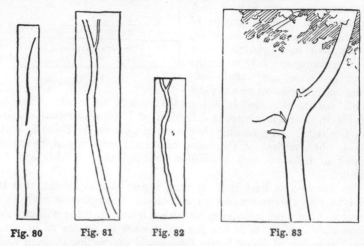

Fig. 80 **Fig. 81** **Fig. 82** **Fig. 83**

convert a faithful but poor drawing into a good one. We spoke of the contrast of curves in separate lines, but contrasts must be recognised in a single line; call it variety if you like (Fig. 80). A Birch stem is undeniably graceful, and the landscape man sees in it the lines that a figure painter finds in the figure of a girl; there is the same spring and ease in the longest curve constructed of less important curves; there are the same accents that give it strength and the same balance that brings dignity. Beginners are apt to miss the swing of the long curve by an exaggeration of the smaller (Figs. 81, 82). The lissom line, so firm and graceful, becomes degraded into a lumpy wriggle reminiscent of bent wire, or it looks flabby and unable to support the boughs and leaves that furnish it. Many stems of trees start from the ground in a perpendicular line, then break into a short curve repeated above by a longer and reversed one (Fig. 83). We have here the variety of a straight line and two dissimilar curves, but the accents at the junction of the curves should not be overlooked, as they influence the curves in different ways. If you draw these alternating curves as one line (Fig. 84a), it becomes a double curve without break until its meeting

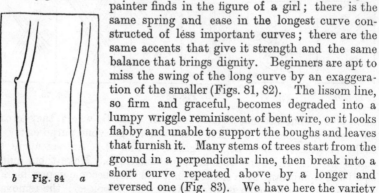

b **Fig. 84** *a*

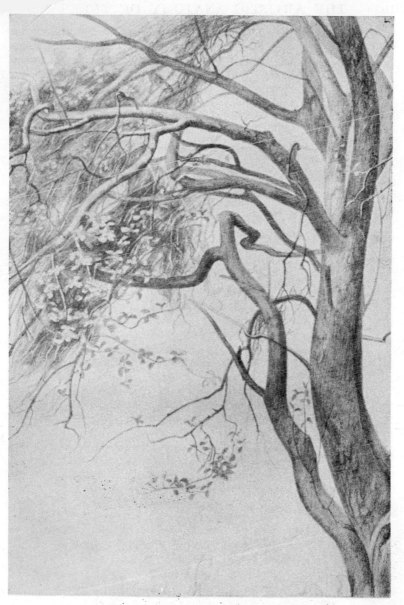

Illus. 38. The Boughs of a Crab Apple Tree

with the perpendicular length. If, on the other hand, you draw the alternating curves with an accent at their junction (Fig. 84b), you get

two distinct curves. Again, if you miss the accent at the top of the straight length, you get much the appearance of three curves (Fig. 85) that alternate in direction. The union of one curve with another is often marked on one side of the stem by a break, while on the other side the flow of the line is uninterrupted. In place of the alternating curves we sometimes see a limb taking its course by curves facing the same direction. If this is strongly marked, a sort of kink is formed, and is of distinctive value as a relief from straight or slightly curved lines. The individuality in the outline on either side of a bough is apparent also

Fig. 85

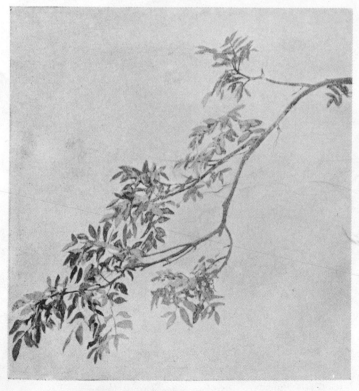

ILLUS. 39. PENDENT BRANCH OF ASH
Notice the "spring" in the curves

from one outline being continuous above and below a junction (Fig. 86) and the other being broken by the added thickness of the older portion. The variety seen in curves may occasionally be due more to perspective than to any great change in their course. A young Sycamore, at times precisely symmetrical, might be irritating from the tameness of perfection if it were not for the perspective changes of the branches coming to and from us.

Our pleasure in the hanging branches is increased by the contrast of curves that spring from the upper or lower sides respectively, and in others (Fig. 87) that start from the upper side, curve downwards, and

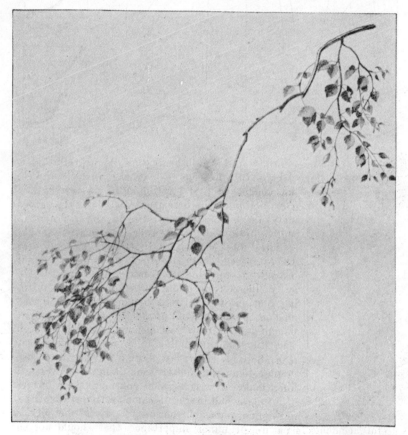

ILLUS. 40. BRANCH OF BIRCH

Compare the loose straying of the branches with the firm lines of the Ash

then up again. Such a line as the last has all the suggestion of a steel spring and nothing of debility. We find it in the hanging branches of an

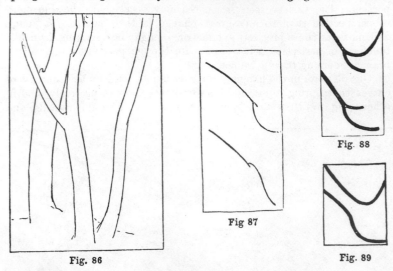

Fig. 88

Fig 87

Fig. 89

Fig. 86

Ash. It is the same formation that in other species (Apple, Oak, Alder, Thorn, for instance) becomes a firm elbow or crozier, with less grace, but conclusive in its testimony to the strength of construction. On these pendent boughs the curves may be repeated again and again. Truth in representation demands that our curves should conform to the habit of the tree, but a choice of curves is legitimate, even so, by painting—as if broken off—any line we consider undesirable. We are at liberty to form our curves out of the remaining portion of the parent bough, continued by the offshoot as one curve ; or we can take the parent bough and destroy the offshoot. It will be seen that the result in each case is remarkably different (Figs. 88, 89). There is a peculiar attraction in those young stems that, after some length of vertical line, make a wriggle and continue their former course ; the halt in the undemonstrative straightness of the line piques our curiosity. It is one of the useful accidents in nature, of minor importance, that should not be forgotten in the uninspiring atmosphere of the studio ; with it rank

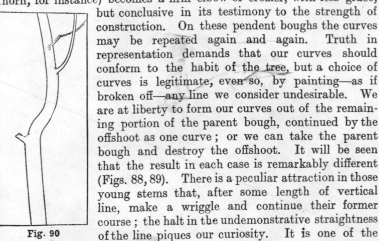

Fig. 90

the amusing and highly decorative loops, knots, and spirals of the clinging ivy and honeysuckle. The custom of pegging down the half-severed Ash and Beech saplings to form a hedgerow is productive of weird curves and tortuous bends, while their intermixing of roots and new-formed shoots create a fantasy out of the commonplace well worthy of consideration.

CHAPTER VII

VARIETY IN LIGHT AND SHADE—VARIETY IN COLOUR—SOME CAUSES OF THIS

A KNOWLEDGE of structure gives to our drawing an almost unconscious variety of light and shade that is independent of the accidents of shadows cast over a form or the difference of tones by which local colour is translated. If we were drawing a nude figure in full light, our experience of the appearances of constructional forms would bring about a constant variety of light and shade while we were engaged in presenting the form of the flat or rounded planes of tendons, muscles, flesh, or of those parts where the bones are near the surface. Each surface—according to whether it was turned towards or away from the light —would represent to our minds a definite tone reserved for it and for all other surfaces that were in a similar plane. From the scale of tones we had decided to employ, we should select one after another, until every surface had a tone to tally with it and explain its position in reference to the light. Variety in tone would ensue from the difference of the angle at which one plane joined another;

Fig. 91

a wide hollow, for instance, might require four tones to describe the gradually inclined plane, when two tones only would give the steep sides of a sharp furrow; so that the transition from light to dark in the former would be gradual, and in the latter abrupt. Additional changes in lighting would follow, by the reflection of light from one surface on to another; and the intensity of this reflected light would explain the proximity of each surface. It

Fig. 92

is the besetting sin of students not to apply the same reasoning (such as we have just considered) when drawing masses of foliage or the limbs of a tree—it is the misfortune of the landscape painter that the multitude

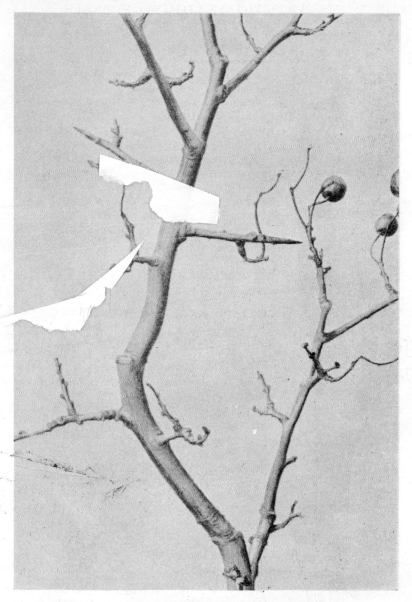

ILLUS 41. THE ROUNDNESS OF TWIGS—THORN TREE

of forms out of doors under an ever-changing light confuse him in his observance of such facts.

The analogy of the limbs of a tree to those of the human figure is at times almost uncanny, at others just discernible. The muscular formations that make up the stems and large boughs of a Holly often bear a marked resemblance to those of a leg or an arm, and it is a common occurrence for the contours of a bough to alternate as do the muscles of the forearm and those above the elbow. It is generally thought that twigs are cylindrical, and in practice they may be considered so, if not seen too near at hand ; and yet very few twigs will be found made like a gaspipe ; they are built up of more or less flattened sides, a formation that cannot be missed in the young shoots of an Alder, Guelder Rose, Ash, Sweet Chestnut, Walnut and others (Illus. 42 and Fig. 93).

Such young growths will not only be (in section) a hexagon or some other flat-sided figure, but will often be enriched with projecting keels that divide one plane from another. These observations would be too botanical to serve the purpose of an artist if it were not that they give one reason for the variety in the lighting of the branches. Again, at the junction of a shoot with a branch there is an increased girth, and in some species the shoots are given out to right and left of the branch alternately. If the bough is then seen so that the shoots are in profile, it will often appear thicker than in the position when the shoots are in front and behind it. This appearance is sometimes emphasized by a flattened space across the junction, that affords a large surface for the light to play upon instead of the line of light that runs down the length of a tube. This point is so obviously enforced by a glance at a Walnut shoot that I illustrate it (Fig. 94), but I am really thinking of its application to those horizontal boughs that bear branches on either side, all being in the same plane. When we admire the roundness of an

Fig. 93.—Fluted shoots of Spanish Chestnut

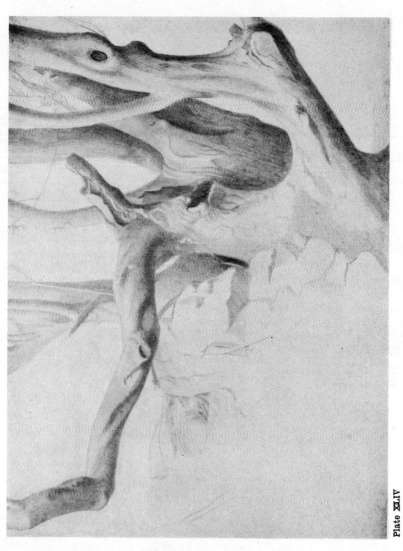

Plate XLIV

THE TWISTED LIMB OF AN OLD HOLLY. PENCIL DRAWING BY R. V. C.

Notice how muscular the limbs appear (see Page 112).

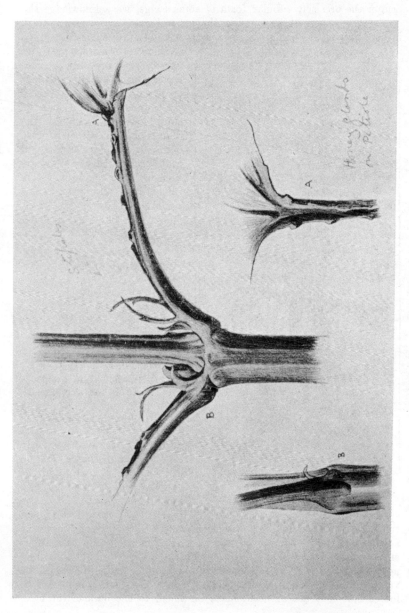

ILLUS. 42. THE LEAF-STALK AND AXIS OF THE GUELDER ROSE—EX. OF FLATTENED SURFACES

arm or the precisely tubular form of some twigs, we acknowledge the occurrence as something outside the general rule, and accentuate it in our drawing. The flat spaces constructing other circular forms give to them just that strength and variety that prevents their relapsing into flaccidity. Under the simple light of a grey sky the foliage of a tree can be considered and studied as the planes that construct a great dome ; a simple statement of each tone that represents each different plane will give fulness and solidity, and some variety. If we take as a

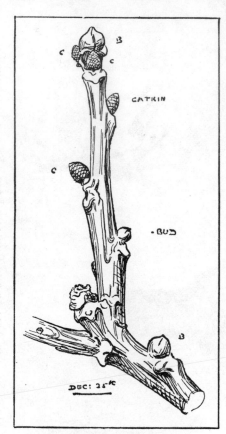

Fig. 94.—Walnut twig

Notice the projecting keels

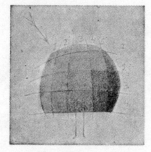

Fig. 95.—See scale of tones
(Fig. 92 of this chapter)

model one of those clipped Yews or Laurels of an old garden, we can see exactly how the light should fall on each surface (Fig. 95), and the exercise will accustom us to look for and recognise in the free-grown forms of the forest tree those surfaces that are in the same plane, and to render them by the same tone ; when painting a tree with this intention, we can differentiate those over-reaching forms which catch another light that does not belong to their plane. When we are hustled, trying to record the variety and charm of the glittering lights or sunlit sprays, it is easy to forget that they are an accident to be added to the bulk of the tree,

and that it must still be built of a definite scale of tones; this we must remember, otherwise we get all sparkle but no tree to hold it. It will not be amiss to think of our tree as made up of a certain set of tones, and for the sunlit parts to use a new and lighter set, quite apart from the others.

Sunlight brings with it other sources of variety, for it passes through the thin layers of leafage and causes them to be lighter (though more rich and transparent) than are many spaces of the more densely leaved groups. When the sun is behind the tree we see the effect of a dark trunk, and perhaps some boughs, against the bright transparent colour of the thin layers of leaves on the far side ; these transparent leaves are of two or three tones according to their density. Projecting groups of foliage on the near-side that abut them tell as a dark against them. These are, of course, much greyer in colour from the sky reflection, though the greyness is replaced by a dark rich green in the recesses, where they are lit by the reflected green light from other leaves ; the tops and edges of the tree take a lighter grey as they recede round its dome. With the sun high up in the sky, spaces towards the apex are caught by a high light of glitter, and the ends that jut out lower down are also touched with sparkle or look greener than the parts in shadow. Where gaps occur, the sunlight streams through ; then the transparent bright leaves, with the grey-lit ones and the general shimmer, confuse the opening, and the halation dispels all matter-of-fact observances. Branches that cut across such a light lose their edges and darkness and modelling, and become thin strips of undecided half tone. Variety in the light and shade of the limbs is caused in part by the texture of the surface ; the smooth bark of a Holly stem catches only that light that should normally fall on a particular strip of a cylinder or on the contours that compose it, while the loose layers of papery bark curling from a Birch stem may on the shadow side catch a light that belongs to the surface facing the light. So also the bole of a Birch or Elder, deeply fissured by split bark of some thickness, carries many darks into the light side, while the bark itself in relief takes light towards the shadow side |; thus the simple gradation from light to dark that would describe the roundness of the limb is interrupted by auxiliary splashes of light, grey, and dark. Other delightful effects, giving variety, come from the cast shadows and sunspots that chequer the boughs ; and one should notice that under some conditions the details of the bark, lichen, and markings are seen best in the sunlit spaces—under other conditions in the shadow spaces ; the strongest colour, too, must be looked for in one or the other. These are not, however, things to dogmatise about, since the effects are the results of the conditions, and these vary beyond description. Boughs are sometimes painted too monotonous in tone ; the

reflected light on the under side of the horizontal ones is not observed, nor is sufficient account taken of the cast shadows from the small branches at their junction, nor sufficient use made of the give and take on the edges when seen first against a dark and then against a light background. Various differences in the size of the branches, and more particularly of the twigs, in various species, account for the wonderfu variety we see in winter time or in the interior of a wood, irrespective of the direction assumed by them. If we remember that the extremities of a Larch or a Birch are made up of millions of minute twigs that collectively would equal the girth of the parent boughs, and that it is the same thing with other trees—a Horse Chestnut, for example— we are not surprised, after comparing the width of each, to find that the Horse Chestnut has but few twigs ; and we are less surprised that the Larch twigs disappear in a haze while the Chestnut shoots stand detached and clearly seen. We come across pictures where the interest to be derived from these variations is neglected for the sake of following a certain method of representing trees, founded on the workmanship of some Master who utilised a particular technique to render a particular species, but had no thought of every tree, however dissimilar, being subjected to it. Such painters have covered English and Scottish landscape with hybrid Oaks, Birches, or Willows, following on the great names that for the time had sway ; when the freshness of the fashion has worn off, their work appears stripped of any pleasure-giving means—just a meaningless representation of nothing in particular, and we notice only its extravagance of untruth.

Variety in colour.—People who do not paint—when talking of variety in colour—usually refer to Beech trees in autumn, or to a hillside [in spring, where Larch and Pine are grown together ; but without straining at these excesses of nature one can appreciate the simple variety in colour noticed in woods, where one tree recedes behind another, until the most distant ones lose their own colour identity in their assimilation with the colour of the sky. Even those near at hand will be affected by the sky, and all will be tinted by the varying light of the sun as the day passes ; so the tree we wrote down as bright green yesterday is grey this morning, and by evening may be golden red. It would be fatuous to try and describe the effects of coloured lights on coloured objects, but we may call to notice the violent contrast between red and green of a tree partly lit by the evening light, or the blue shadows that fill the hollows of gold-tipped masses, and we can but say that the atmosphere makes such colours at times, and at other times fills the contours and hollows alike, with the red glow or golden haze. For these things unwearying observation and homage only can be the teachers. Each tree has its colour, as we have said, influenced by the sky, and each

colour has its own grey—the difficulty and most of the charm of colour
lie in this relation of the one to the other. I know nothing more

ILLUS. 43. TWIG OF ASPEN (SEE ILLUS. 44)

difficult to match than the exquisite greys on the reds and mauve of
bare trees under a winter sky ; it is not the self-coloured grey of the

Oak limbs (beautiful as that is), but the hazard grey that belongs to red and mauve twigs under the right atmosphere. The passage from the grey of the sky to the grey of the twigs is so slight, yet the greys are

ILLUS. 44. TWIG OF GOAT WILLOW
Compare thickness with twig of Aspen (Illus. 43)

distinct, though in harmony. It is a mistake to suppose that greys are only seen in the shadows ; at times most of the colour of an object is seen in the shadows or in the little hollows that miss actual sunlight on the sunlit side ; here the colour is often reinforced by reflected light

from the same colour (as we notice in the hollow of a half-closed hand). Sunlight may show up the full colour of an object or it may, by heightening its tone, reduce the effect of colour. The golden leaves of an Elm look wonderfully brilliant in the sunlight ; if you bring them inside they lose their brilliance, but appear a stronger colour. It is difficult to distinguish exactly between the brilliance of light colour and the glow of strong colour when speaking of colour, and beginners get confused between the two when imitating them, as is seen by their making a sunset yellow but not light, and when they put a distant roof as vermilion when it should be pink. Apart from sunlight, it is usual to find the full colour absent from those places where the strongest light falls ; for these spaces, fully lit, contain many tender greys, or they actually reflect the sky colour so forcibly that it becomes more important than the local colour.

To conclude these scrappy remarks on colour (a thing terribly difficult to write about), I strongly advise students to constantly paint nice coloured objects indoors, carefully noting the grey that belongs to them, and how it is influenced by the texture and lighting.

Exercises in colour on unchangeable objects that leave no loophole to excuse misrepresentation, are full of interest for artists who, by experience, understand their value ; but still-life objects such as a piece of cloth, velvet, or glass are only interesting to paint as compositions of tone and colour ; so it is difficult to wean students from the more engrossing task of perpetual figure drawing. This we readily grant to be the finest training for drawing, but slovenliness in matching colour is more difficult to overcome in later life than slovenliness in drawing. Neglect of the science of colour in early days can only bring regret in later life, when each year adds to our conviction of the possibilities that mastery over colour can achieve. Facility in matching colours correctly should coincide with the acquirement of correct drawing. These two together should be the preliminary training for the next step—that of painting in good schemes of colour and drawing in expressive sets of lines. If the patience of the student would withstand such a test, I would like him to cut out from a piece of neutral grey paper some targets, and on each successively place a bull's-eye of black, white, orange, blue, red, and emerald green, noting in each case how the grey target seemed to become in turn a light grey, dark-grey, blue-grey, yellow-grey, green-grey, and red-grey, and observing that none of the greys were identical with the piece of paper from which the targets were cut. This done, he should turn his back on them, and with his paints repeat from memory each grey. Surely such an exercise would profit him more than elaborating an already superfine stipple on his drawing from the antique.

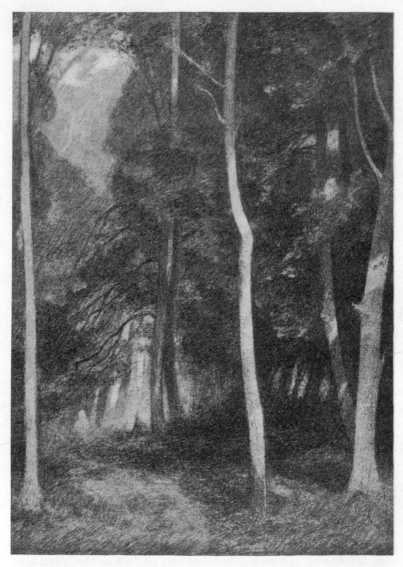

ILLUS. 45. TREES CROWDED IN WOODS

CHAPTER VIII

INFLUENCE OF SITUATION—HOW TREES ADAPT THEMSELVES TO IT—
EFFECT OF AGE, WIND, FROST, AND SNOW—MOONLIGHT

Influence of situation.—As a rule young trees, when cultivated with
others of a different species (to nurse them by their shelter in early
life), are crowded together to promote straight long timber in the
trunks ; for a tree that has not elbow room devotes all its energy
to reaching the light above it, and the lower side boughs are weak
and dwindle away. When it has overtopped its neighbours, or
they have been thinned out, it begins to expand with vigour. Such
a tree would present quite a different appearance if grown by
itself and permitted to develop naturally. The tall straight trunk
would then divide into large boughs at no great height from the
ground, and the lateral boughs would spread to some considerable
distance from the trunk. In an exposed position a solitary tree is
likely to grow squat in form, or to become straggling, denuded
of many limbs and scanty of foliage. Others seem unable to push
their way into the inhospitable space, and remain short in stature and
overcrowded with internal forms shorn close by the wind like over-
grown bushes matted, dwarfed, and constrained. But if an exposed
position is a calamity for some trees, it is life to others ; we find the
frail-looking Birch luxuriating in high positions and withstanding the
severest cold ; in fact, I understand it is the only species of tree in
Greenland, and is a common inhabitant of Russia and Siberia, though in
the more northern climates it becomes dwarfed to a mere bush. It
is common knowledge that trees have—like all other vegetation—a
preference for certain soils, and develop fine or poor specimens in
relation to how they are suited ; but it may not have been generally
noticed that a wet or dry site has a distinct influence on the colouring
of the leaves in autumn.

Trees easily adapt themselves to positions ; a chance seed dropped
on a rock will find nourishment among the moss, and the roots—
gripping with a tenacious hold the uneven surface of the stone and
pushing their way into the crevices—will reach in time the soil ; and
the tree will flourish in spite of such a precarious start in life. A tree
overblown can often exist by the few unsevered roots left to it, and can

121

put forth new vertical shoots at right angles to the stem, though its
habit normally would be to bear them at perhaps half that angle.
Large poles of Willow are so tenacious of life that, if planted, they will
sometimes form roots—just as a small cutting would—and become
before long promising young trees. Stacks of Withies are often seen
with their butt-ends in water peppered over with fresh young green,

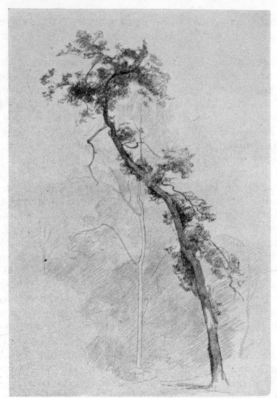

ILLUS. 46. OAK TREE DEFORMED BY BEING CROWDED

while logs of Elm ready for firewood will sometimes break into leaf.
The old stools in the copses of Spanish Chestnut, Oak, and Hazel,
though cropped every seven years, yet make a fresh start, and the same
season may give forth shoots of four or five feet in length. If a tree
is crowded on one side, it always makes good use of vacant space
on the other. Trees that fringe the roadway find elbow-room above it

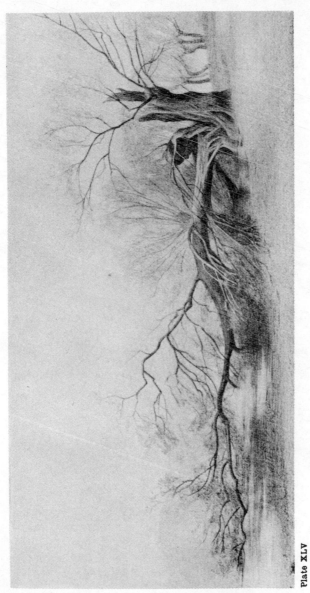

PENCIL STUDY OF FALLEN WILLOW BY R. V. C.

until they meet one another and form those delightful arches of living green through which the road winds. Trees overhanging a roadway are always pleasing, for their pose accords with their position, and the trunk and lower boughs continue the curved lines of the shelving banks and road. Elsewhere they might seem unbalanced—might seem to be leaning over and sheltering nothing ; we want the road or bridle path to which they are so harmoniously related.

Effect of old age.—Some trees in their old age take a totally different form to that of their younger days—the Scots Pine or Stone Pine, for instance, is cone-shaped when young (then spaces of sky are visible cutting in from the outline to the trunk between the tiers of branches) ; in its old age it might be caricatured as an umbrella ; since all but the upper boughs have decayed, leaving a bare trunk. Again, a Larch no longer remains feathered from tip to base as it grows older, but retains merely the upper part of the cone supported by an immense bare trunk. It is a feature of a well-grown tree that the extremity of each main bough is terminated by a straight line, and a number of these lines go to the building up of the outline shapes. In mature specimens of many sorts of trees these straight lines are practically unbroken, though serrated by the unevenness of the foliage or twigs, and small spaces of sky are seen between them at the edge. In a later period these spaces are widened by the loss of branches and the edges become more deeply cut—gaps appear in place of boughs and symmetry is lost, though a new element of irregular or grotesque forms is gained. These borders of straight edges are a feature of the Elm, Oak, Sycamore among others, but are seldom to be found on a Beech, and are absent in most young trees. A total dissimilarity in appearance between young and old trees, as we see in the Scots Pine, is due to the fact that, unlike most trees, it has not the power to form new boughs below those already grown. As tier by tier the lower boughs decay and fall, the trunk—still increasing in height and girth—is left bare except for those stumps and nodes that mark the position of former boughs. In contrast to this law we may quote the hedgerow Elm, which for every bough lopped from its trunk responds by sending out a new crop of young shoots, and these often form so dense a clothing that the trunk itself is invisible. The branches of a young tree, hastening to reach the limit of the outline allotted to them, make great strides each season, and one finds the vigour of an Elder (or perhaps a shoot from the stool of a Spanish Chestnut) enabling it to form robust shoots some six or ten feet long ; but impetuosity like this cannot be maintained throughout life, and as their span draws near the yearly growth of the twigs may be measured by half inches, and the closeness of multiplied forms is seen instead of the long loose sprays of a former period. In young trees the branches are drawn

ILLUS. 47. THE TOP OF A YOUNG SYCAMORE SHOWING THE
REGULARITY OF ITS PAIRED SHOOTS

upwards towards the sky, but presently those formed above them obscure it, and they have to seek the light by spreading horizontally, thus a larger angle between stem and bough becomes an irrevocable feature of maturity. The upward tendency of the branches is a point to be noticed as common to all young trees. The young Birch with stiffened branch formations set at an acute angle shows but little plasticity, and the moulding of the branchlets into the graceful pendant lines to be taken later on is merely hinted at. A Spanish Chestnut or an Oak through early and middle life has a freedom in growing unconnected with its old age. The extreme vigour and preciseness of form in the saplings of an Ash or Sycamore (Illus. 47), the regularity of their paired shoots, their smooth texture, variety of contour, with the regular diminishing in the proportions of the old to the new wood, give pleasure not unconnected with wonder at the exactness of equipment and regulations for growing; that, if followed, would make each Sycamore exactly like any other Sycamore, and every Ash appear as a twin brother. That this does not happen is chiefly due to an habitual failure year by year of certain buds to perform their allotted part of producing branches as their companions are doing, and these wasters have as great an influence on the eventual shape of the mature tree as have those buds that bring forth boughs with unfailing regularity— a matter we shall inquire into in detail presently. In a very young tree—despite the want of grace, sturdiness, or complexity, for which it will be noted when fully grown—there is always sufficient character for its identification. The right angles of the Oak may be diminutive, but they exist, and its dislike to forming branches on the under side of a bough is in evidence. Often a branch formed on the under side is crowded out of existence later on as the boughs become horizontal (Illus. 48). A glance at the crowded buds explains the bushiness assumed later on, just as the widely spaced buds of an Ash foretell an open system of branching (Illus. 47). Reference again to the stem of a Birch shows the youngster with a red-brown shining bark instead of the silver-greys, salmon, and pinks we see on the older trees. This difference comes about by the peeling off of the outer bark, so exhibiting the linings previously hidden under it. Twigs on a grown tree have later on to assume a new position for display of their leaves to the light, as their attitude, when free to the air, becomes untenable when shadowed by masses of foliage above, so they curve and recurve in a way suggestive of human ingenuity—but again we are trespassing on Part III of the book.

Oaks in their extreme old age acquire a pictorial interest quite unrelated to them as trees merely. They are just records of time and the stress of life—gaunt fantastic skeletons, survivors of the time past ;

and they are seen at their best under a thunderstorm such as they have for centuries defied, or in the mystery of nightfall when an owl startles the silence and the nightjar flaps ghostly with a warning cry (Illus. 49).

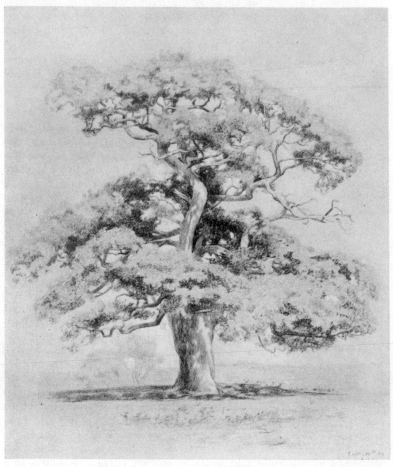

ILLUS. 48. "THE OAK"

The age of these veterans is prodigious. A life of from five hundred to a thousand or more years has been estimated for an Oak—a wonderful age, but surpassed by the Yew, which, if we may credit statistics, has but

ILLUS. 49. THE LAST STAGE

1eached middle age at three hundred, and in abnormal instances has lived five thousand years.

Effect of wind—We have spoken of the permanent habit of growth on trees subjected to habitual wind from one quarter, and for an effect of a great storm it might be well to choose such trees as models. The effect of wind on different species is by no means similar ; the slender Birch boughs bend before it, offering no resistance ; the stiff branches of the Oak and Alder defy it ; Elm boughs sway to it, and the pendent Larch twigs swing in unison. The leaves of the Poplar, Aspen, and Willow flap up and down and also rotate. This latter spinning movement that is so characteristic of the Grey Poplar and Aspen (caused by the twisted axis of the long stalk) would be impossible for the leaves of a Chestnut, nor could it be performed by any leaves attached to the twig by sturdy or short stalks.

Trees are often indices of the prevailing wind, by the heeling of the trunks and the straying of the boughs from the windy quarter. Saplings caught in a strong breeze bend till the stem resembles a bow, though the stiffness of the lower portion just prevents a geometrical regularity in the line ; the ends of the supple branchlets to windward cross the stem and stretch out on the lee side. A similar effect is seen on the Lombardy Poplar, though the stoutness of the trunk prevents it taking part in the manœuvre except towards the apex. The usual appearance of a shimmer of light over the foliage of most trees is of course due to the paler colour of the under side of the leaves being exposed when they are turned over. Nearly all leaves are tinted with

Fig. 96

a paler hue on the under side, and the texture of the two surfaces is dissimilar. A pure silver is found on the under side in one species of Willow, and many leaves that are dark and glossy on the upper side (Holly, Bay-leaved Willow, &c.) are dull beneath. So we find particular greys that belong to certain trees on a windy day—a grey that belongs to the leaf but is tempered by the colour of the sky. Ruskin, in one of his tirades against the old masters of landscape, attacks Salvator Rosa for letting stiff boughs bend before a storm, and for my part I can listen peacefully to this edict ; but students—to read Ruskin with profit—require as much intelligence in sifting chaff from grain as he showed in his writing. Ruskin should be read for the pleasure derived from style in writing, and for the bias for good that will be gained from any teaching in which sincere homage and adoration of nature is the prevailing note. *Modern Painters* makes one think, but the first use of the thoughts should be to analyse and debate on the author's dogmas and contentions.

Frost and snow.—If anyone tells you that only broad strong effects in

ILLUS. 50. A FALLEN LARCH

landscape can produce great thoughts in the spectator, go out one frosty morning and look at the Brambles and Whin bushes cobwebbed and heavy with dew, every leaf sparkling under the melting sunlight and throwing blue shadows over the stiff, rimed grass. The man who sniffs at these as "petty details" may be a good picture-maker, but was not born with the artistic instinct. The very quality of the air is a poem and every humble object a picture. Even the droop of the cobwebs overladen with moisture and the thickening of the frost-bound threads will gain a larger significance in their association with the visible atmosphere that makes the background of trees so immense under the golden haze, and the lower film of grey-blue mist cut by rays of palpitating sunlight. Another fairyland—a trifle theatrical, perhaps, though charming—is given to us at intervals when every branch is outlined white with hoar frost, the rime giving delicate shape to the smallest twigs whose form is lost under the somewhat similar appearance of powdered snow. At other times snow lies heaped on the twigs, and the uncovered part looks dark and the white twigs clumsy under their burden—and it looks so chilly and white against the snow-charged sky! In rough weather drifts hide the boles of the trees that skirt the woods, the exposed sides of the trunks are powdered, the uncovered parts look unusually dark and strongly coloured; all traces of man are lost then—walls, gates, and stiles lie buried out of sight, and the excursions of the wild life of the woods can everywhere be followed by their tracks.

Moonlight.—Many of the Old Masters, I think, must have studied and brought into their daylight pictures some of that grandeur and mystery that belongs to moonlight. The roadway—that in the daytime was bordered by bright flowers, sparkling leaves and reflected light, where our attention was caught by the cart ruts and hovering butterflies—has become by moonlight a mystic dark tunnel. The roadway passes into banks, and banks into foliage, without a perceptible break—just one immense dark but luminous shadow encircles it, with patches of broken light sufficient in places to explain the roadway, in others just enough to enhance the mystery of it. The leaves close at hand seem sharp against those behind that have taken a pale greyness unrelated to their distance; but nothing is really sharp, and the scheme is set in dark and grey where the moonlight strikes on some really light object that looms out preternaturally white. Trees seen against the moon lose their detail, but we can distinguish most of them by the loss or comparative sharpness of the outline. Delicate young trees make a broken blur against the sky, the Birches are a haze but suggest an outline, the Oaks and Elms are at a little distance blank spaces of dark with straight-cut edges. Here and there a lighter space on trees behind shows undecided between the trunks, just enough to mark their

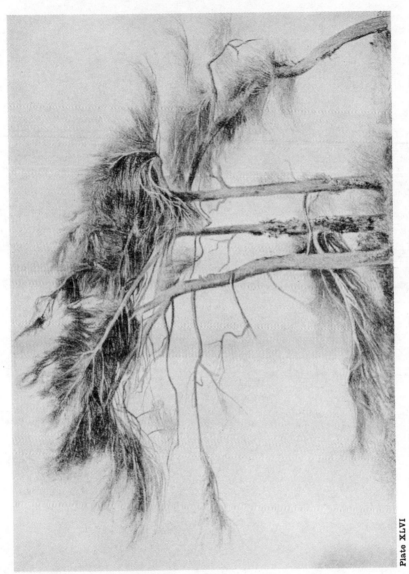

Plate XLVI

Larch Trees Contorted by a Prevailing Wind. Drawing by R. V. C.

existence, but not enough to prove their reality. The boles of those near are lost in the shadow on the ground. It is just this want of difference between level and vertical forms that is the distinguishing gulf between the day and the night. A wall by day would be a wall until it meets the ground, the shadow on the wall would have its

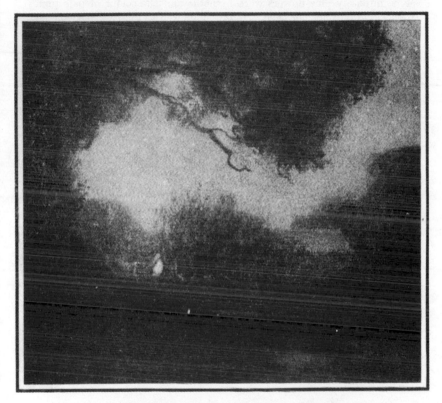

ILLUS. 51. MOONLIGHT SKETCH IN CHARCOAL BY R. V. C.

colour, and the shadow cast from it over the ground would also have its particular colour and tone, and the one would send reflected colour into the other. By moonlight the shadow passes over both without distinction, though there is a slight variation if the moonlight comes from one side.

In a picture of moonlight allowance must be made for the supposed position of the spectator ; the strong blues that he would see if looking

at the scene from a lamp-lit room would not be there without the artificial light that forces them by contrast. One should make a memorandum of those colours that are lost or are well seen by moonlight. I have noticed bright pale yellow flowers such as Evening Primroses easily distinguishable from white flowers at a distance of thirty feet, though some intensely blue flowers were invisible and the colour of pale pink roses could only just be seen. It might be well to take all the colours of the palette (as they would be easy to refer to) and set patches of them on a board one moonlight night, and note the difference in the intensity of colour and tone in each.

CHAPTER IX

ASSOCIATIONS are so inseparable from our conceptions of nature and art that we are unconsciously biassed, and it is difficult to gain any fresh view of either. The key to this difficulty is a consistent following up of some particular truth or beauty observed, and this can only be done, as Samuel Smiles says, by " perseverance, knowledge, and ability diligently cultivated." Some aspects and arrangements of nature I cannot like, nor can I see them in any other way than the one I dislike. I dislike them simply because they recall certain types of pictures that I consider bad. The very untruths or want of sympathy with nature in these pictures (such as water being represented by straight horizontal lines, or rank autumn foliage against a leaden blue-black cloud) crowd upon me and even seem to have some foundation of fact ; though to think that would be to libel nature. On the other hand, we have had our senses awakened to all the good and fine things in nature by the good and great paintings of the past and present. Even the little foibles of convention are often delightful. I can never see a picture of Oaks without a sneaking wish that I may find in it the little old woman with the red shawl. If she is not there, I wonder how the painter resisted the temptation and left her out. The concession to custom in such little touches seems the remaining link with childhood—when we repeated meaningless rhymes and drew houses with the chimney in the centre of the roof because it was the custom so to do. Any conscious straining for originality, or any distortion of nature for the purpose of being thought a clever young person, or any view adopted except a sincerely personal one—though it may for the moment gain some kudos or cash—will eventually ruin any real artistic instincts and what they should lead to.

But to return to our trees, is it not well to let associations guide our judgment in the matter of things unusual ? I have seen Willows high up on a mountain side—and there was no reason why they should not be there, as the place was water-logged ; still, association connects Willows with the lush meadowland among Alders and Poplars growing with King-cups, Meadow-sweet, and the Reeds of the river-side ; among the boulders of a Yorkshire moor surrounded by Ling they half lost their

power to please. The Wellingtonias, Deodars, and " Monkey-puzzlers "
planted round new houses seem to me a blot on the landscape among
the Beeches and Oaks—things to leave out ; nor would I, if I were a
poet, compose a rhapsody on a Stone Pine overhanging a duck pond,
but I might do so on a Willow overhanging a ditch. Yet one sees a
constant disregard of association—sketches of cornfields with a neatly
painted Spruce Fir strayed into the hedgerow, Alders on dry lands, and
Larches on wet ones. I would rather have a picture of a Lavender bed
with the flicker of butterflies and bees hovering over it—that, at least,
would recall the hum of insects and the scent and warmth of a summer's
day. Care without knowledge of nature may easily be the cause of life-
lessness in a drawing, so that fact is substituted for the essence of life,
movement, sound, and scent in as far as these can be suggested by paint.
Misdirected energy may give an elaboration of leaves clear and sharp,
without the suggestion of movement, and so the flicker and frolic of the
pattering Aspen leaves—their chief charm—be lost. I do not think
one can suggest the plaintive song of a Fir wood ; but the sway of
the Lombardy Poplar or the rush of Ash foliage before the storm, and
the dash of silver on Willows, Whitebeam, and Poplars, stirred by the
wind, can be given. Trees, ever responsive to the moods of nature, take
their proper place in the scheme. When grown on the coast they often
look as though they had been caught in a gale and transfixed in the
act of movement ; their heads are bent, boughs stream horizontally to
the lee-side, and those on the windward side are bent back and wrapped
round the trunk—a permanent record of a passing effect.

Association enables us often to like forms that are unbeautiful, and
we become so accustomed to the effects of cultivation on certain trees
that their natural habit is not familiar. Hedgerow Elms shorn of their
lower branches, pollarded Willows, copses of Sweet Chestnut, Osier
beds and the Box hedges of our gardens—all seem right in their place.
Many trees, whose grotesque trunks we now admire, such as the Beeches
of Epping, were formerly pollarded, and have been allowed to grow
their boughs in later life after continual lopping had given them trunks
of quite abnormal size. The topiary art of the old gardeners—who
forced their Box and Yew trees to resemble a peacock, an urn, or a
pilaster—associated as it is with grottos, mazes, artificial waterfalls, and
lakes, the whole bordered by living walls of evergreens, gives us a garden
of pleasure in which only modern dress is an anachronism. Imagine,
however, one of the Box effigies in a Beech wood ! To me this would
be a parallel to that Spruce in the cornfields. Small matters are of
moment in the suggestion of surroundings : a path I travel is bordered
by Alder-Buckthorns ; and a sketch of them clustered with pale unripe
berries brings back the sultry heat and the reflected glare of the orange

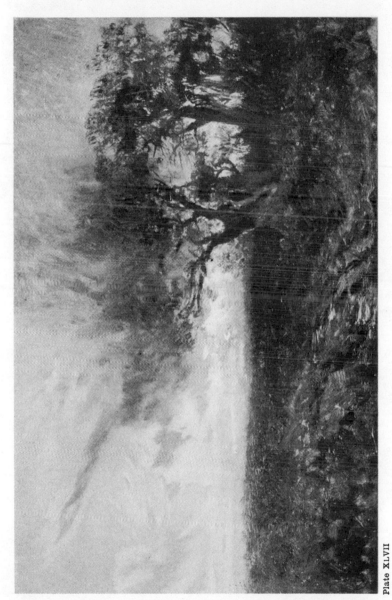

Plate XLVII

STUDY IN OILS BY VICAT COLE, R.A.

sandstone forming the eaves of the shelving sides; it requires no imagination to see again the quivering white heat spread over the tableland and to hear the popping of the gorse pods and the rustle of a snake. I wish I could stretch a point in veracity, and say that all representations recall the scents connected with the object; if that were so, we should renew indoors the sweet balsam scent of the Poplar buds and leaves,

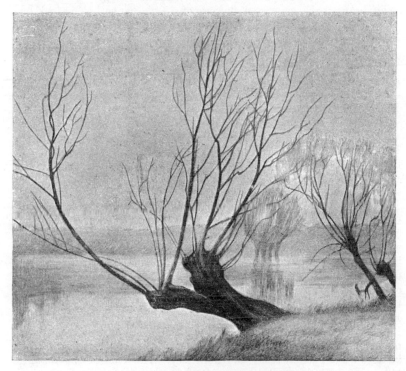

ILLUS. 52. POLLARD WILLOW

and the subtle perfume of the young Beech leaves, the fragrance of Holly and Hawthorn flowers and honey-scented Lime, the resinous sweetness of the Pine Woods and the pleasant but acrid scent of Walnut leaves. The aroma of autumn would come with a carpet of fallen leaves, and the freshness of spring in unfolding buds. But if this were so, who would dare to paint the blossom of Elderberry or Rowan, or the white stars of the Garlic!

If the connection of scents is outside the painter's province, there is still the association of seasons with particular trees. The silver buds and golden flowers of the Sallow (Illus. 53) and the cold white Blackthorn—forerunners of spring—are followed by the spring harmony, in which Cherry (Illus. 58), Crab Apple (Illus. 59), Wild Pear, and Plum (Illus. 54) contribute their share. The crimson and orange of the Cherry leaves, the downy silvered buds of the grey Poplar and Whitebeam, with the waxen flowers of Larch, cannot be passed by unnoticed as we watch expectant for the pink of the unfolding oak leaves.

The connection between places and trees has often come about by the industries established. The osier beds of Berkshire, or the copses of Spanish Chestnut in Sussex, are now familiar features of certain districts —though the hoopers' craft is passing into neglect. They say the Yews in the churchyards were planted as a reserve for the making of archery bows, and we know that the Larch forests of Scotland were planted for the sake of the long tough timber (as recently as 1700). Association has been utilised more in the past for picture-making than is now the custom. Turner's pictures did not stop at being merely beautiful harmonies of tone, colour, and line, but contained in addition all the incidents and accidental life connected with the locality. To his mind, Greenwich was no Greenwich without the holiday-makers, and Chatham must have her soldiers ; the way they make a stone wall in Yorkshire or a fence in Surrey interested him and was part of the place ; we cannot conceive him satisfied with a picture of trees which might be grown anywhere, but were not those of the special district. Each district for him was clothed in a particular verdure, and had its idiosyncrasies ; and the people there lived a life of their own and wore a distinguishing dress. I am afraid we sometimes recognise in pictures of English scenery Millet's Barbizon peasants who must have strayed into Essex, and dainty London models carrying the milk, or little Dutch figures on the bridges of English canals. Every place is permeated with its own atmosphere literally and indirectly. The blue of the distant hills in Surrey is not the blue of the Scots mountains. Yorkshire moors in outline do not resemble the South Downs; the Alders in Wharfedale are distinct in character from the Alders by the Mole, and you need not wait to hear the countryman speak ; his figure, gait, dress, and consequence all tell of the land he toils on ; he is a literal son of the soil, moulded by his labour on it, and showing the inheritance of generations bred to a similar task. Critics tell us that the painters of the mid-Victorian period were wrong in their assiduity in the selection of the picturesque. In their day each object had its type of beauty—every detail was the best of its kind—a fence, a hedge, a gate were things in

Plate XLVIII

STUDY IN OILS BY R. V. C. OF TREES SEEN AGAINST THE SUN

ILLUS. 53. HERALDS OF SPRING—CATKINS OF SALLOW

ILLUS. 54. WILD PLUM IN FLOWER

ILLUS. 55. CATKINS OF THE HORNBEAM

ILLUS. 56. UNFOLDING FLOWERS AND LEAVES OF THE SYCAMORE

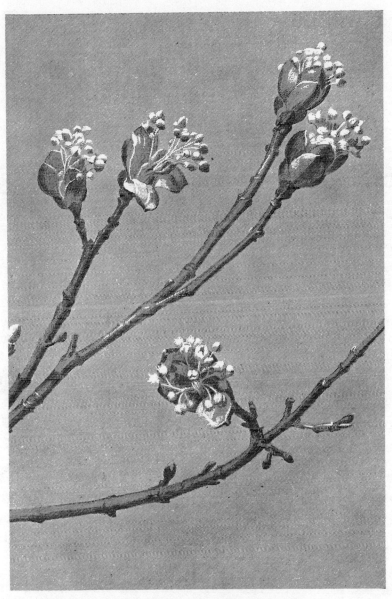

ILLUS. 57. OPENING FLOWER BUDS OF A MAPLE

ILLUS. 58. BOUGH OF CHERRY

ILLUS. 59. FLOWERS OF THE CRAB APPLE TREE

themselves beautiful to look at and diligently sought for and culled from the particular district. Perhaps over-selection in objects, as over-selection in colour or line, may from its fastidiousness approach tameness ; but we can forgive rather easily errors of scruple that made an old piece of fencing too perfect. It seems to me more difficult to ally ourselves with those who say a white painted railing would do equally well, and add, " and it was there," as if art and the camera had gone into partnership.

PART II
THE ANATOMY OF A TREE

CHAPTER X

INTRODUCTORY

FAMILIARITY with the general aspect of the things we paint is followed after a time by a desire to learn all we can about them. A figure painter is discontented until he has a knowledge of anatomy at his finger tips, and can recognise the period of a dress at a glance. The painter of genre pictures, from collecting bric-a-brac in his studio, becomes an authority on furniture and arms ; and the painter of gardens, a rosarian. Whilst studying shipping, the artist becomes master mariner and is learned in tides and the rake of a yacht. Landscape men dip into the science of light and the forms of water, and may be naturalists or dabblers in geology and botany in their spare moments. It may be that instinct pulls with two strings at once : one that makes us wish to paint—to paint anything and everything ; another that calls us to a particular subject that we must in some way be connected with. Perhaps it is that ambition to excel in our profession is so strong that every possible or probable study likely to aid must be acquired. Perhaps it is mere inquisitiveness. Anyhow the reason matters little, and it just remains to select those studies that will be most helpful. To learn what a tree is like and how it grows, it is not necessary to become a botanist, and I doubt whether it would be desirable, as you would then probably have to dissect a bud to find out the species it belonged to, and you would classify in groups all sorts of dissimilar looking forms. Your object, as a painter, is to know in what manner one tree differs from another in its growth, so as to recognise a type and to be able to distinguish the vagaries of individuals by their departure from that type. Surely it is interesting—if not artistically profitable—to know that one tree is female, another male, and a third the two combined in one ; and surely it is artistically profitable—if not interesting—to know that one tree bears its branches in pairs and another singly, and that a similar difference is observed in the disposition of the leaves ; or that the branches in one case divide at an acute angle and form sweeping curves, while in another they form zigzag lines and divide at something near a right angle ? I know the ready answer to all this is that it is sufficient if a man paints the general look of a tree without troubling to analyse its structure, and I also know the result looks generally unlike a tree ;

147

just as a general painting of a nude figure does not generally give us a painting of the figure.

I do not suggest that a student should give up time to the investigation of the minutiæ of trees that could otherwise be spent on the study of matters that vitally affect his art—such as effects of light and shade, combination of colour, or the relative importance of lines. To do so would be an indulgence in laborious idleness and a piece of extraordinary folly. Nor should a figure student be content to devote the most sensitive and receptive years of his life to acquiring a mechanical and accurate knowledge of the form of the human figure only. In both cases an exact knowledge of form should be acquired gradually, as the student finds he is unable to express his ideas without it. He should cultivate ideas and continuously attempt to express them in paint. His failure to draw the painting present in his mind will teach him to observe, and incessant observation and practice will teach him to draw, and he will take up the study of structure in his spare time as a means of overcoming his difficulties in drawing. Every student at an art school should, I think (after a short and very severe training in drawing), be engaged on painting a picture—his own picture—something he has evolved himself and is intensely interested in. As he paints it, problems in light and shade will occur—they can be studied separately and used for his picture. Schemes of colour will present themselves—he will have to face them ; draperies will have to be arranged, figures be studied in groups and in relation to their background instead of separately. All these are the things his mind should be employed on from the beginning, and it should be given no chance of becoming slothful by a perpetual but purposeless routine of drawing single figures on one scale with nothing in particular aimed for. From his want of energy and enterprise he obtains only the benefit of instruction from competent artists in things he could— if he meant to—teach himself ; while the very things in which their experience and artistic intuition could be of the most assistance to him are disregarded. He goes out into the world to paint pictures, equipped with a facility for drawing accurately the human figure on a sheet of paper two feet high, and a capability in painting a study of a similar size with colours that resemble the model ! The same inertness is shown out of doors, where a student will contentedly copy a foreground under a blue sky when he has already painted a grey one to his study ; or when he adds more than he has had time to observe to a sketch of a passing effect ; or, worse still, when he neglects to sketch momentary effects of interest because they occur at times inconvenient for painting. Efforts that should result in strenuous, searching studies are allowed to degenerate into pleasing sketches. Sketches that should be rapid and forcible statements of effect tail off into uncompleted pictures.

Pictures that should be composed and carried through against all odds are neglected for purposeless copies of pieces of unselected nature. The remedy is easy. Let nothing interfere with your enthusiasm for art; keep it more than warm, and follow up nature as a hunter would his game, always trying to compose pictures you cannot yet paint. Be absolutely truthful, but not mechanical, in everything you paint from nature. Spend less time in talking over abstract questions of art, and more in making intelligible—but not aggressive—your own bent and impulse as you find it revealed to you in nature. I have had to use my own words in this sermon, but really it is the meaning that I have gathered from reading the lives of great painters. I think it is what they would have told you to do; so I have preached, and apologise—for my book was to tell you something about trees. I am sure good art can be achieved only by a close, loving, and continuous study. Reynolds puts it thus: "Every object which pleases must give us pleasure upon some certain principles; but as the objects of pleasure are almost infinite, so their principles vary without end, and every man finds them out, not by felicity or successful hazard, but by care and sagacity." Again he says: "It is indisputably evident that a great part of every man's life must be employed in collecting materials for the exercise of genius. Invention, strictly speaking, is little more than a new combination of those images which have been previously gathered and deposited in the memory; nothing can come of nothing; he who has laid up no materials can produce no combinations." No doubt Sir Joshua (in this last paragraph) was thinking chiefly of main effects of colour, lighting, and action; but throughout his teaching he insists on the necessity for closer and accurate study of form, and for perpetual work.

"Though a man cannot at all times and in all places paint and draw, yet the mind can prepare itself by laying in proper materials at all times and in all places." In the next chapter we shall consider generally the difference in the outline shapes of trees; and it is a matter of some interest to notice how instinctively we look to the outline of an object to discover what that object is like. If it is smooth in surface, its unbroken outline declares it; if it is downy, hairy, fluffy, or gritty, we note the exact difference by the outline. When things are farther off and we can no longer distinguish differences of their surface, we still cling to the habit of trying to recognise them chiefly by their outline shape. A round piece of water we conclude is a pond, an oblong piece we think may be a flooded field or part of a river. If we see a square shape of colour on the Downs we jump to the conclusion that it is a cultivated plot; but if it is uneven in outline we suppose it may be a patch of wild flowers or weeds. It is curious how easily we recognise objects at a distance.

Our mind says, " There is a cow, there some sheep ; that is a thatched cottage, that one is tiled ; there is an Elm tree, the other an Oak ! " This reads like a French exercise book, but is true and

really rather wonderful ; because, on referring to the objects, you find the cow is only recognised by the straight line of the back and the triangle of her head and neck (Fig. 97),

Fig. 97

Fig. 98

while the sheep are known by their curves (Fig 98). The cottage is known to be thatched because its edge is indistinct ; the eaves of the tiled roof are sharp and dark. The man

we know by a little knob for a head and a lozenge for a body ; his face and neck and feet are unseen. The Elm is an Elm because it is oblong and has a top as straight as a board (Fig. 99). The Oak is not an Elm because it is the shape of

Fig. 99

a mushroom (Fig. 100). This makes us think that our eyes must be very sensitive, and our brain unconsciously receptive but not very retentive ; because the first time we paint away from nature we shall find it hard not to give the cow some legs or to complete our man with face, and even feet, though all these things were missing in reality and the objects were just as recognisable without them.

I expect the Oak and Elm painted indoors will in the end have their peculiarities smoothed over. We seem beset with the difficulty of dissociating appearances of

Fig. 100

form from our knowledge of actual form. (Figure painters often err in this : they lose the association of the ground and air with figures supposed to be outside. They are apt to miss the large half-tones that usually replace the little darks seen indoors, and to forget that the grass or uneven ground often hides the feet and throws a coloured reflected light on the legs. The edges of objects out of doors become assimilated by other things next to them, and the division is lost ; the little cast shadow under a man's boot indoors is not seen outside.)

CHAPTER XI

OUR first recognition of a tree is taken from its outline form ; and we wonder why each tree should conform so nearly to the shape of its species and why the shape of each species should be so different. We have mentioned that branches have a definite distance to grow. Whilst they are reaching their limit they at first grow rapidly, and the pace is each year slackened until they cease growing. It happens therefore that young trees take more or less the form of a cone, because all the branches are young and growing at about the same pace. The main stem, however, usually grows rather quicker than the side branches; and it is this additional length in the season's growth (of the stem) that makes the tree a cone (Fig. 102) and not a pyramid—as it would be if the stem and the side branches increased at an equal length each year (Figs. 101, 103). The shape of the tree varies according to the distance to which the upper or lower boughs respectively spread ; also according to the comparative length of these lateral boughs with the height of the trunk, and partly to the local position of individual trees. The character is also modified or accentuated by age. In some species those boughs that are first formed — the lowest — continue to lengthen at the same rate as those formed afterwards above them (Illus. 60), consequently the lowest boughs are the longest and those above are necessarily shorter, and the form of the tree is that of a cone or a dome (Fig. 104) according to the comparative length of the lateral boughs with the height of the trunk. A young Spruce or a Larch is a good example of a cone formed by a

Fig. 101

Fig. 102

Fig. 103

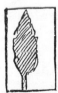

Fig. 104

long main stem and short lateral boughs that decrease in length from the longest at the base to the shortest at the apex; while a mature

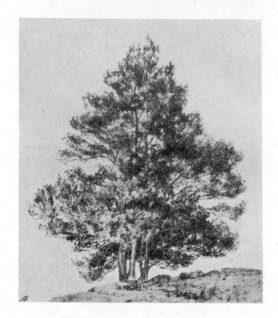

ILLUS. 60. HOLLY

Fig. 105.—Thorn

Oak or Thorn is conspicuous by its outline having the shape of a dome (Fig. 105). In some other species the boughs halfway up the

trunk outstrip the others, then a circle would all but describe the outline; this is seen in a Horse Chestnut. Another type is found where the boughs above the centre extend farther and the tree is pear-shaped, a form often seen in the Hornbeam (Fig. 107), and exemplified, to take an extreme case, by the Stone Pine (Fig. 106).

Fig. 106 Fig. 107

To return to our young tree. Whilst the main stem is giving out side branches —of which the lowest (because they were formed first) spread farthest, and those above are successively shorter—each side branch is giving forth its own side branchlets in a similar way, so that the tip of each is made up of a central shoot furnished with short side shoots (Fig. 108). It is natural then that there should be gaps in the outline of the tree between the extremities of each branch with its complement of branchlets; and it is by these regular breaks in the outline that we recognise the second great characteristic of young trees (Illus. 61). Each side branch, then, with its branchlets should be a replica on a reduced scale of the main stem and the branches; but the main stem is set in a vertical position, and the side branches take an inclined position (something between horizontal and vertical). This of necessity is the cause of difference in construction; because the lower branchlets would have to grow horizontally, or even downwards (Fig. 109), away from the light, and the upper ones would have to grow inwards among a mass of foliage —a thing they both avoid doing by stretching more or less obliquely (Fig. 110) towards the tip of the branch where the light is. In this way the lowest branches and their branchlets are ranged in something like one flat plane, whilst those at the tip of the tree spread in many directions away from the parent branch. As the tree becomes older, the gaps between the extremities of

Fig. 108

Fig. 109 Fig. 110

the boughs become filled in with newly formed branches and their branchlets; and it becomes more and more compact as the annual

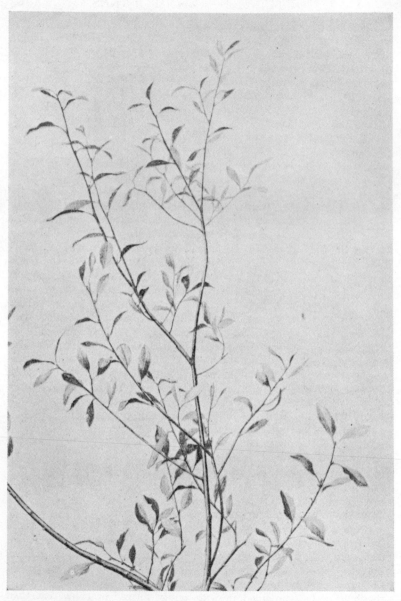

ILLUS, 61. THE TOP OF A GOAT WILLOW

shoots (now much shorter than formerly) fill in every available space.

When taking a rough survey of trees, as we are now doing, we notice that one of the chief points of dissimilarity is caused by the angle at which the young shoot begins life, and that the position it would naturally take, when it has grown to the size of a branch, becomes modified in the struggle for existence. Let us compare a Lombardy Poplar with a Black Poplar. In the Lombardy Poplar the young shoots are set at an acute angle with the parent branch ; it is so acute that the main stem, the side branches, and their branchlets are all confined within the space of a narrow cone (Illus. 62). The main stem can grow unimpeded towards the sky above it ; the side branches attempt the same thing, but their progress becomes blocked by the newly formed branches on the stem above them, so that they must either alter their course or die. Meanwhile, other little branches are being formed on the side branches at the same acute angle, and these try to grow upwards in the place occupied by the parent branch. We have, as it were, one continuous strife, occasioned by many branches set at the same angle

Fig. 111

intent on occupying one place, and this is what happens :—The branchlets formed on the inner side of the branches (between them and the main stem) are soon crushed out of existence ; presently the parent branch itself to which they belonged can find no light or air, and dies ; its position is seized by a branchlet formed on the outer side ; this in turn dies, and its direction is continued by another of these outside branchlets. In this way the growth of the branch is continued by steps, and the upright position is maintained throughout, and the whole of the branches and boughs are formed within a small space.

Now take the Black Poplar. Its leaves are larger, but are otherwise identical with those of the Lombardy. The young shoots of both are difficult to distinguish, but as a

Fig. 112

tree it is totally unlike the other. The shoots start at a wider angle, the branches have consequently more space to expand in ; branchlets formed on the under side of the branches continue a downward course unshadowed by massed forms above ; the lower boughs spread more horizontally when they can no longer take an upward direction, and the whole tree is free-growing and made up of branches stretching in any and every direction. Every space is occupied, but there is no overcrowding. The number of branches formed on the under side of the branches and taking a downward

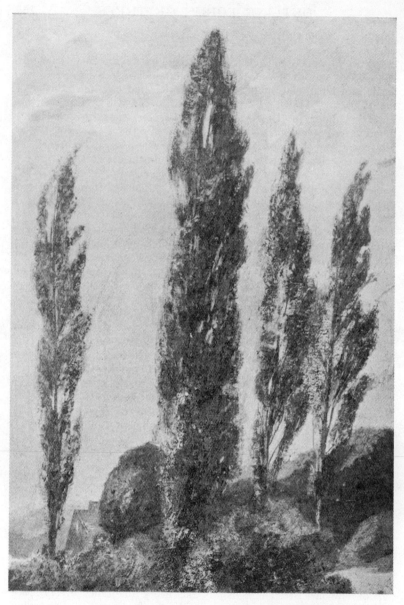

ILLUS. 62. LOMBARDY POPLAR

direction strikes one as unusual, until one remembers that the leaves also hang vertically instead of taking the more usual position of lying level or turning upwards as on most trees.

Now take an Oak (Illus. 63). The shoots start off, a number together, at nearly a right angle instead of at the very acute angle of

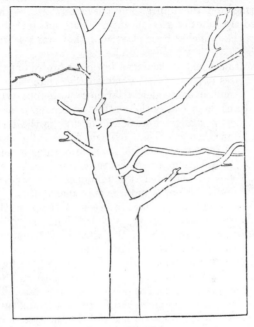

ILLUS. 63. OAK

the Lombardy Poplar. Try multiplying a number of right-angled forms, and you find they become terribly crowded. Many have to die, and some must change their direction. Remember that the annual growth is a short one, and that the boughs are consequently sturdy and can hold themselves horizontally. Think of the dense foliage that is the cause of branches not developing on the under side, and you will now make a diagram that has something of an Oak about it and nothing that belongs to the Black Poplar, where the leaves hang separately, the boughs are long, and rather pliant and produced at wide intervals, instead of being bunched in groups.

Fig. 113

Compare the Oak with an Ash—you find the angles in the latter are less open ; that the branches are in pairs (each pair at right angles to the next pair) instead of in groups ; the boughs farther spaced from one another, and forming simple flowing lines in place of the complex angular arrangement ; that the boughs are more inclined upwards, and that they support pendent branches below them ; that other branches formed on the upper side curve downwards, making with their recurved tips lines of great beauty.　You notice that the slighter foliage allows the branches freer play, and they are less cramped and twisted.

Now look at an Elm ; it has but a few main limbs, but these rapidly divide into a mass of small twigs, much smaller than those of the Ash, and, in consequence, far more numerous.　The quantity of them makes the outline unbroken ; each characteristic straight line of the outline is the termination of one bough.　These straight lines are of greater length than any on the Oak, whose outline is formed of the termination of more numerous limbs, and is still farther indented by branches of leaves instead of individual ones more evenly distributed.　The boughs do not take the easy sweep of the Ash, though there are pendent branches, but these are of a stiffer nature.

Fig. 114

What a difference there is, too, in the lighting of the foliage.　The Elm exposes large surfaces that take a fairly even light ; one can trace the foliage into the recesses and notice the overlapping of the foliage-masses. The Ash offers a less massive group for the light to play on—the distinction between one group and another is less definite.　The Oak has the spaces broken up by the detached star-shaped bunches.　A glance at a Beech shows how it retains throughout life the system arranged for it, that is seen in the new and perfect structure of its twigs ; they are very similar to the Elm twigs, and are quite unlike those of the Ash, Oak, or Poplar.　The simple zigzag of the twig from bud to bud is repeated in later life throughout the flat layers of the branches, and the leaves dispose themselves in a pattern as orthodox as the twigs—not twisted hither and thither like the Oak, but lying in monotonous exactness in one plane.

A cursory notice like this of four types of trees—i.e. the Ash with pairs of buds set at right angles to one another, the Oak with grouped buds, the Elm with alternate buds in rows, and the Poplar with single buds starting from many points—seems necessary in order to excite curiosity and interest for a more detailed examination.　There is the consistent perverseness of certain trees that—starting life with the same

Fig. 115

equipment—attain in full vigour greatly varying characteristics ; or of other species that by a perfect observance of their particular laws of growth, become intensely interesting from having done just what they were expected to do. We said that the outline of a tree was determined by the comparative length of the upper and lower boughs; we might add that a different direction in the boughs of similar length would account for much diversity of appearance (Fig. 116). Nor should we expect trees drawn up by the shelter of plantations to have features exactly corresponding to others which are grown in the open, or still less those found in exposed positions.

Fig. 116

CHAPTER XII

THE LIKENESS BETWEEN TWIG AND BOUGH—THE DIFFERENCE BE-
TWEEN SHOOT AND TWIG—THE ARRANGEMENT OF BUDS ON
THE SHOOT : (1) OPPOSITE BUDS ; (2) BUDS ARRANGED SINGLY ;
(3) BUDS CROWDED IN GROUPS

IT may seem to you, whose purpose it is to become a painter of fine
landscape, of trivial importance whether the buds you see on a twig are
arranged in systematic way or not. All you wish to know is how the
large boughs ramify, and in what manner one species of tree is different
from another. It is exactly this that you will find out from an exami-
nation of buds and by following carefully the life history for a few years
of those buds and the growth they give rise to. To understand this,
you must know that a bud is nothing else than a young shoot with its
leaves tightly compressed into a compact space ; when the shoot and
leaves have broken their confinement and become fully grown, they will
form the annual addition at this point to the growth of the tree. We
illustrate here (Illus. 64 and 65) two shoots of different trees (Sycamore
and Sallow) : you notice that the arrangement of the buds on the former
and latter are quite unlike ; but if you collected a number of shoots,
you would find that the buds on all the Sycamore shoots were placed in
the same way as on this Sycamore shoot, and also that all the shoots on
the Sallow would have their buds placed alike. Each species of tree has
its buds arranged on the twig in a definite manner. There are about
forty distinct species of trees, but there are not forty different methods
of bud-arrangement. There are about six or seven. Each species con-
forms to one or another of these plans, while every individual tree has
its buds set on the plan observed by its species. Some of the arrange-
ments merely differ in matters of detail, and the species they embrace
can be grouped together, except when an exact representation is re-
quired of the smaller parts ; then a little observation will make clear
the points of deviation, or they can be ascertained by reference to a
botanical treatise.

There is a rather interesting cause of differentiation in the branch
anatomy of some species of trees that have a precisely similar arrange-
ment of buds. On one species, certain buds consistently fail to produce

160

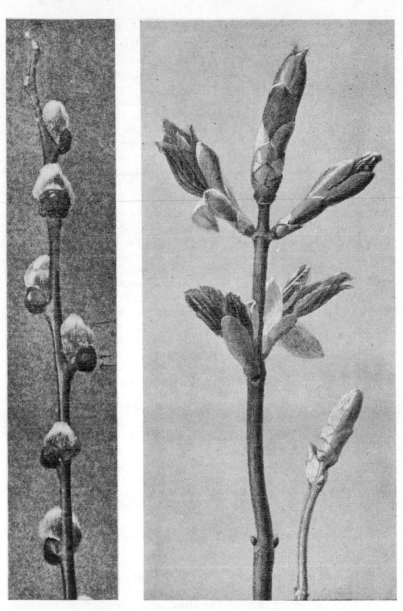

ILLUS. 64. CATKIN BUDS OF SALLOW ILLUS. 65. SYCAMORE BUDS

EX.: DISSIMILAR BUD ARRANGEMENTS SEEN TOGETHER

a shoot, while on another species all the buds produce their shoots with an almost unfailing regularity. In this way two species, equally equipped for the formation of a similar branch system, are productive of systems that have little in common, except the young shoots that are formed each season. Nature seems unsatisfied until she has exploited every possible variety; and other species add to the variation just mentioned yet another by giving out extra buds in addition to those that regulate its anatomy. It would not be surprising if individual trees should "sport" and not strictly conform to the habits of their species; but it is curious that all the individuals forming a species should consistently be wayward in following out the plan arranged for them. Since a new shoot with its buds will, in the following season, have become part of a twig (carrying in its turn new shoots), and the twig will in a few years have developed into a branch (bearing in its turn twigs and shoots), and the branch in time becomes the bough supporting the branch, twig and shoot, we should expect to find a considerable likeness between their old and young formations. Generally speaking, the twig does bear a very remarkable likeness to the larger parts; in many cases it is indeed a replica in miniature of the bough; the predominant lines of the bough are repeated, with slight though endless variations, throughout the structure of the tree.

If, on the other hand, we examine a shoot of one season's growth, and assume that each of the buds it bears will in time produce a new shoot; and if we then compare it with a twig which represents the growth of several seasons, the result is not in all cases quite what we had taught ourselves to expect. The general resemblance between the twig and the bough of which we have spoken is modified in various accidental ways—by the loss of certain parts of the bough through overcrowding, by injury, by a change in the direction of growth, or by the position of some one part (Illus. 66). Owing to these accidents, the true character lines are often more noticeable in the twig than in the bough, a twig of two or three years' growth giving the best material for determining what are the main points of identification of its species. A study of the development of the twig from the shoot is necessary, if we are to understand the origin of those differentiating features. The first step in that study must be a classification of the various ways in which the buds are arranged on the shoot.

(1) *Opposite buds.*—By an arrangement very commonly

Fig. 117 found, the shoot ends in a bud bearing beside it other buds, one on either side of the shoot and opposite one another. Other buds are arranged at intervals along the shoot, every bud being paired with its fellow on the opposite side of the shoot, and each pair

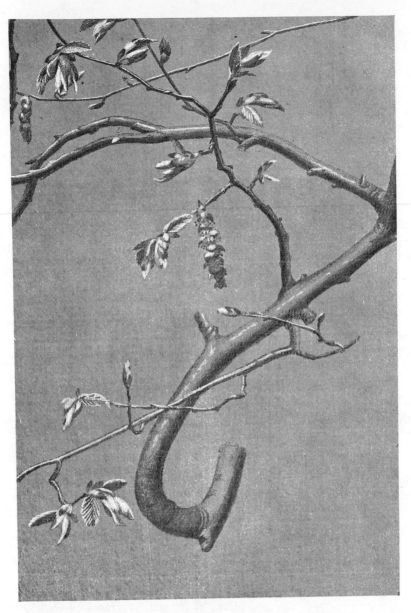

ILLUS. 66. EXAMPLE OF CHANGE IN DIRECTION—HORNBEAM

being set at right angles to the pair above and below it. A plan of this arrangement (as seen from the tip of the shoot) would be as follows :

A. The 1st and 3rd pair of side buds.

B. The 2nd and 4th pair of side buds.

Fig. 118

It is the arrangement found on a shoot of the Ash, Horse Chestnut, Sycamore, Maple, Elder, Guelder-Rose, Spindle-tree, Dogwood, Wayfaring-tree, and Privet (Illus. 67) (Fig. 117).

(2) *Buds arranged singly.*—By another ordinary method the buds, instead of being in pairs, are arranged singly, though still on a definite plan. If we follow up the buds in order from base to tip of the vertical shoot, we find that each is placed a little higher up than the last ; but the points from which they spring are not in a straight line one above the other.

Fig. 120

(*a*) In cases where they spring alternately from the near and far side of the shoot, two straight lines drawn from the apex down the whole length of the shoot would cut all the buds ; a plan of this arrangement would be as follows :

Buds 1, 3, 5 on one side and buds 2, 4, 6 on the other (Fig. 119).

Such an arrangement is the normal one in the case of the Beech, Elm Hazel, Lime, and Hornbeam, and occurs, though less consistently, on the Birch and on upright shoots of the Sweet Chestnut (Illus. 70 and Figs. 119, 120, 121).

Fig. 119

Fig. 121

(*b*) In some species, however, the buds spring from three sides of the shoot, and three lines would have to be drawn from apex to base to cut through them all.

Buds 1, 4 ; Buds 2, 5 ; Buds 3, 6 (Fig. 122).

Fig. 122

This can be seen on a shoot of Alder, but it occurs on some other trees also.

(*c*) In other cases five or even eight lines would have to be drawn down the shoot in order to cut all the buds (Illus. 71 and Figs. 124, 125).

Fig. 124

Fig. 125

Fig. 123

The buds of the following species are arranged singly on one of the plans thus described (under the headings of (*b*) and (*c*) : the Bird Cherry, Oak, Willows and Poplars (Illus. 71), Walnut, Apple, Plum, Pear, Cherry, Hawthorn (Illus. 70), Sloe and Alder Buckthorn. The

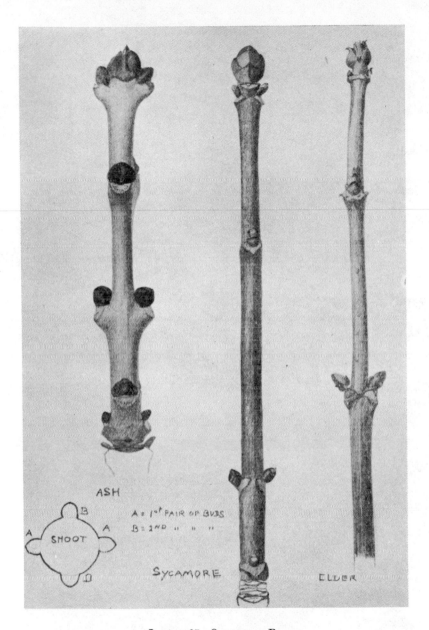

ASH

A = 1ˢᵗ PAIR OF BUDS
B = 2ᴺᴰ " " "

SHOOT

SYCAMORE ELDER

ILLUS. 67. OPPOSITE BUDS

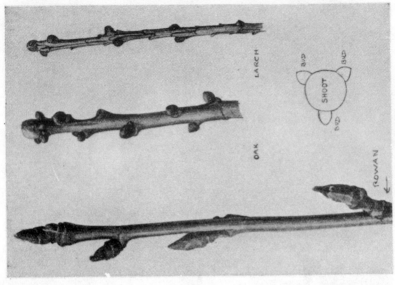

ILLUS. 69. Buds in Three or More Rows

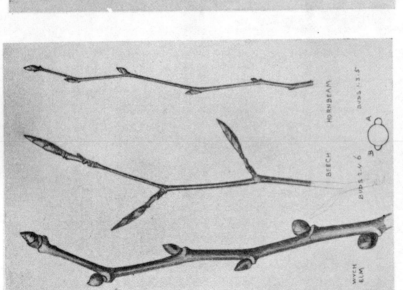

ILLUS. 68. Buds arranged in Two Rows

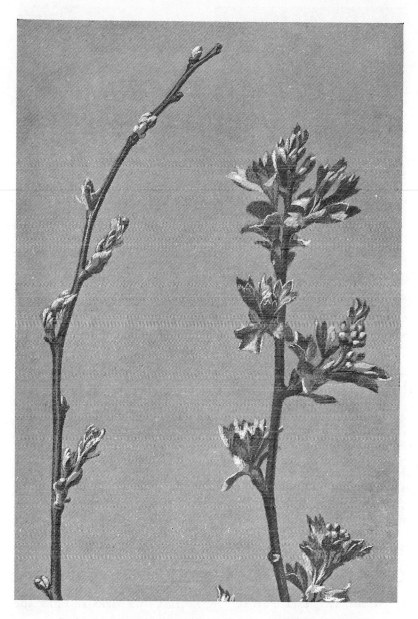

ILLUS. 70. ARRANGEMENT OF BUDS ON THORN TREE

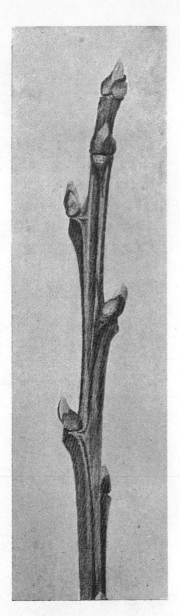

ILLUS. 71. BLACK POPLAR ILLUS. 72. SPANISH CHESTNUT

ARRANGEMENT OF SINGLE BUDS

ILLUS. 73. EXAMPLE OF CLUSTERED BUDS—SPRUCE FIR
(See Branches developed on this plan, page 183, Fig. 143)

Oak (Illus. 69) and Apple and Cherry included in these are examples of buds forming five rows.

(3) *Buds crowded in groups.*—The two arrangements described above (1 and 2), with their modifications, occur in about thirty-five species of trees ; but in some other cases the buds cluster round the shoot at certain points, and long empty spaces are left between them.

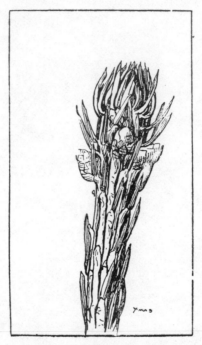

Fig. 126.—Crowded buds of Spruce

This is most noticeable in the Spruce (Illus. 73), (especially in the young trees grown in a nursery garden for " Christmas trees "), the Scots Pine, Silver Fir, and Holly. The Oak has groups of buds clustered on the tip of the shoot. A more accurate description of these " clustered " buds would be " buds arranged singly on a spiral, so short as to make them appear to radiate from points at the same level on the shoot."

CHAPTER XIII

WE must next examine into the effects produced by these differing bud-arrangements upon the branch anatomy of the tree.

1. *Opposite buds.*—Where the buds are found in opposite pairs, we should have the formal arrangement shown on Fig. 128 if everyone produced a new shoot in the following season.

Fig. 127

A. 1st and 3rd pair of side-shoots.

B 2nd and 4th pair of side-shoots.

Each of these new shoots in their turn would be furnished with buds, and in the year following would produce a similar set of shoots. Every bough would end in a central shoot set between two others like a trident (Fig. 129). This, with slight modifications, is actually what happens with some of the trees already mentioned, *i.e.* the Sycamore, Spindle-tree, and Privet. Anyone who works out an imaginary sketch of this arrangement to represent some few years of growth will find the branches becoming inconveniently crowded. This is the result in actual fact; some of the shoots die for want of light and air, others take an unwonted direction in search of these necessities, others again produce fruit in place of twigs. Notwithstanding these accidental modifications, the rule remains apparent.

Fig. 128

Fig. 129

Differentiation of a more regular kind begins where the terminal

1 The base of a twig is thicker than its tip, consequently the buds at the base project farther than those above them. This is shown in the following plans. In the former plans the twig was supposed to have an equal thickness throughout its length (to save confusion).

171

branch (the " leader " which prolongs the shoot) makes a more or less rapid growth than the side-branches. A marked deviation from the

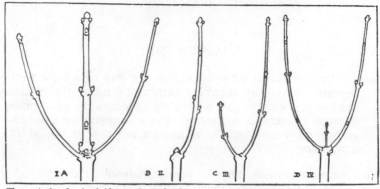

I A	B II	C III	D IV
The central and pair of side shoots all growing equally	Central and one side shoot not growing.	Central shoot dead. One side shoot growing stronger than the other.	Both side shoots growing ; central shoot dying.

Fig. 130

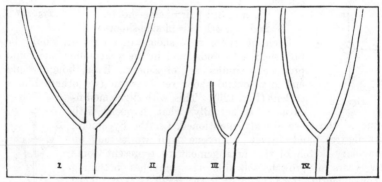

I	II	III	IV
Central and side pair of branches formed as explained by diagram 1 A.	Curve in a stem. Side shoot acting as " Leader." See B II.	Side shoot as "Leader," other side shoot seeming to spring from it. See C III.	Fork in a stem from both side branches growing nearly equally.

Fig. 131

The upper illustration shows the various ways in which buds fail. The lower illustration shows the effect in each case on the branch formation. The diagrams represent an Ash.

branch-type may be expected to follow where the buds in certain positions die away habitually year by year (Figs. 130, 131, and Illus. 74).

Failure of buds.—If the bud at the tip of the shoot withers, the

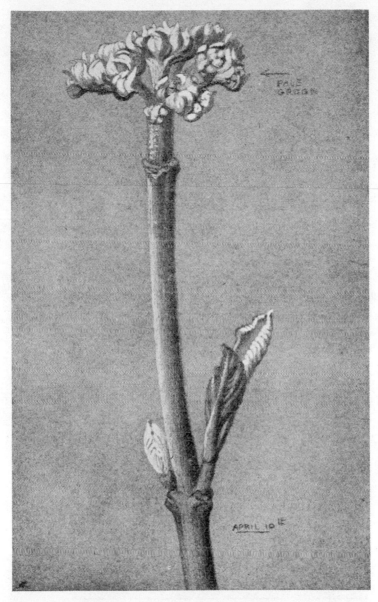

ILLUS. 74. EXAMPLE OF GROWTH BEING ARRESTED AT THE POINT
WHERE FLOWERS ARE FORMED—SHOOT OF WAYFARING TREE

ILLUS. 75. EXAMPLE OF IRREGULARITY IN THE BRANCH FORMATION OF AN ASH

The reason for it is given in Figs. 130, 131

growth may be continued by the upper pair of lateral buds ; and every
year we find a succession of forks, in place of
the tridents which should be looked for if all
three buds came to maturity. If one of the
side-buds perishes, as well as the terminal
bud, an angle is the result. Both these forms
occur on the Guelder-Rose (Illus. 85) and the Fig. 132 Fig. 133 Fig. 134
Elder. There the central bud produces a
flower instead of a leaf-bud, and growth is continued by one or both

ILLUS. 76. SHOOT OF CORNEL SHOWING THE TWO YOUNG SHOOTS,
 ONE ON EITHER SIDE OF THE TERMINAL BUD. AN EXAMPLE
 OF THE FORMATION OF A FORK

of the side-buds. In the Guelder-Rose it is not uncommon for a whole season's growth to die back, and the branches be renewed in the following season by a fresh set of buds—a habit which results in a bush-like tree with a frame full of abrupt angles. The Horse-Chestnut, when a young tree, closely follows the plan of the Sycamore ; but before long the terminal bud is often replaced by a pair of side-buds. In old specimens, the drooping habit of the lower boughs, which must still bear upright new shoots, produces an irregularity un-mistakable by its very marked deviation from the original type.

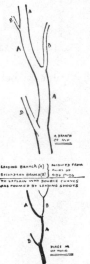

The Ash, again, starts with the same equipment of buds as the Sycamore, but its individual habit of growth soon makes an appearance (Fig. 135). One of the side-buds replaces the terminal bud, and forms a "leader," while its companion bud produces a comparatively insignificant twig. The main line of the bow is continued in this way by one of the gentle curves which are such an attrac-tive feature of the tree.

Fig. 135

2. (a) *Buds arranged singly on alternate sides of the twig.*—In the trees which fall into this class, it should be noted that bud and shoot lie in one plane, which is not the case where the buds are arranged in opposite pairs. If every twig, developed from the buds, carried on this habit consistently, all the boughs would be in flat layers—after the manner of a fern ; a cursory glance at the bough of a Lime or a Beech will show how nearly this comes to pass (Illus. 77). The zig-zag line of the shoots is also a noteworthy feature.

Fig. 136

In some cases the tips recurve, either in the direction of the apex or towards the base of the spray. This is one cause of the variations found in these flat layers of twigs ; another is due to the fact that some buds produce minute shoots only, while others are making long lengths of young wood. It is possible, how-ever, for one of these arrested twigs (which season after season has hardly made any head way) suddenly to develop long

Fig. 137

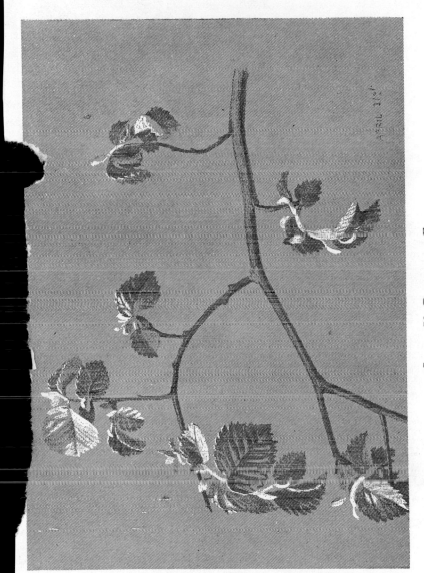

April 11st

ILLUS. 78. BRANCE OF ELM

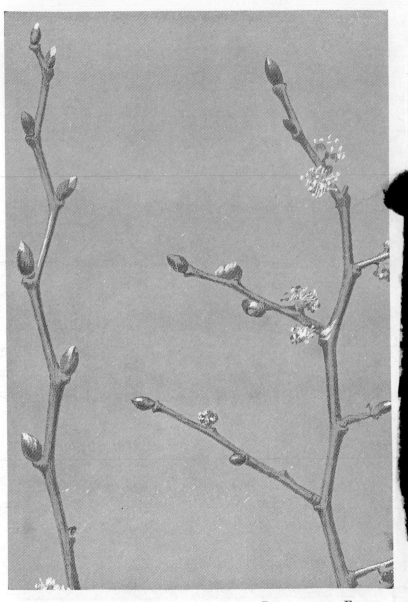

ILLUS. 77. THE ARRANGEMENT OF THE BUDS ON THE ELM
AND THE BRANCHES THEY GIVE RISE TO

shoots; the closely packed rings at their base, which represent the

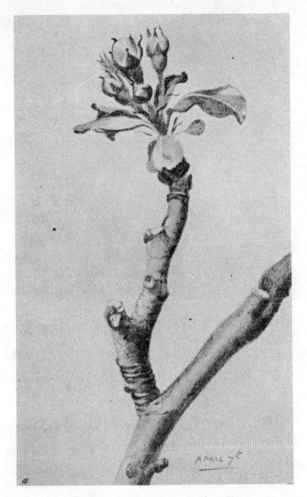

ILLUS. 79. RINGS SHOWING ARRESTED GROWTH AT THE
BASE OF AN APPLE TWIG

remains of former leaves, alone serving as a reminder of less vigorous
days (Illus. 79, 84).

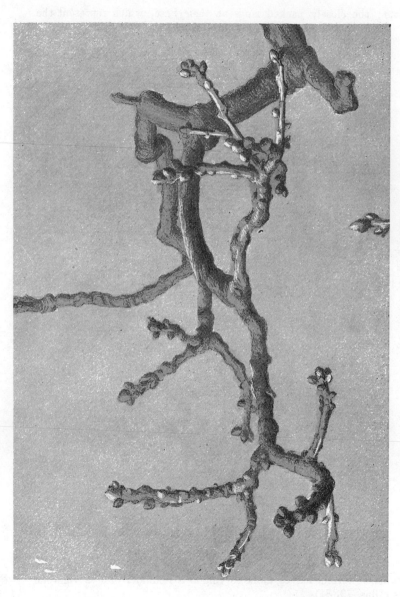

ILLUS. 80. BRANCH OF OAK—BUDS IN FIVE ROWS CLUSTERED AT THE TIP OF SHOOT

Compare this with drawing of Elm

(b) *Buds on three sides of the shoot.*—The ramification that follows this plan does not show the simplicity of lines observable in No. 1 arrangement, where the boughs are formed in decussate pairs.

Nor are the flat layers of branches of No. 2 arrangement to be found. The boughs are more evenly distributed without much interlacing or confusion. Trees

Fig. 138

Fig. 139

Fig. 140

of this group rely more upon the difference of angle between bough and stem for their identification than do some other groups.

Buds on five or more sides of a shoot.—The want of order, rather than its observance, becomes the feature to look for here. The branch-anatomy becomes too intricate for any close application of botanical facts, though often in young

Fig. 141 Fig 142

trees they are easily discernible (Illus. 80, 81).

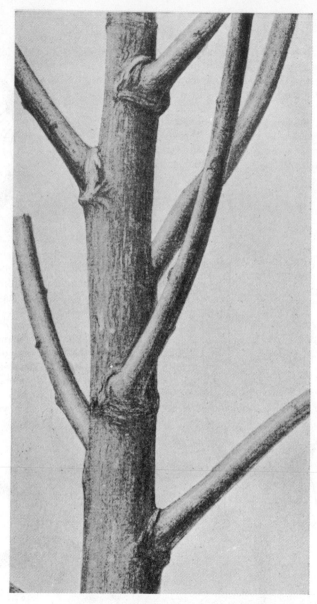

ILLUS. 81. BLACK POPLAR.—TO EXPLAIN FROM WHAT
POINTS ON THE STEM THE BRANCHES SPRING

(See Buds, Chap. XII. Illus. 71)

Buds clustered in groups.—Where the buds are clustered in groups at certain points on the stem, with long intervals between, the branches to which they give rise appear to radiate from each of these points like the spokes of an umbrella from the shaft. On the subsequent branches this comparison does not hold good ; for to prevent crowding, and to obtain light and air, the twigs take a more or less horizontal position. Therefore on a horizontal bough the twigs forming on the under side curve upwards, while those on the upper side grow outwards to avoid confusion with the boughs above.

Additional buds.—The aspect of certain trees is nearly as much altered by the presence of additional buds as it may be by the habitual loss of others. The old wood of the Pines is not capable of bearing buds below those already formed,

Fig. 143

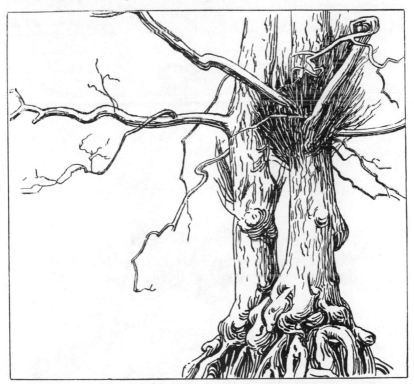

ILLUS. 82. ADVENTITIOUS TWIGS ON THE BOLE OF AN ALDER

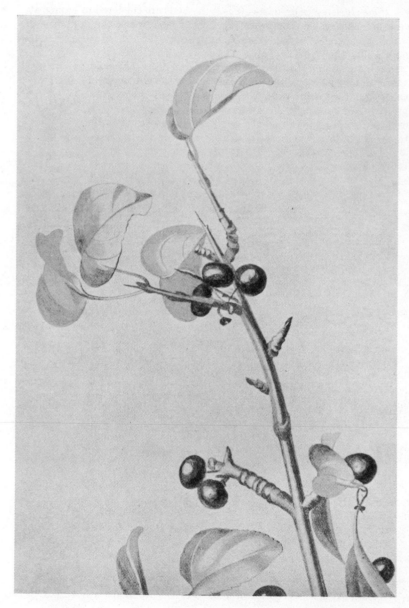

ILLUS. 83. EXAMPLE OF SPINES (ARRESTED TWIGS) FORMED INSTEAD OF TWIGS—BUCKTHORN

and the loss of a bough cannot be replaced by new branches, but this is rather the exception. Many trees when lopped, notably the Willows and the Elms, are capable of putting out quite a crop of new shoots ; and the suckers from the roots of the Poplars and the Elms, and the adventitious shoots on the Alder and the Holly, contribute largely to their characteristic appearance, since their upward direction comes in direct contrast to the older forms. A fallen Holly, where the roots have not been severed, often shows a row of new vertical shoots springing from the old trunk; and our pollard Willows, Copses, and Osier beds have a charm specially their own, and show how this power has been

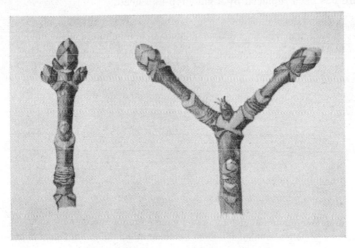

ILLUS. 84. TWIGS OF SYCAMORE

Compare the two figures in this drawing and also Illus. 47

utilised in the case of the Beech, Chestnut, Alder, and some other trees.

Twigs arrested in growth.—A somewhat similar effect is produced upon trees belonging by their normal bud-arrangement to other classes, and is shown in the spurs and short stumpy shoots common on the Hawthorn, Sloe, Crab-Apple, Buckthorn. On these trees are found the two extremes, very long shoots bearing many scattered buds, and short dwarf shoots reduced to sharp spurs bearing tufts of buds. This is also to be seen in the case of the Pines and the Larch.

Differences in the branch-system of old and young trees.—The habit of branching shown by a young tree becomes considerably altered

in middle life or old age. This is partly explained by the fact that some species attain a fair height before bearing fruit, their energies being entirely expended on making long shoots. In greater age the rule is reversed ; short, much-branched twigs, arrested at each point where fruitage occurs, take the place of the long shoots and subsequent branches. An example will be found in the number of short, forked twigs which terminate the boughs of an old Sycamore (Illus. 84). Trees on attaining their full height continue to expand laterally, instead of in an upward direction, while their lower boughs decay. We have already given a comparison of a young Scots Pine with an old tree where a tall spire has been replaced by a flat mop-like head.

CHAPTER XIV

HOW A TREE IS BUILT UP

The leader.—We have seen that there are certain definite arrangements of buds on the stem of a young tree, and that its upward growth is continued either (1) from the bud at its tip, or (2) from one of the side buds, or (3) from two side buds, or (4) from one or two of the lower side buds.

(1) If the stem is continued each year from the tip of the previous year's formation, it may be likened to a telescope drawn out section by section (Fig. 144).

(2) If, however, the stem is continued from one of the side buds, the straightness of its line is interrupted each season in one of the following ways. (*a*) If the shoot that is to pose as the true "leader" springs in successive seasons from the same side, a series of curves repeating one another breaks the continuity of the stem (Fig. 145). (*b*) If, however, the pseudo-"leader" is formed year by year from right and left of the stem, a line of alternate curves or breaks is produced (Fig. 146). More often the stem is continued for a year or so from one side and then from another, giving us infinite variety in its curves.

Fig. 144

Fig. 145 Fig. 146

(3) It is the habit of some species to continue the stem by shoots from the two side buds instead of from the terminal bud; in other words, the stem forks and two main limbs take its place, and they in turn fork until they ramify into branchlets and twigs (Fig. 147).

Fig. 147 Fig. 148

In more rare instances only those buds at the base of the shoot grow, and the whole of the shoot above them dies (Fig. 148). The Guelder-Rose is the most noteworthy example of this habit. If this method is

repeated each season, it is obvious that the dimension of a bush will hardly be extended ; but it is not to be understood that every shoot dies back to the base ; many of them are continued by the upper side buds (Illus. 85).

The stem—thus formed on one of the above plans—each season produces a set of side buds on the new

portion. These buds become branches which grow in the following year, and repeat with their branches the system followed by the stem, which again, in turn, is repeated by the branchlets and the twigs they produce. The stem itself increases yearly in girth and in length between the points where branches are given out, and a similar addition in length and thickness occurs on the branches and newer formed growths (Fig. 149).

The annually formed junctions and curves in the stem just described become softened and less abrupt with each year's increase in girth ; and in those cases where it

Fig. 149

forks, one limb of the fork generally predominates so that its neighbour appears to be only a side bough (Fig. 150). Additional notes of difference between the species will be found in the various angles formed between bough and stem, and in the lines which the branches and twigs take in reaching the extent of their growth ; also in the form of the outline itself (Fig. 151).

Fig. 150 Fig. 151

Angles between stem and bough.—The

Fig. 152

angles formed between the larger and the lesser parts of the tree-structure vary from the right angle found in an Oak to the acute one of a Birch (Fig. 152). The predominant angle, as a rule, is more obvious in the space left between the twigs than in that between the trunk and boughs. In the latter case the sharpness of the angle becomes lost by a yearly addition to the girth of the limbs and trunk, and a sort

Fig. 153 Fig. 154

of bracket between the two is formed (Fig. 153). In some species the
smaller forms are joined to the larger by a gentle curve—Ex. : Holly

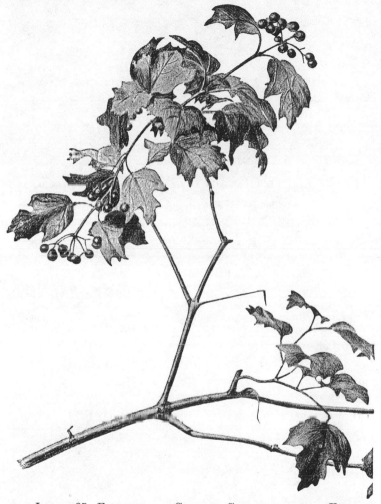

ILLUS. 85. EXAMPLE OF GROWTH CONTINUED BY A FEW
OF THE BUDS—GUELDER-ROSE

(Fig. 153). In other species the junction is formed by nearly straight
lines (Fig. 154).

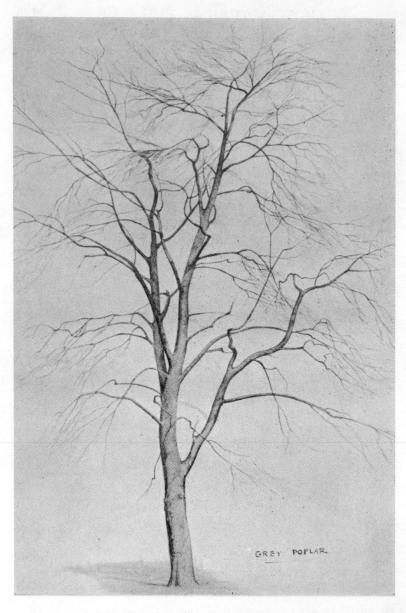

ILLUS. 86. THE GREY POPLAR

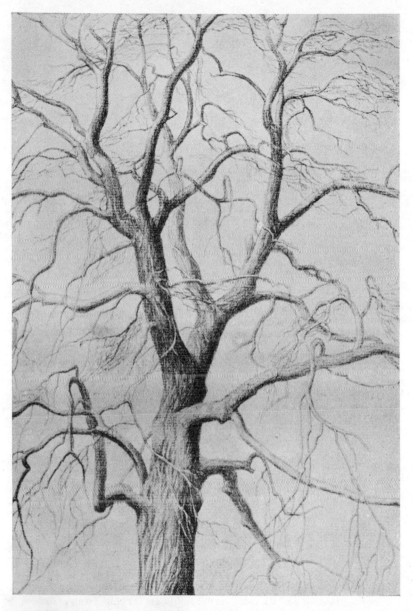

ILLUS. 87. THE BOUGHS OF AN OLD SPANISH CHESTNUT

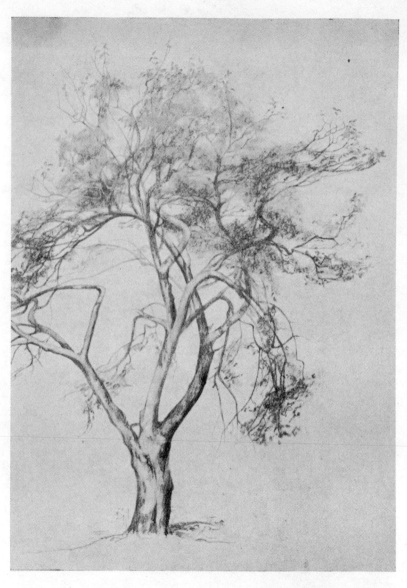

ILLUS. 88. BRANCH SYSTEM OF AN APPLE TREE

The proportion of boughs, branches, and twigs.—The gradation in girth from trunk to bough, bough to branch, and branch to twig is carried out by regular stages step by step (Fig. 155). The trunk (if one excepts the bole) is of equal thickness throughout its length until it gives forth a bough. Its next length (diminished in thickness) is again of even width up to the point where the next bough springs. It is noticeable that, if a drawing were made of the portion of the trunk that is above the bough, an increased thickness of the trunk below would have to be added on the side under the bough (Fig. 156). This even gradation from large to small forms gives delicate lines of great charm, and is especially noticeable in the case of the Goat Willow, the Birch, and the Ash, though the rule is found in all trees. The trunks of some conifers (especially those of the Spruce and Larch) appear at first sight not to observe the rule ; they

Fig. 155

Fig. 156

seem to taper from the base upwards, instead of being reduced in girth stage by stage, after the fashion of a telescope (Fig. 157). This tapering appearance is partly due to the lack of branches (that in other trees would accentuate the successive reductions in the thickness (Fig. 158)), and partly to the shortness of the lengths of trunk between the scars that mark the position of former branches, so that the stages by which the trunk was diminished are hardly apparent (Fig. 159).

Fig. 157 Fig. 158

Fig. 159

It may be stated on a rough calculation that, when a trunk divides, the limbs of the fork measure together rather more in diameter than the trunk below the division (Fig. 160). If the main limbs of a tree are conspicuous, and the boughs suddenly ramify into a great number of twigs, the whole effect will be vastly different from that of a tree where the twigs are fewer in number ; as in the latter case the succession from the large to the smallest part is is more gradual (Fig. 161). A comparison of the anatomy of an Elm and an Ash will show the importance of this observation.

Fig. 160 Fig. 161

The position taken by twigs.—The rigidity or flexibility of twigs accounts for some variations in the position of future boughs. One sees

the supple shoot of a Scots Pine bent with the weight of the cones ; also the shoots of a Birch unable to hold themselves upright under their slight burden of catkin-fruited twigs (Illus. 90). From the upper side of such pendent branchlets new buds give life to sturdy twigs, which, in turn,

Fig. 162.—Hanging Bough of Pear

bend down and add new leverage to the parent branchlet. In this way a succession of curved steps, as it were, are formed, leading the branch outward curve by curve. This becomes a more noteworthy feature as time goes on ; for the few branchlets that were formed on the inner side of the pendent branch die away for want of light. On the other hand, the rigid shoots of an Oak or an Ash can hold themselves in a position

ILLUS. 89. EXAMPLE OF GRADATION FROM LARGE TO SMALL BRANCHES
(BAY-LEAVED WILLOW)

ILLUS. 90. TWIGS OF BIRCH WEIGHED DOWN BY CATKINS

ILLUS. 91. PENDENT BRANCH OF APPLE TREE IN FLOWER

unattainable by the supple twigs of the former trees. It is not implied that pendent branches formed in the manner described are only to be found on trees with flexible twigs ; for the lower boughs of Pear trees are commonly constructed on this plan ; though here it may also be conjectured that the unusual weight of the fruitage may be in part responsible for the position.

PART III
DETAILS

CHAPTER XV

EVERYTHING that fosters admiration for the objects we paint should be exploited. Our natural delight in the exquisite forms of buds, flowers, twigs, and leaves should not be checked by looking upon them as details with which we have no concern ; rather we should look upon them as the delightful ornaments that deck our idol with a new fascination for each passing season (Illus. 92). Every year we find new cause for happiness in the growing buds, unfolding leaves, and the shaping of blossom. We add to our pleasure in these things by tracing their development. We cannot but wonder at the manifestation of the perfect mechanism that enables a small bud to contain during the winter a complete set of leaves, stem and flowers, and to unpack them in regular order at the coming of Spring.[1] Then we watch the unfolding of layers of crumpled up leaves as they emerge from the bud, each still nursed by a protecting stipule ; and see them take an unwonted position to protect themselves from cold or when they sleep (Illus. 93). We note their change in colour and texture, month by month, until the fall, when the delicate greys and daintiness of form of the bare twigs seems even more satisfactory than the full richness of summer.

The understanding of how a tree grows from a seed will not help us to paint trees any better ; but we may gain by it an added interest to counteract some dry details of construction that are of importance to us in our art. For instance, the Sycamore has its seed encased in two round balls linked together at the base by a pair of wings. This winged fruit, when ripe, comes spinning through the air, and lands some distance from the tree. The radicle (little root) appears, and soon pushes its way into the ground, and the seed case is lifted into the air by the growing stem. In it are the pair of seed-leaves, lying face to face and rolled up in a ball. Soon they push the husk off and unroll themselves, until presently they are spread apart like bands of narrow green pointed riband in the shape of a V. Next, the first pair of real leaves appear between them ; but these only show the rudiments of the lobes so characteristic of the

[1] " We apply the word ' bud ' to an assemblage of undeveloped leaves, placed on a short axis about to develop itself into a branch." This concise and pleasing definition is taken from Wilson's translation of botany by Jussieu.

perfect leaves. The next pair of leaves resemble the mature ones more closely, and it should be noted that the pairs of leaves are set at right angles to one another. It is a remarkable thing that in this little tree, a few inches only in height and a week or two old, the chief character of the whole tree should have already asserted itself (as shown

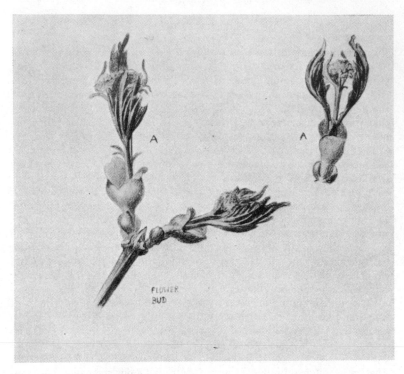

ILLUS. 92. OPENING FLOWER BUDS OF GUELDER-ROSE

Observe the exquisite precision of each part set at right angles with its neighbour, and the decorative shapes

in branches and leaves being arranged in pairs, each pair at right angles to the next).

In other trees besides Sycamores the leaf buds afford a wonderful example of the ingenuity displayed by nature in all her arrangements. There is pleasure in noting the many different ways in which leaves are packed in the bud, so as to conform to its rounded shape and yet to

take up the least possible space. Some are rolled up like a spill, others folded like a fan, others folded in half; every possible device seems to have been made use of, not only in the folding up of individual leaves, but in the precise order in which the layers of them are packed together (see Chap. XVII., Figs. 175–182). The methods of protection of these young leaves during the winter are equally diverse; some are packed in wool, others varnished with a gum, or are protected by

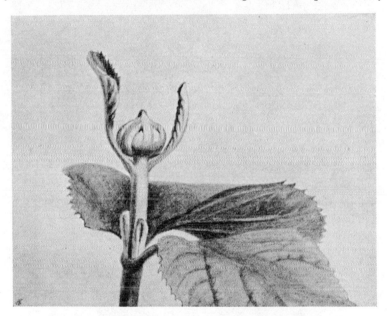

ILLUS. 93. WAYFARING TREE

The unpacking of leaves at the coming of Spring

stipules that fall off as soon as their mission has been brought to conclusion (Illus. 94, 95); but the care exercised over some buds begins in the summer, when they lie snugly hid at the base of the leaf-stalks.

Many beautiful effects and forms are provided by the means of dispersion that is given to seeds. The winged forms of the Hornbeam, Maple, Ash, Sycamore, and Lime are in themselves beautiful, and are interesting as showing means of conveyance by the wind.

The down and tufts of hairs to which fruits of some Willows are attached give the trees an uncommon and interesting appearance at the

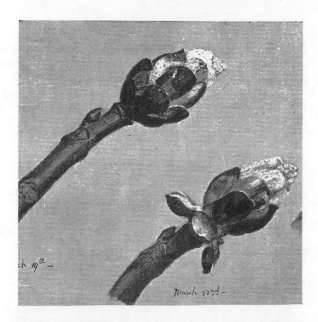

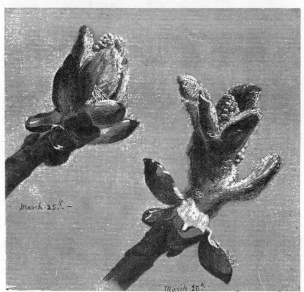

ILLUS. 94 AND 95. THE PROTECTION OF HORSE CHESTNUT
BUDS BY VARNISHED SCALES AND LINING OF WOOL

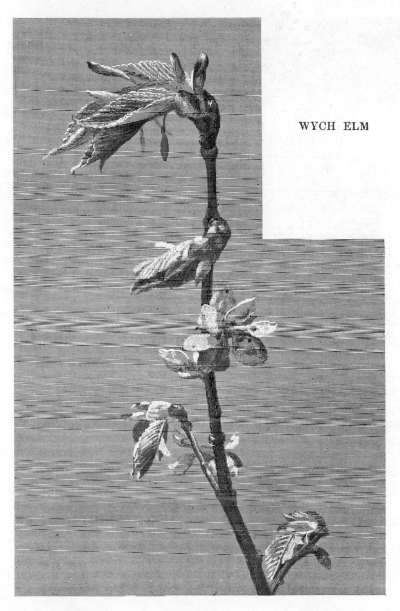

WYCH ELM

ILLUS. 96. YOUNG LEAVES AND FRUIT OF THE WYCH ELM

Notice how the buds turn downwards, and the folding of the leaves

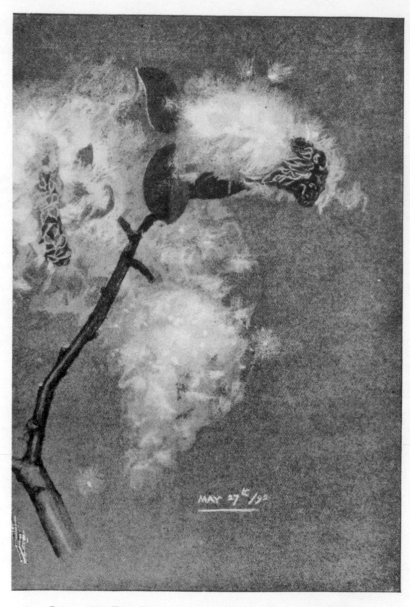

ILLUS. 97. THE DOWN THAT COVERS ONE OF THE LESSER
WILLOWS WHEN THE SEEDS ARE LIBERATED.

time they ripen (Illus. 97). The flowers or fruits on all trees are conspicuous at some time of the year ; and our pleasure in them need not be confined to the most outstanding, such as the delicate Apple or Larch blossom, or the gay Cherry, Hawthorn, or Horse Chestnut. There are others less shapely in themselves, yet capable of changing the whole appearance of the tree. This the catkins of many trees do, particularly those on the Hornbeam, Spanish Chestnut, and Alder ; the Hazel or Birch without their " lambs' tails " would have lost something of their power to charm. We see dark Hollies changed to white by the profusion of the blossom, the Scots Pines dusted with yellow pollen, Rowan trees and Hawthorns painted scarlet and crimson with their fruit, Ash trees tufted with bloom—as Gilpin puts it, " in such profusion as to thicken and enrich the spray exceedingly, even to the fulness almost of foliage " [1] —we could continue the list till hardly a tree was excepted.

What a mass of material in the shapes of tree-flowers and leaves lies to hand for the decorator ! In the blossom of the Holly alone are found four distinct shapes of geometrical precision (Chap. XIX., Figs. 269, 270). One is apt to look at a leaf, and notice that it is long and narrow, or short and rounded ; but one forgets to ask oneself why it is given that shape, and yet a little inquiry shows that the shape of the leaf coincides with its method of attachment to the twig. We owe much to the men who have made the common facts of life interesting to us, and to none more in this connection than Lord Avebury,[2] who in such books as *Buds and Stipules ; Leaves, Flower, and Fruits* brings home to us the perfect construction of nature, even in her smallest formations. Buds are not mere lifeless cases containing young leaves. Not only do they lengthen and become fuller, as we should expect, with the young growth within them, but they move—some curve towards the twigs, others away from it, others turn upwards and downwards. Some are constructed of dry scales that wither and fall off as the leaves emerge, others are made up of stipules that lengthen with the leaves ; those of the Sycamore and Norway Maple attain a considerable size ; the latter take a rich scarlet colour when exposed. Cones are interesting from the exactness of their construction, and if we follow the spirals of imbricated scales we find that the cones of all the Pines are not alike in those spiral arrangements. Nature in every detail displays variations of a great plan that is in itself different from other plans. In the words of Ruskin, " they seem perpetually to tempt our watchfulness and take delight in outstripping our wonder."

Gilpin's *Forest Scenery*, 1808.
[2] Better known from his writings as Sir John Lubbock.

CHAPTER XVI

LEAVES—THE WAY LEAVES ARE SET ON THE TWIGS : (a) RIGHT-ANGLED
PAIRS ; (b) ARRANGED SINGLY IN TWO ROWS ; (c) IN MORE THAN
TWO ROWS ; (d) LEAVES CLUSTERED—THE POSITION OF YOUNG
AND OLD LEAVES—LEAF-STALKS AND HOW LEAVES ARE SET ON
THE TWIGS—DURATION OF LEAVES

To enable leaves to perform their function of assimilation, it is neces-
sary that each should be placed so that its surface is exposed to
the light and air. This is effected by methods that are quite
distinct. Certain species may conform to one system, other species
may be governed by a different system ; but individual trees habitu-
ally conform to the method that governs their species, subject to some
modifications that we shall explain presently. The greatest amount
of light would fall on a leaf lying in a horizontal position or nearly
so (Illus. 98). This is actually the position of leaves on the majority
of trees, though different methods of attaining this position are em-
ployed. We are acquainted with the various ways in which buds are
arranged on the shoots, and the set of the leaves coincides with them.
The reason for this is that the buds (destined in the following year
to produce new shoots) are formed in the angle between the leaf-stalk
and the twig.

(a) *Right-angled pairs*.—To take first those trees with pairs of buds
set at right angles to one another—the Ash, Horse Chestnut, Sycamore,
Maple, Guelder-Rose, Spindle, Dogwood, Wayfaring
tree, and Privet—it is merely necessary to substitute
leaves for buds, when the arrangements already de-
scribed will answer for those of the leaves also. We
have this plan which depicts an upright shoot seen
from its tip (Fig. 163).

A A—1st and 3rd pair of leaves.

B B—2nd and 4th pair of leaves.

SH—Shoot to which the leaf-stalks are attached.

Fig. 163

If the alternate pairs of leaves (viz. A A, B B)
were exactly under one another, they would not receive the full
amount of light and air ; the stalks of the lower, therefore, are suc-

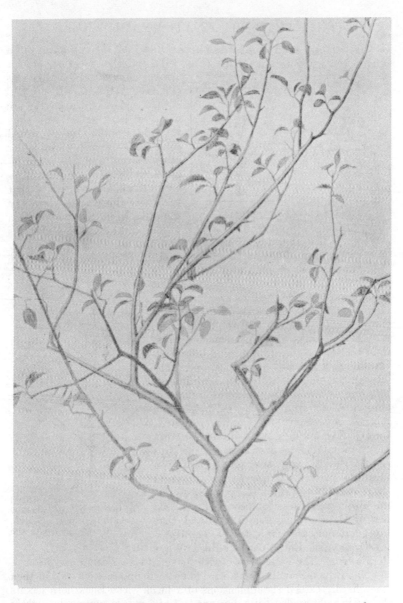

ILLUS. 98. A BOUGH OF AN APPLE TREE SHOWING THE MORE
OR LESS HORIZONTAL POSITION OF THE LEAVES

cessively longer than those of the upper, and then the appearance of a shoot seen from its tip is this (Fig. 164), and the side view of this arrangement would look like this (Fig. 165).

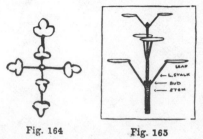

Fig. 164 Fig. 165

The shoots on these trees are more or less vertical; if they were horizontal, leaves would come directly and close under other leaves, and the arrangement would no longer be effective. It will also be noticed that there are long spaces on the shoot between the points from which each pair of leaf-stalks spring, so that the rays of light play on the lower leaves, and they are not in the shade of those above them (Fig. 166). The Horse Chestnut is conspicuous from carrying the lower boughs in a drooping position, but the branchlets and tips recurve upwards. In this way the leaves are still set on a nearly vertical shoot. On the other hand, the Ash also has many pendent branches, and the leaves are often carried on a horizontal shoot instead of a vertical one. The reason for this probably lies in difference of construction of the leaf; the leaflets of the Horse Chestnut are heavy, larger, and entire; Ash leaves are lighter, narrower, and broken up into small leaflets, so that the light is able to pass between the gaps in the leaves, and the same precaution against shading is unnecessary. It should be remarked that three of the trees of this group have leaves composed of leaflets, i.e. Horse Chestnut, Ash, Elder, and that five of them carry large leaves, i.e. Horse Chestnut, Ash, Elder, Guelder-Rose, Way-

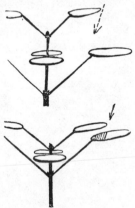

Fig. 166.—In the upper diagram the widely-spaced leaves avoid the shadow seen in the lower diagram. The arrow represents the light

faring tree. The Field Maple, with its small leaves, is an exception.

The Privet, Spindle, and Cornel have small opposite leaves, but then they hardly exceed the dimensions of a bush. The Buckthorn has its leaves in right-angled pairs, but one leaf of a pair is commonly slightly lower than the other.

We have pointed out the necessity for right-angled pairs of leaves

to be carried on a (nearly) verical shoot ; but the lower branches of these trees are arranged at some angle with the stem that varies from 90° to 45°. So if the branchlets, to which they give rise, followed the system that governs the tree (*i.e.* pairs of branches set at right angles to one another , only one branchlet out of every alternate pair would be pointing upwards, and its fellow would be actually pointing downwards ; the rest would be in the same plane as the branch itself (Fig. 167). This difficulty is in some cases overcome (to take a Field Maple as an example) by these nearly horizontal branches carrying a number of very short branchlets all pointing upwards—a position attained by those which are on the under side of the branch curving round it till they become vertical. Another obvious advantage of the shortened shoots is that they do not become cramped by the branches above them, but allow the leaves they carry to obtain their share of the light. Occasionally,

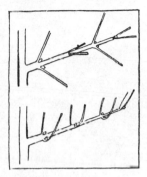

Fig. 167.—The way in which a difficulty is overcome

however, this manœuvre is unsuitable, and a totally different one (which we illustrate) is enacted. The twig remains horizontal, but the leaf-stalks twist until they have arranged the leaves in a flat layer, after the fashion of Beech leaves (Fig. 168). In our illustration leaf B has moved across the twig as no vacant space existed on its proper side. Fig. 169 shows the normal arrangement of Maple leaves on a vertical twig.

(*b*) *Leaves arranged singly in two rows.*—Taking, next, the trees with alternate leaves set singly in two rows, we find a totally different arrangement. The twigs form flat, more or less horizontal, layers ; and in the case of the lowest boughs they droop. The leaves are arranged all in one plane with these twigs, as if they had been pressed under a weight (Fig. 170). This is conspicuously the case with the Beech and the Hornbeam (Fig. 171, Illus. 99), and hardly less so with the Hazel and the Lime. It also occurs on vigorous young shoots of the Elm when it is young ; but it is less noticeable on the shorter twigs that are formed when the tree is older. It will be seen that the leaves of this group have short stalks, and are rounded or egg-shaped in form ; also that the nodes on the shoot from which they rise are set near together—in fact, just near enough to allow each leaf to be next its neighbour without overlapping, but with no wasted space between. Elm leaves are borne on a nearly straight shoot, Beech leaves on one

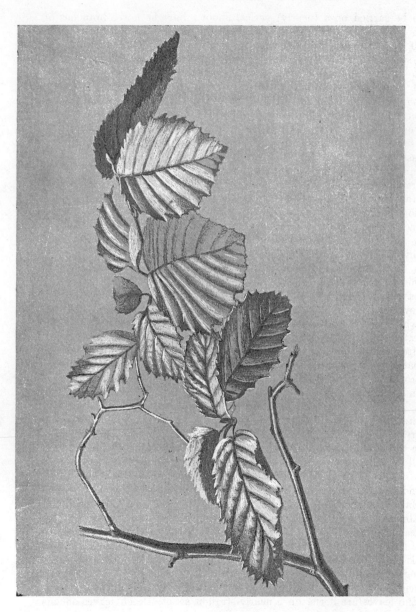

ILLUS. 99. FOLIAGE OF HORNBEAM, SHOWING HOW EACH LEAF IS EXPOSED TO THE LIGHT

that zigzags from one side to the other. Consequently, an economy of space is effected by the stalks of the Beech leaves being set obliquely and those of the Elm leaves at nearly a right angle with the shoot. The upper shoots of these trees, on the other hand, are often upright ; and the leaves, accommodating themselves to the position, are commonly set with the blade at right angles with the shoot (so as to remain horizontal). Though the leaves of the Sweet Chestnut,

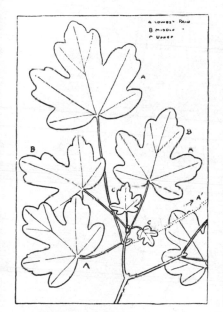

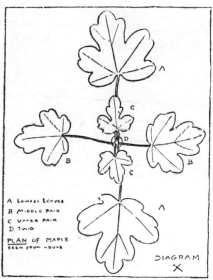

Fig. 168 Fig. 169

Birch (Illus. 101), and Yew (Illus. 24, p. 75) are arranged on quite another plan; they sometimes form flat layers (in one plane) on the horizontal twigs.

The chief point to remember about this group (b) is that the leaves and twigs all lie in one plane, while group (a) was distinguished by the blades of the leaf being set at right angles to the twig.

(c) *Scattered leaves arranged in more than two rows.*—A diagram plan of leaf-stalks, when they are arranged singly, but in more than two rows on the shoot, would represent the spokes of a wheel (Fig. 172)— the number of spokes corresponding with a set of leaf-stalks, counted spirally in succession until one is found springing from the same side

of the shoot as the first one counted (*i.e.* on an imaginary line directly above the first one). In these cases the leaves do not lie in the same

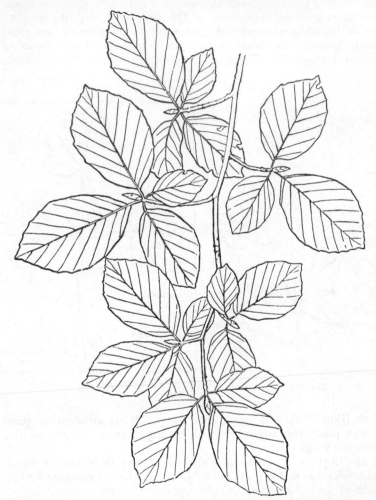

Fig. 170.—The way in which Beech leaves are spaced

plane with the twig (as happens when the leaves are in two rows). They generally are borne on twigs tending upwards (Illus. 89), the blade of the leaf lying more or less at right angles with the axis of the twig,

and the leaf-stalk set at less than a right angle with the twig, so that

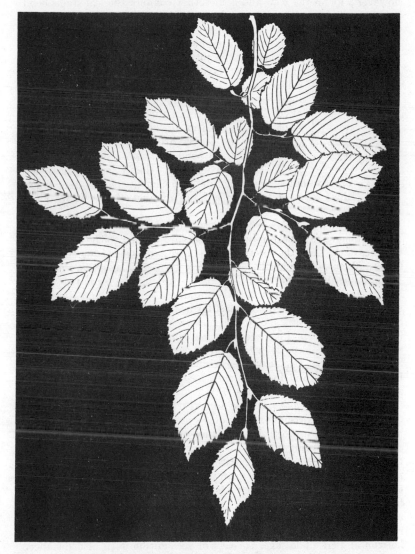

Fig. 171.—Example of economy of space—leaves of Hornbeam

the leaf is pointing in the direction of the apex of the twig rather than

lying horizontally (Illus. 100). This plan is not consistently followed, however ; for in the Yew and some other conifers the leaf-stalks bend round the twigs (when they are lying horizontally), and so the leaves are in one plane with the twig.[1] The difference between an upright shoot of Yew—with its single scattered leaves jutting out in several directions— and these flat layers of leafage on the same tree is conspicuous. The leaves of the Birch and Alder form three rows down the stalk, though the leaves of the former sometimes appear to be in pairs. The Poplar, Ash, and Apple form five rows. On some of these trees the leaves droop, either from a curved leaf-stalk or from pendent twigs. The Willows, the Birch (Illus. 101), and the Cherry (Illus. 58, p. 142), are examples ; and a more conspicuous one is the Black Poplar (Illus. 25, p. 77), where a large number of the leaves hang vertically.

Fig. 172

(d) *Leaves clustered.*—When the leaves are borne so close together on the shoot as to appear in tufts, rosettes are formed. The star-shaped bunches of the Oak, the rosettes on the arrested twigs of the Hawthorn (Illus. 70, p. 167), and the shuttlecock form of the Scots Pine and Larch (Illus. 104) are easy to recognise. It should be noted that single leaves, spaced clearly apart, are also produced on Larch and Hawthorn shoots, and that the spiral lines formed by the leaf bases on the Spruce are characteristic of it and of members of the Pine tribe. The leaves of the Scots Pine are sheathed at the base, two leaves to a sheath (Illus. 141, p. 287). The Austrian and Stone Pines, like the Scots Pine, have two leaves in a sheath ; some other Pines have bundles of three and five to a sheath. The Firs, on the other hand, all carry the leaves singly (Illus. 73).

The position of young and old leaves.—Young leaves, after breaking out from the bud, assume a temporary position that is not retained in maturity. This is worth noting, since the general appearance of the same trees in Spring-time and Summer is so at variance ; and much that gives the key-note to the season is due to this small fact about the position of the leaves. As an example, bring to mind a Horse Chestnut tree in Spring, with its stout shoots draped in young leaves that hang limp and nerveless after the fashion of a damp half-closed umbrella (Illus. 159, p. 309), and then recall it in Summer with radiating leaves that stretch out from the shoots and form the horizontal tiers of leafage, so easy of recognition even at a distance. Again, those quaint white leaves stiffly upright (whether on upturned

[1] See illustrations of leaves, Illus. 24, 25, 26, Chap. IV, pp. 75, 76, 77.

ILLUS. 100. LEAVES ON AN UPRIGHT SHOOT OF A THORN TREE
(See also drawing of the rosettes of leaves on arrested twigs, Chap. XII, Illus. 70.)

ILLUS. 101. BIRCH LEAVES

ILLUS. 102. THE VERTICAL LEAF ARRANGEMENT OF THE
GREY POPLAR

ILLUS. 103. LEAF ARRANGEMENT OF THE OAK

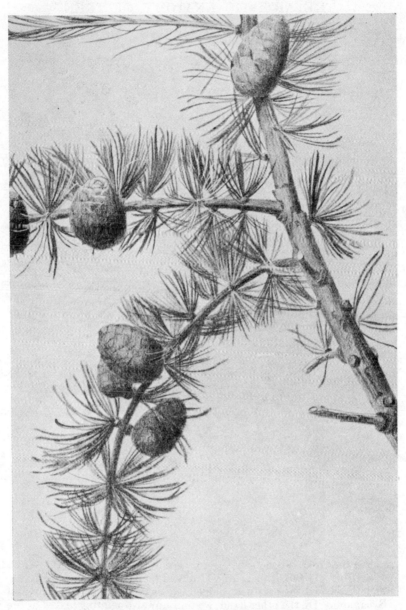

ILLUS. 104. THE TUFTED (SHUTTLECOCK) FORM OF LEAVES ON
THE LARCH

or horizontal twigs) mark the Whitebeam in the copse, by their shape and the exposure of the white under sides, that in their Summer pose are inconspicuous unless ruffled by the wind (Illus. 107). E amples of

Fig. 173.—Oak

voung leaves that droop during expansion are afforded by the Wych Elm (Illus.96, 106), Lime, Maple (Illus. 112, p. 232), Beech, Hornbeam, and Hazel, and the partly developed leaves of the Horse Chestnut and Sycamore. On the other hand, we find upward-pointing leaves in the

ILLUS. 105. MATURE LEAVES OF ENGLISH ELM

ILLUS. 106. LIMP YOUNG LEAVES OF WYCH ELM

Ash, Whitebeam (Illus. 107), Holly, Wayfaring tree (Illus. 93, p. 203), the Guelder-Rose (Illus. 92, p. 202), Oak (Illus. 111, p. 231).

Leaf-stalks and how leaves are set on the twigs.—The way a leaf is attached to the twig is worth consideration. We find an Oak leaf, some four or five inches long, attached by a petiole one-eighth of an inch or less in length ; and an Aspen borne by a petiole longer than the leaf itself. To take less extreme cases, we have the Poplars, Lime, Pear, Buckthorn, Birch, Sycamore, Maple, Guelder-Rose, Horse Chestnut, Crab Apple, with proportionately long stalks ; while the Oak, Holly, Privet,[1] Wayfaring tree, Hornbeam, Beech, Hazel, Sweet Chestnut, some Willows, Whitebeam, and Elm have proportionately short ones. The Larch and the Conifers, since their leaves take the form of a more or less thickened leaf-stalk, need not be considered. The flexibility or rigidity of the stalk often accounts for the lie of the leaves. Some arch with the weight of the leaf, such as the Sweet Chestnut, Wild Cherry, and many others ; they may even hang, in their limpness, as do[2] some of the Poplar leaves. The contrast to these are the Horse Chestnut, Sycamore, Maple, Beech, Hornbeam, and Hazel, where the leaf is held by a stiffer petiole. The twist on the leaf-stalks of some of the Willows adds to the decorative pattern the leaves make, while the upward curve of a Holly petiole seems in keeping with the branch formation. These matters and the actual shape of the petioles—their round, rectangular, flattened or keeled surface, and their swollen bases where they hide the young buds for next year—may be worth the study of the designer. On most trees the leaves lie in a set position—horizontally or slightly drooping—such as those of the Maple, Horse Chestnut, Beech, and Hornbeam.

Fig. 174.—Holly

This is also the case with the Ash, Walnut, Hazel, Elm, and Spanish Chestnut, except that in these they incline upwards on the young

[1] See " Leaf Patterns," Chap. XVII.
[2] See illustrations, Chap. IV, p. 75 *et seq.*

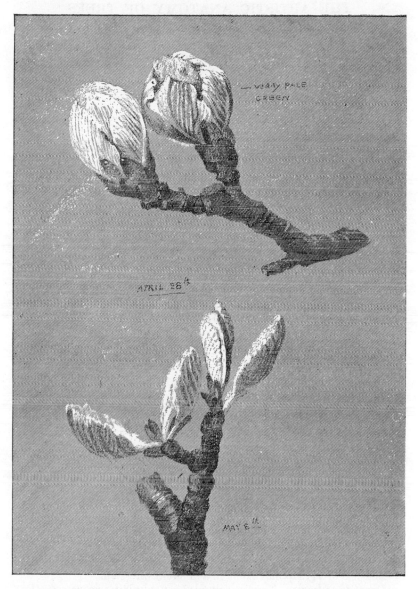

ILLUS. 107. YOUNG LEAVES OF WHITEBEAM STANDING UPRIGHT
THE UPPER TWIG WITH THE FAT BUDS CONTAINS FLOWERS

vertical shoots (Illus. 108). Oak and Holly leaves, and also many others, are set on the twig at rather less than a right angle, and preserve that position in whatever direction it may take. Larch leaves

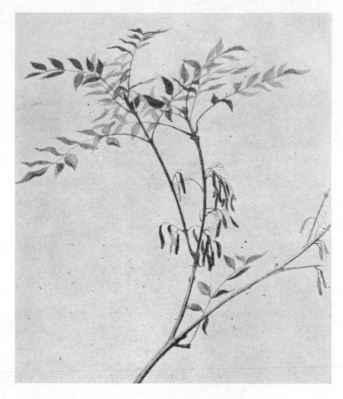

ILLUS. 108.—ASH LEAVES

This branchlet of an Ash shows the normal position suitable for leaves that are arranged in decussate pairs. The plan that is followed by the buds is described Chap. XII, p. 162. The leaves on a pendent branch are drawn, Chap. VI, p. 106.

seem to follow no rule; they point upwards, downwards, and sideways, or each leaf of a group may point in a different direction.

Duration of leaves.—Trees are divided roughly into two classes—(1) Deciduous, (2) Evergreen.

(1) Deciduous trees are those whose leaves fall before new ones are

formed, so that the branches are for a time naked. This is not strictly true of the Oak and Beech, as they occasionally retain the brown shrivelled leaves during the winter.

(2) Evergreen trees are those which retain their leaves until new ones have been matured—as in the Holly, where the leaves of one season remain till the next. Some of the Pines retain their leaves for several years, and on one species—the monkey puzzle (*araucaria imbricata*)—they are persistent for about twelve to fifteen years.

CHAPTER XVII

FORMS OF YOUNG LEAVES—TEXTURE OF LEAVES—THEIR COLOUR—LEAF
PATTERNS—THE MARGIN—THE VEINS—THE PLANES OF A LEAF

Forms of young leaves.—As might be expected, the method by which
leaves are folded up while in the bud is discernible for a long time

after expansion. Thus in Spring-time we
see quite large leaves of the Cherry still
folded in half (Illus. 109). Other examples
of leaves that in the bud are folded in
half from the central rib after the fashion
of a sheet of writing paper are afforded

Fig. 175 Fig. 176 Fig. 177

Three methods by which leaves
folded in half are packed in
the bud

by those of the Ash, Hazel, and Lime;
others are folded like a fan (Fig. 178),
such as the Maple (Illus. 116), Syca-
more (Illus. 156), Hornbeam, Beech,

Birch, and Wayfaring tree. Some leaves are neither
folded nor crumpled up, but are curved to fit the
dome of the bud (Fig. 179), *i.e.* those of the Pine,
Fir (Illus. 73), Larch, Yew, Holly, Privet, and Spindle.
Others, again, have the two halves of the leaf-blade
rolled up from the outer margin inwards towards
the central rib, so that each leaf resembles a pair of scrolls of equal

Fig. 178 Fig. 179

size, united by the rib, the outsides
of the scrolls being the back of the
leaf-blade (Fig. 180). This happens
with the Apple, Pear (Illus. 110),
and Poplars. The leaf of the Plane
is also rolled like this; but in its

Fig. 180 Fig. 181 Fig. 182

case the outside of the scrolls is the upper surface of the blade (Fig. 181).

A single scroll (Fig. 182) is formed by leaves of the Buckthorn,
Plum, and some Willows. These are rolled up as a spill might be, from
one margin of the blade only, with the under surface of the leaf outside.

It is quite usual to see large Poplar leaves still in scroll form. The
limpness of young leaves of big build is conspicuous in those trying
to obtain their first horizontal position, such as the Sycamore, Horse
Chestnut, and Plane (Illus. 112).

228

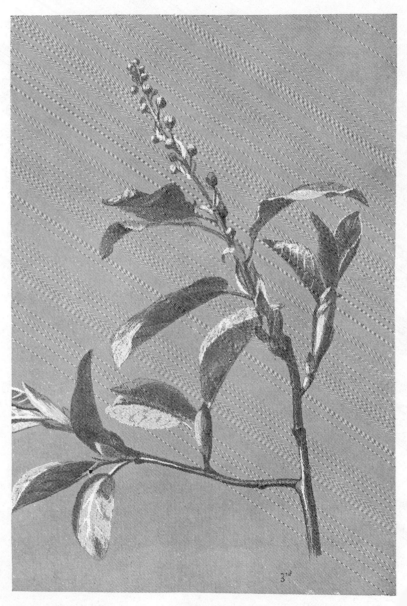

ILLUS. 109, THE LEAVES OF THE BIRD CHERRY REMAIN FOLDED
IN HALF AFTER GAINING THEIR LIBERTY FROM THE BUDS

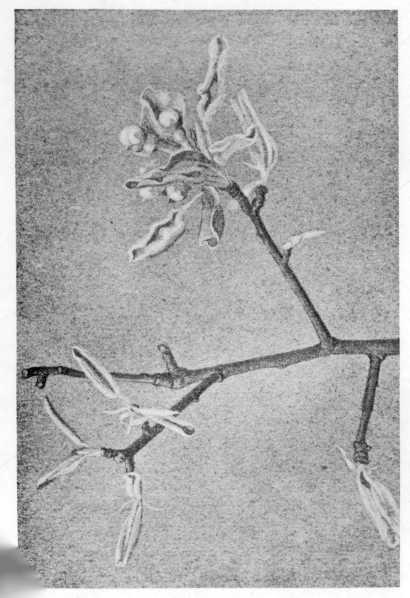

ILLUS. 110. ON A PEAR TREE THE LEAVES ARE PACKED IN SCROLLS WHILE IN THE BUD AND RETAIN THIS SHAPE FOR SOME TIME AFTERWARDS

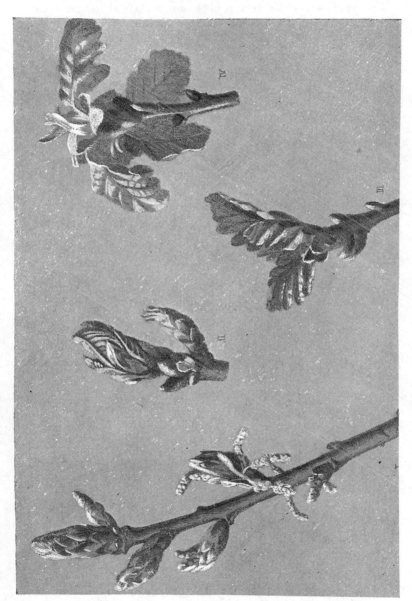

ILLUS. 111. OAK LEAVES BREAKING OUT FROM THE BUD

Texture of leaves.—The texture of the leaves plays an important part when the trees are seen close at hand. The transparency of a young

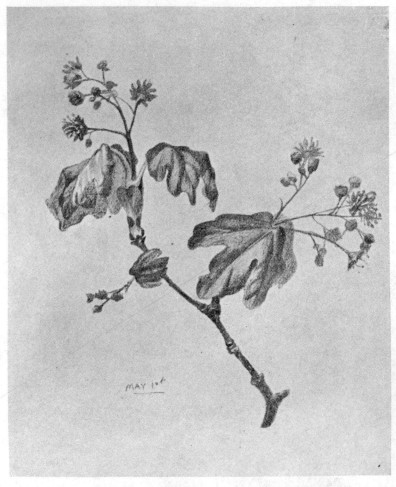

ILLUS. 112. YOUNG LEAVES OF THE FIELD MAPLE

Compare their limp attitude with that of the mature leaves illustrated Chap. XX, Illus. 136

Beech leaf in one position through which the sun shines—so sweet and gay in colour—looks nearly white in another position, from its silky

surface. The glitter from the polished Holly leaves takes many tints in response to the changing sky, to which the gritty surface of an Elm or Hazel leaf is less responsive. The thick leathery texture of the Privet, Box, Holly, and Holm Oak, the furry or downy-coated under sides of the Whitebeam, White Poplar, and Wayfaring tree are all worth observation.

Colour of leaves.—The local colour of leaves seems to defy description, for the hairs on one, the gloss on another, gather so much of the sky colour as to lose the individual colour that might apply to them when seen indoors ; but since the leaves of each species are consistently dull, glossy, granulated, or hairy, they never lose their identity. It must be remembered, however, that in some species young leaves have a gloss that is lost as they mature (example, Sycamore, Beech), and that others start life with a coat of fur and become smooth (example Plane). The light can pass through some leaves when they are young only, as is the case with Holly leaves. It seems superfluous to add that the local colour of leaves is different in spring, summer, and autumn.

Leaf Patterns : (a) *Of conifers.*—Most of the conifers agree in having leaves remarkably narrow for their length. The leaves of the Spruce (Fir tribe) are needle-shaped and angular, those of the Silver Fir and the Yew are flat, while those of the Scots and Austrian Pines have one side convex and the other flat. The species vary between a blunt leaf and one sharply pointed. Yew leaves are curved, Larch leaves are straight. Deciduous trees (with the exception of the Larch) have their leaves in the form of a more or less thin blade, instead of the needle form of the conifers.

Leaf patterns of deciduous trees.—On some deciduous trees the leaf-blade is long and narrow ; conspicuous examples occur in several of the Willows, the Privet, the Almond, and less noticeably in the leaflets of the Ash, Mountain Ash, and some leaves of the Blackthorn and the Spindle. The Cherry and the Sweet Chestnut take a more elliptic form. The chief character of many of the foregoing depends upon whether the base or the tip, or both, tapers or has a more or less blunt ending. Some leaves might almost be enclosed by a circle ; this is seen chiefly in those of the Aspen and often of the Grey Poplar, and in some leaves of Hazel and Lime. A triangle (set with the leaf-stalk joining the centre of its base) would be the guiding form for leaves of several species, *i.e.* the Birch, Black Poplar, Lombardy Poplar, and some leaves of the Maple, Planes, White Poplar, and Hawthorn. Some of the leaves of the Lime and of the Black and Lombardy Poplar bear the shape of a conventional heart. The outline of an egg with the leaf-stalk joining the stoutest end is seen in the Pear, Apple, Goat Willow, Elm, Cornel, Beech, and Buckthorn. The same form—but usually with a more

elongated tip—is found in the Wayfaring tree and the Whitebeam. The egg reversed would describe the leaf of the Wych Elm and the Spindle.

GREY

POPLAR

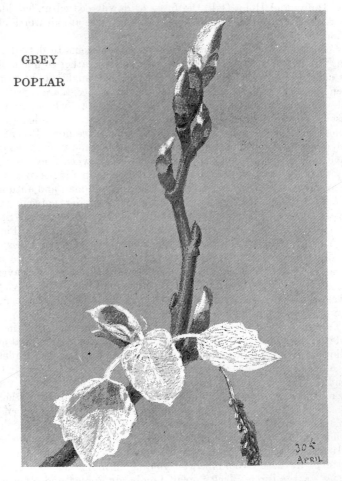

ILLUS. 113. WOOL-COVERED LEAVES OF GREY POPLAR

(See Chap. XVI, Illus. 102, for the position and texture of the mature leaves. For shape of leaf see page 241, (C) of " Leaf Patterns," in this chapter)

though the latter has a sharp tip added. An oval describes the leaflets of the Walnut and the broadest leaves of the Blackthorn. A more

unusual form is found in the leaf which has a blunt tip and tapers to the leaf-stalk like a tennis racket. This form distinguishes the Alder and many leaves of the Alder-Buckthorn. The Hazel leaf has this shape with a short-pointed tip added, and the base often ends in small lobes; the leaves on an individual tree vary so much in form that an oval (or egg form) set either way might equally well describe them. However, the foregoing descriptions, with the leaf plans illustrated before one, should explain the chief difference of the species. (See "Leaf Patterns," Figs. 200–250.)

If a leaf is folded at the midrib, the two halves are usually found to be similar; but in some trees the leaves are lop-sided (Fig. 183), as is seen in the Elm, Lime, and Oak. Some Willow leaves, instead of having the central rib straight from tip to base, have it bowed to one side; consequently the outline of the leaf is convex on one side and concave on the other (Fig. 184).

The Margin.—The outline of a leaf may be smooth and unbroken, as is seen in the Privet, Scots Pine, Yew, Larch, Medlar, Cornel, Box, and others (Fig. 185 (1)).

Fig. 183 Fig. 184

More often, projections are formed, where the secondary ribs (those given off by the central rib) reach the margin. The points on the margin may be very sharp, and the spaces between them deeply fluted like a fish's fin, as in the Sweet Chestnut and in some leaves of the Plane; or less sharp and the fluting shallower—like a fan, as happens in a Beech leaf. In the Grey Poplar and the Aspen, the projections and hollows are sometimes rounded like a cog-wheel, and more often like a toothed wheel. In most leaves the margin is toothed like a saw (Fig. 185 (2)) (the handle of the saw being at the leaf-stalk), as in the Black Poplar, Mountain Ash, Ash, Apple, Alder, some Willows, &c. The teeth themselves may be furnished with small teeth, as are those of the Hornbeam, Birch, Elm, Lime, Horse Chestnut, Hazel, Cherry. The teeth, instead of being set saw-like, may point outwards, as in the Wayfaring tree. The leaf may be deeply scalloped between the secondary ribs, thus forming the characteristic lobes of the Oak (Fig. 185 (5)); or, if the incision reaches the midrib, separate leaflets result, as in the Ash. The incisions may be between several main ribs that radiate from the junction of leaf and stalk (Fig. 186);

Fig. 185.—Six types of the edge of a leaf shown one in front of another.

there is then, as a rule, a terminal point on either side of the main lobe formed as in the Guelder-Rose. The side lobes may give off a pair of basal lobes, as in the Oriental Plane. Again, these lobes at the base may be distinct, as in the Maple and Sycamore. All or some of the lobes may be equally or unequally notched, toothed (Sycamore, Maple), or rounded. This form of leaf, when incised to the leaf-stalk, produces radiating leaflets (example, the Horse Chestnut). The leaves of the Planes and Maples are remarkable for their diversity of form and proportion. The leaves of the Holly usually bristle with spines ; but those at the top of the trees are often smooth-edged. Some Holly trees are composed of entirely smooth-edged leaves ; this is also the case with the Holm Oak. (See Figs. 200-250.)

Veins of the leaf.—The manner in which the blade of a leaf is sectioned by the veins will be sufficiently understood by the diagrams of leaf forms (Figs. 200-210) ; though, in most cases, only the noticeable divisions are there represented. The mid - vein running from the stalk to the tip (or in lobed leaves, such as the Plane and the Sycamore, to the tip of each lobe) is the stoutest,

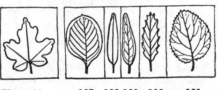

Figs. 186 187 188 189 190 191

and is termed a rib ; the ribs that rise from it are smaller ; while others that rise from the secondary ribs are still less, and give rise in turn to numerous small veins intersecting the space (reticulated leaves) between the ribs. Generally, the ribs are conspicuous as raised cords on the under surface of the leaf and as furrows on the upper surface. In some the midrib only is noticeable (Fir, Privet) (Fig. 188) ; in others the whole network is clear (Goat Willow). Leaves in which the principal ribs start from the base (or from points on the midrib), and tend towards the tip of the leaf, have usually an unnotched margin (Cornel) (Fig. 187). Leaves with a toothed or indented edge have a central main rib, from points along which arise secondary ribs running into each principal tooth (Spanish Chestnut, Chestnut, Beech, Oak, Hornbeam, Alder) (Fig. 190) ; if the leaf-edge is broken up into a number of teeth, the secondary ribs branch, so that many of the teeth are reached by the secondary ribs or others to which they give rise (Wayfaring tree, Lime, Poplar, Elder) (Fig. 191). When leaves are compound, each leaflet follows one of the above plans ; as also happens with each lobe of a deeply sectioned leaf. It should be observed that in many leaves the main rib does not take a straight course from base to tip, but zigzags from side to side

ILLUS. 114. THE BLADE OF AN ALDER LEAF LIES IN ONE PLANE

from each point from which it gives off a secondary rib (example, Beech).

Planes of a leaf.—In many trees the whole leaf blade (if we except the undulations of its surface) lies in one plane, as, for instance, in the Alder (Illus. 114), Beech, Hornbeam (Illus. 99), Wayfaring tree, Whitebeam, and others. Often the blade forms more than one plane (see drawing of Elm leaves, Chap. XVI, Illus. 105) ; it may be because the two halves from the midrib form a wide V—this is usually the case with the Sweet Chestnut, Buckthorn, Goat Willow, and many young leaves. Sometimes the leaf is curved from base to tip or twisted on its axis—noticeably in some Willows. The Holly leaf attracts attention by its many diverse planes with the consequent power of reflecting different lights on the same leaf. The leaf surface itself is drawn into various forms by the ribs. These forms are very diverse, but are characteristic of each species. In some the surface between the ribs is deeply puckered or bulging, in others merely wavy or wrinkled. On suckers (shoots produced from adventitious buds on the roots), and vigorous shoots from pollard stools, the leaves are often abnormal in size, shape, and colouring.

Fig. 192

Figs. 193–199

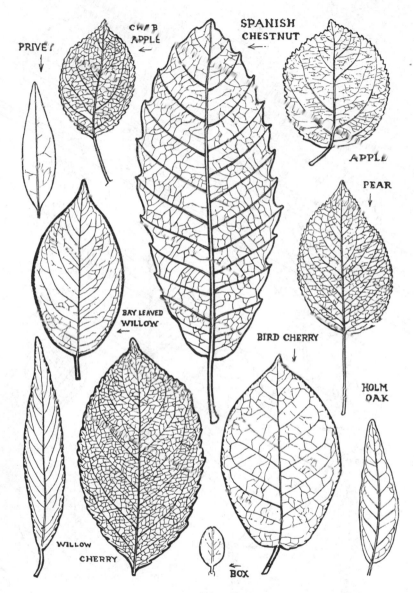

PRIVET

CRAB APPLE

SPANISH CHESTNUT

APPLE

PEAR

BAY LEAVED WILLOW

BIRD CHERRY

HOLM OAK

WILLOW

CHERRY

BOX

Figs. 200-210.—" A " Leaf Plans

These diagrams are half the size of the real leaves

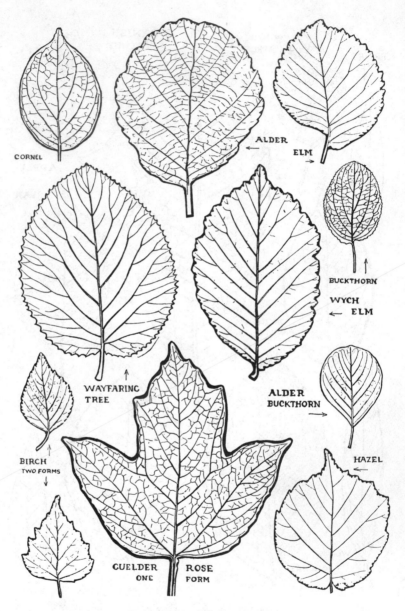

Figs. 211–221.—" B " Leaf Plans

These diagrams are half the size of the real leaves

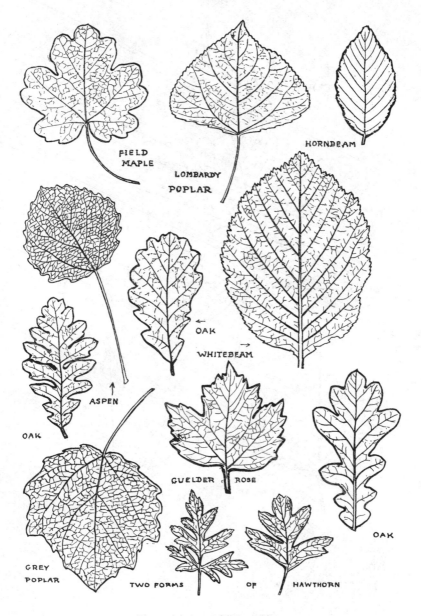

FIELD MAPLE

LOMBARDY POPLAR

HORNBEAM

OAK

WHITEBEAM

ASPEN

OAK

GUELDER ROSE

OAK

GREY POPLAR

TWO FORMS OF HAWTHORN

Figs. 222–233.—" C " Leaf Plans

These diagrams are half the size of the real leaves

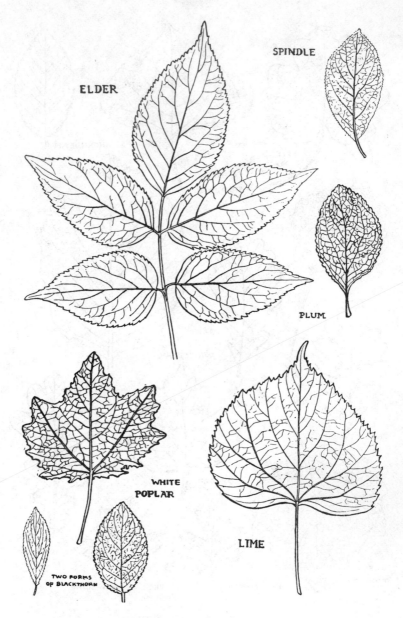

SPINDLE

ELDER

PLUM

WHITE
POPLAR

TWO FORMS
OF BLACKTHORN

LIME

Figs. 234–240. — " D " Leaf Plans

These diagrams are half the size of the real leaves

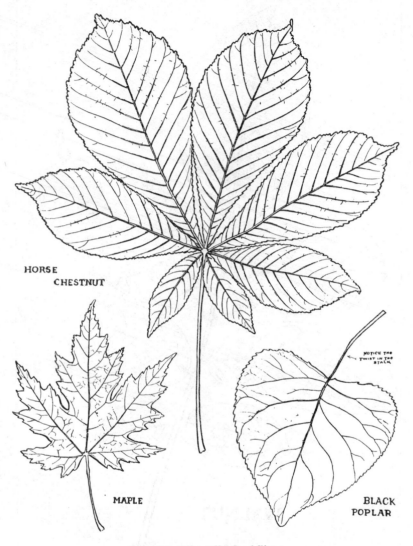

HORSE
CHESTNUT

MAPLE

NOTICE THE
TWIST IN THE
STALK

BLACK
POPLAR

Figs. 241–243.—" E " Leaf Plans

These diagrams are half the size of the real leaves, except the Horse Chestnut,
which is one-third

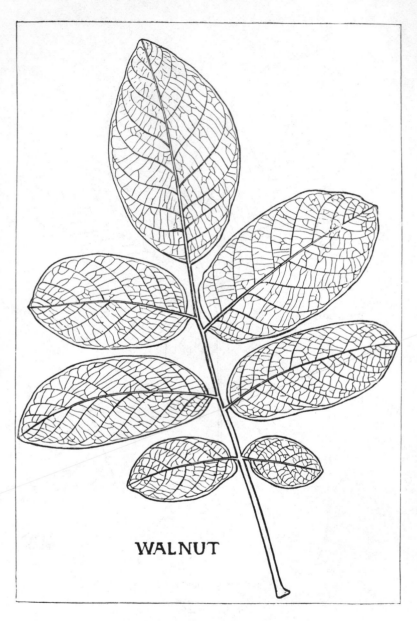

WALNUT

Fig. 244. — Leaf Plan " F "

The diagram is half the size of the real leaf

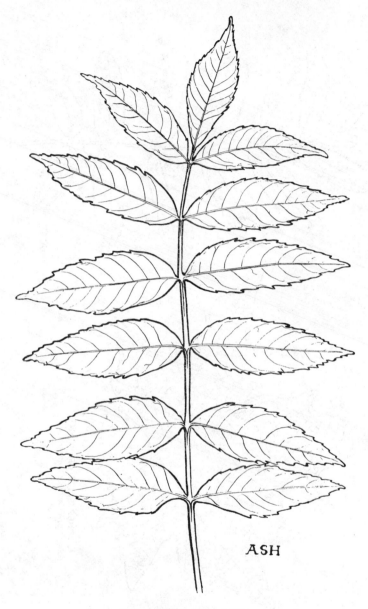

ASH

Fig. 245.—Leaf Plan " G "

The diagram is half the size of the real leaf

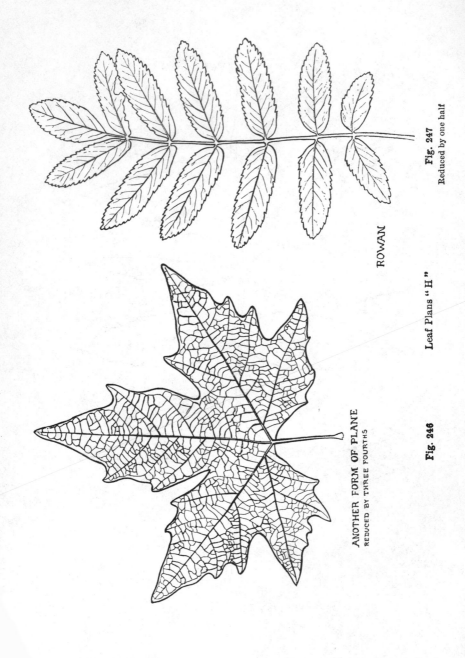

ANOTHER FORM OF PLANE
REDUCED BY THREE FOURTHS

Fig. 246

ROWAN

Fig. 247
Reduced by one half

Leaf Plans "H"

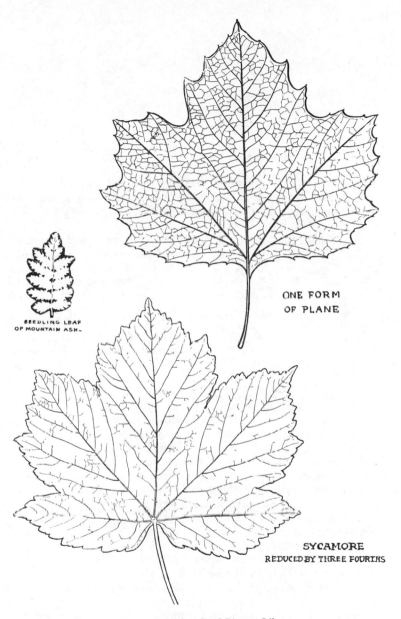

SEEDLING LEAF
OF MOUNTAIN ASH.

ONE FORM
OF PLANE

SYCAMORE
REDUCED BY THREE FOURTHS

Figs. 248–250.—Leaf Plans " I "

Leaves reduced by one half except the Sycamore leaf

CHAPTER XVIII

THE mode in which flowers are arranged is called the inflorescence. There are two distinct kinds of inflorescence, and to one or the other of these belong the various arrangements of flowers to which distinctive names have been given :

(1) Indefinite inflorescence (Fig. 251).

This term is used to explain that the main axis of the flower system is not terminated by a flower ; but that the main axis gives rise to lateral stalks, each terminated by a flower.

(2) Definite inflorescence (Fig. 252). This term, as its name implies, is used when the main axis (as well as the lateral stalks) is terminated by a flower.

Fig. 251. — Simple "indefinite" type. Lateral stalks terminated by a flower. Stalks not branched

Fig. 252. — Simple "definite" type. Terminal flower to main axis and to lateral stalks

One of the most important differences in these two systems is seen in the comparative succession in which the flower-buds open out into flowers ; and it will save confusion if we confine ourselves first to an explanation of these different effects.

(1) *Indefinite Inflorescence.*—In this system, the main axis gives off flowers in succession from the side of the growing point of the axis until it ceases growing. If the main axis is so short that the lateral stalks bearing flowers seem to radiate from one point (Fig. 253), the buds on the outer stalks will be the first to open into flowers ; while the buds in the centre of the mass (because they are the newest formed) will be the last to open. The same order in the expansion of the flowers takes place when the main axis is not shortened ; but the flower stalks are successively shorter towards its tip, so that they and those below on

Fig. 253 **Fig. 254**

longer stalks are brought up to the same level (Fig. 254). If the main
axis is lengthened (and the lower flower stalks are not elongated as in
the last example), the flowers at the base of the axis will be the first to
open, followed successively by others to the tip of
the axis, where buds are newly formed (Fig. 255).

(2) *Definite Inflorescence.*—In this system
(Fig. 256), the flower-bud terminating the main
axis is the first to develop, and is followed by
others formed below it. These spring from the
axils on the main axis, or from the axils on the
secondary stalks. In the latter case, each
secondary stalk—with its branchings—follows the
same plan of the central flower, developing before
the outer ones (Fig. 257).

Fig. 255 Fig. 256.—
Definite

Various arrangements are the result of one or the
other of these indefinite or definite types.

(1) *Indefinite Inflorescence.*—Taking first the (1) In-
definite Inflorescence, we find it broadly divided into
arrangements known as Raceme, Catkin, Corymb,
Umbel, and Capitum.

Fig. 257

The term *Raceme* is applied when a central growing
stalk bears on its sides axillary stalks tipped with flowers. These
stalks are produced successively, and carry a bract at their
base (Fig. 258). The Bird Cherry inflorescence (Illus. 109,
p. 229), with its long central stalk and its stalked flowers
developing successively from the base of the main stalk to its
tip, where buds are still forming, is a good example ; the
Sycamore (Illus. 115), Acacia, Laburnum, and Field Maple
are others. The axillary stalks on a raceme are of nearly
equal length. When a raceme is compound—by some of
the secondary axes being branched—it is called a Panicle.

The *Catkin* consists of a main stalk that is deciduous,
having attached to it, without stalks of their own, the
unisexual flowers. Catkins are carried by the Poplars,
Willows, Hazel, Sweet Chestnut, Birch, Alder, Oak, Walnut,
and Plane (Illus. 66, 90 ; 117–119 ; 129–140, pp. 163, 196 ;
252–254 ; 272–277 ; 281, 286). Poplar catkins are pendent, while in
most of the Willows they are erect. The catkins of the Poplar consist
entirely of male or female organs. The Sweet Chestnut catkins carry
the male flowers on the base portion, and from there to the tip the
female flowers. On the Hazel, Oak, and Walnut, it is only the male
flowers that are produced as catkins.

Fig. 258.—
Raceme
Main axis
long, lateral
axes equal
in length

The Capitum.—The Plane has the male and female flowers com-

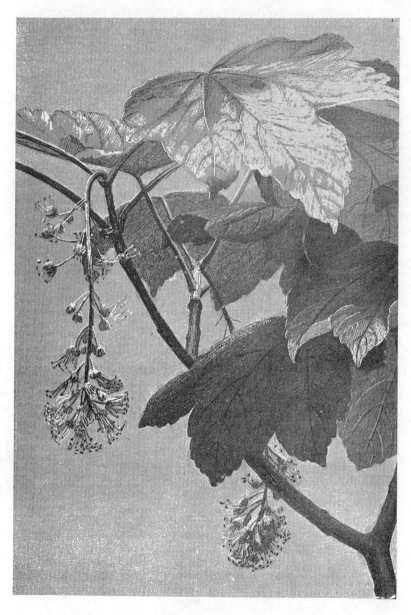

ILLUS. 115. EXAMPLE OF RACEME—SYCAMORE FLOWERS

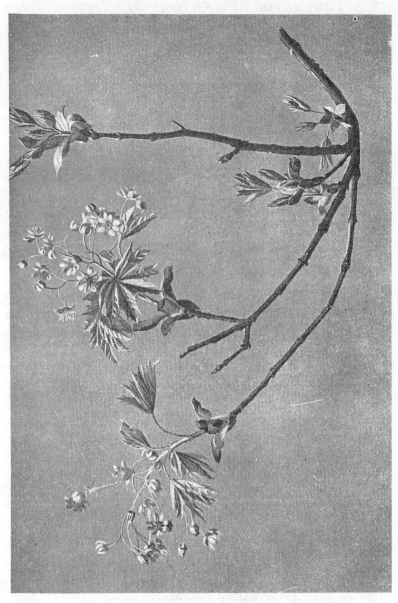

ILLUS. 116. EXAMPLE OF RACEME—MAPLE FLOWERS

(See larger drawing Chap. XXI, p. 306)

pressed to a ball, suspended by the catkin stalk ; like beads threaded at intervals on a string, the arrangement is known as a " Capitum " (Illus. 120).

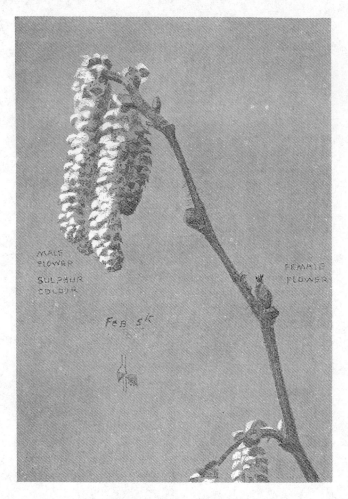

ILLUS. 117. EXAMPLE OF CATKIN—THE HAZEL

The Corymb.—If you make a drawing of a raceme, and then alter the length of the axillary stalks—making those at the base the longest and the rest successively shorter to the tip, so that they carry their

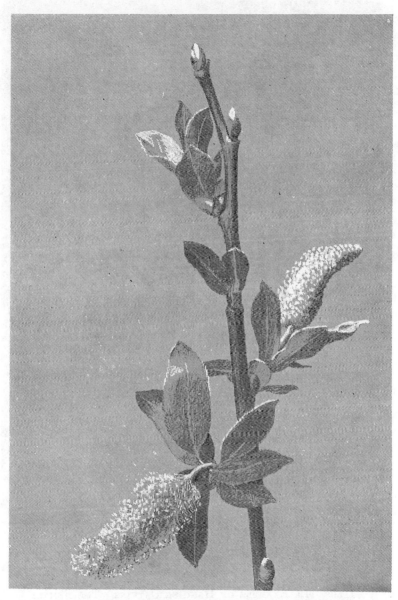

ILLUS. 118. EXAMPLE OF ERECT CATKIN—MALE FLOWER OF AN OSIER

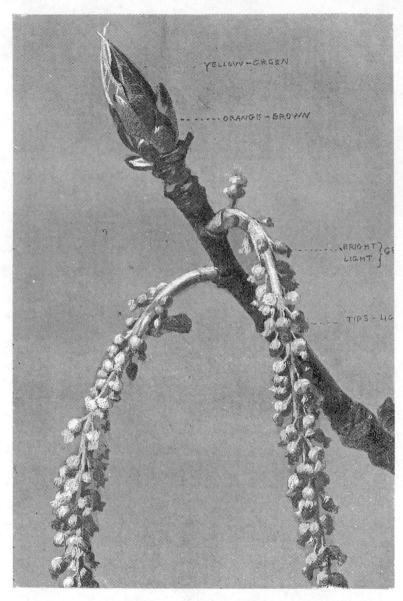

ILLUS. 119. EXAMPLE OF HANGING CATKINS. THE FEMALE
FLOWERS OF THE BLACK POPLAR

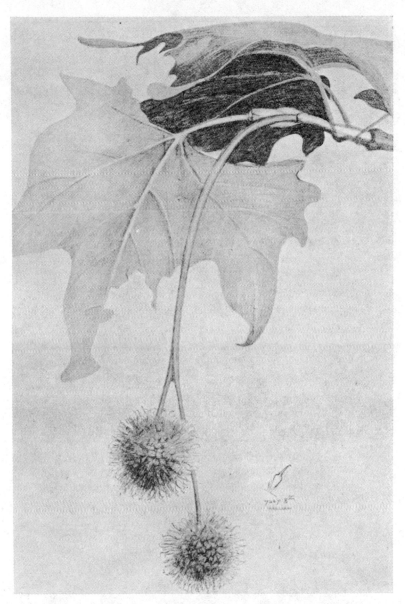

ILLUS. 120. EXAMPLE OF A CAPITUM ON CATKIN STALK. THE
CATKINS OF THE PLANE TREE

(For earlier stage of development see Chap. XXI, p. 304)

ILLUS. 121. EXAMPLE OF CORYMB—HAWTHORN BLOSSOM

ILLUS. 122. EXAMPLE OF UMBEL—FLOWERS OF THE CRAB APPLE

ILLUS. 123. EXAMPLE OF PANICLED CYME—FLOWER HEAD OF
THE PRIVET

ILLUS. 124. EXAMPLE OF CYME—LIME TREE

flowers on a domed or even line—you construct a Corymb (Fig. 259);
example, Hawthorn (Illus. 121).

The Umbel.—This differs from the corymb in having all the axillary

stalks, that are placed on a main
axis, so short as to make them
appear to radiate from one com-
mon point like the spokes of an
umbrella (Fig. 260). At the point
of insertion, they are encircled

Fig. 259.—Corymb

Lower stalks longer
than upper

Fig. 260.—Umbel

Stalks equal in length on
an undeveloped main
axis

by a necklace of collected bracts.
Each bract subtends a stalk;
but, from the compressed length
of the axis, they, like the stalks,

seem to start from one point. These flower-bearing stalks are of nearly
equal length, so that the head of the flower-cluster is
flat or slightly domed. The flowers of the Crab Apple
(Illus. 122) and Gean (Wild Cherry) are examples.
Umbels are not restricted to the simple form of a
main axis, bearing secondary stalks with flowers ; the
secondary stalks themselves may be branched, and
with the tertiary stalks (that carry the flowers) repeat
the construction of the original plan (Fig. 261).

**Fig. 261.—Com-
pound Umbel**

Lateral axes branched
like main axis

(2) *Definite Inflorescence.*—This arrangement, as
we have said, consists of a main axis terminated by a flower (so that
new flowers have to spring from points
on the axes below the flower already
formed). This arrangement is known
under the general name of Cyme
(Fig. 262). The branching of the
secondary stalks is carried out in the
same manner as they were divided
from the main axis, and the tertiary
stalks again in their turn follow the
same routine. When three lateral

**Fig. 262.—
Cyme**

Each axis ter-
minated by a
flower

**Fig. 263.—Two-
branched Cyme**

axes radiate from one point below the terminal flower so that it resembles
a compound Umbel, it is called a Cymose Umbel. (Fig. 263.) Other
compound forms of the Cyme are known with descriptive adjectives, as
Panicled Cyme, Corymbose Cyme. The Privet (Illus. 123) is an example
of the former, and the Elder of the latter. Cymes are formed by the
flower-clusters of the Lime, Rowan, Spindle, and Elder (5-branched).

CHAPTER XIX

SHAPES OF FLOWERS

THERE is as great a variety in the forms of the florets themselves as there is in their inflorescence. This will be best understood if we describe a typical flower ; then the discrepancies in others will be appreciated.

A flower is made up of separate parts, that have a distinct mission to fulfil in their business of reproduction. These are (1) the essential organs of reproduction—the Stamens (male organs) and the Pistil (female organ). (2) The leafy envelopes that protect them.

A flower which is composed of (1) and (2) is called a " Complete " flower ; all its parts are arranged on a more or less convex form, which is the enlarged extremity of the flower-stalk, and is called the Receptacle (Figs. 264–265). Each set of organs is arranged in a circle on the receptacle, one circle surrounding another. Taking these sets in order from the base (nearest the stalk on the outside of the receptacle), we find (a) an outer envelope called the Calyx. This usually consists of separate leaves, green in colour, called Sepals ; sometimes they are united so as to form a collar. (b) Inside the calyx is the next envelope, called the Corolla. This is usually brightly coloured ; commonly consisting of separate forms called Petals, but occasionally composed of an entire circular funnel. (c) The third circle is composed of stamens ; each of these is constructed of a stalk named the Filament and a head called the Anther (the latter being of twin cells containing the fertilising material called Pollen). The

central form round which all the others radiate is this Pistil —the female organ of reproduction. The base of this pistil is called the Ovary. It contains the ovules (which, after fertilisation by the pollen, become the seeds). On the apex of the ovary is the Stigma.

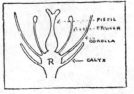

Fig. 264 Fig. 265

This receives the pollen, and it is usually connected with the ovary by a cylindrical stalk called the Style. This diagram (Fig. 264) of a vertical

261

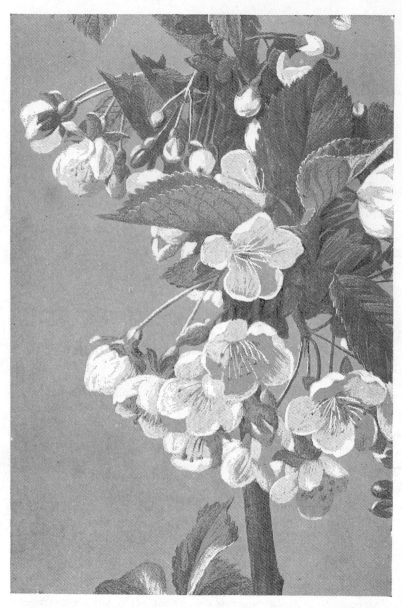

ILLUS. 125. EXAMPLE OF "COMPLETE" FLOWERS—THE CHERRY

section of a flower explains the order of these parts on the receptacle. The plan of the flower (seen from above), Fig. 265, shows how the parts are arranged in circles, and the alternating arrangement of the individual forms.

The Calyx and Corolla are usually each made up of five parts—5 sepals, 5 petals—examples, Apple, Lime, Plum, Maple, etc.

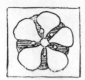

Fig. 266

(Fig. 266) ; commonly the stamens are numerous, but their number is some multiple of five—such as thirty. Flowers made up of four parts (Fig. 267) are not uncommon—4 sepals —4 stamens —4 petals (examples, Cornel (Illus. 127), Spindle). The parts of each circle, whether they are five or four in number, alternate with the parts of the next circle; so that in a four-petalled flower the forms of each circle would by themselves form a cross, and each cross would

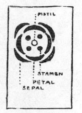

Fig. 267

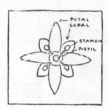

Fig. 268

alternate with the next (Fig. 268). In this way the sepals and stamens would lie in the same direction—forming two Saint Andrew's crosses, while the petals would make a Greek cross between them. To save confusion of terms, we called the female organ simply a pistil ; but to make the change from flower to fruit understood, we must explain its construction further.

A Pistil may be theoretically considered as made up of one or more modified leaves. These modified leaves are called carpels, and are either separate, united, or partly united together, to form the pistil. That they are merely transformed leaves will be seen by examining the central forms of a double Cherry flower, where they retain the leaf forms, and comparing them with the pistil of a single cherry flower, where the same forms will be found, but united at the margins, to form a single carpel. Carpellary leaves can also be found in a simple pistil, in the " neuter " flowers of the Holly and Guelder-Rose (Figs. 270 and 278), and other trees, instead of a pistil. In a simple pistil the margins of a carpellary leaf are turned inward to form the wall of the ovary, and are turned outward at the tips to form a two-lipped stigma. A Compound Pistil may be formed either of single carpels adhering to one another so that the ovary is divided into the cells (one cell created by each carpel), or several carpels may be united—the margin of one to the margin of another—and thus make an undivided ovary. Examples of compound pistils are provided by the female flowers of Oak, Beech, Hornbeam,

ILLUS. 126. EXAMPLE OF "COMPLETE" FLOWERS—THE PEAR

ILLUS. 127. EXAMPLE OF A FOUR-PETALLED FLOWER—THE CORNEL

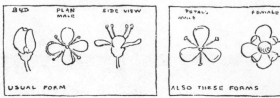

Fig. 269

Fig. 270

Bud and five forms of flowers of the Holly

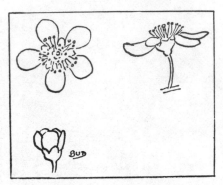

Fig. 271.—Bird Cherry

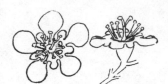

Fig. 272.—Elder

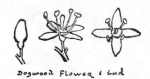

Fig. 273.—Whitebeam

Fig. 274.—Hawthorn

Fig. 275.—Cornel

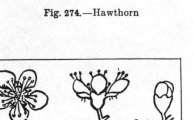

Fig. 276.—Rowan

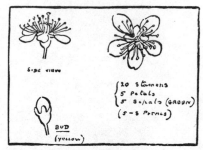

Fig. 277.—Blackthorn

A. Figs. 269–277.—THE SHAPE OF FLOWERS ON SOME TREES

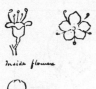

Inside flowers

BUD FLOWER

Fig. 279.—Spindle

BUD OF OUTER FLOWERS

OUTER FLOWERS

3 Stamens

FORM OF FLOWER
INVERTED

SIDE VIEW

Fig. 278.—Guelder-Rose

Fig. 280.—Sycamore

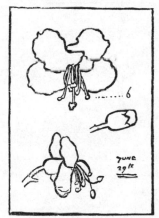

Fig. 281.—Horse Chestnut

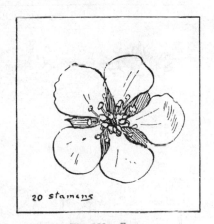

20 stamens

Fig. 282.—Pear.

Fig. 283.—Walnut
Female Flower

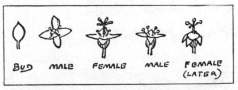

BUD MALE FEMALE MALE FEMALE (LATER)

Fig. 284.—Buckthorn (*Catharticus*)

B. Figs. 278–284.—THE SHAPE OF FLOWERS ON SOME TREES

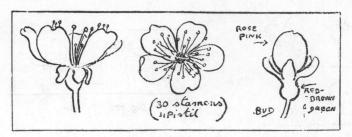

Fig. 285.—Cherry

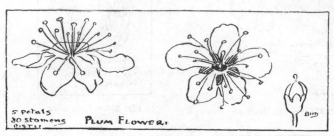

Fig. 286.— Plum

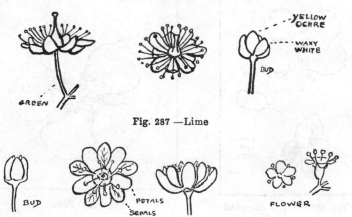

Fig. 287 —Lime

Fig. 288.—Maple Fig. 289.— Wayfaring Tree

C. Figs. 285-289.—THE SHAPE OF FLOWERS ON SOME TREES

and Hazel—in these the ovary is divided into separate cells ; examples of Simple Pistils, by the flowers of the Plum and Cherry.

A complete flower, such as we have described, contains within itself the necessary fertilising medium (pollen), also the ovules capable of being fertilised.

Fecundation may be effected by the pollen being dropped direct on to the viscid surface of the stigma, that retains it ; but it is a curious fact that this is not of common occurrence. It is more interesting that the prevention of self-fertilisation is brought about by the habits of the flowers. Some flowers mature the stigma before the pollen is ripe (example, Birch), others allow the pollen to ripen and be dispersed before the stigma is ready to receive it. In these cases, cross-fertilisation between different trees has to be effected ; and we recognise the use of the gay colouring of the petals and the sweet scents of flowers in attracting insects that may act as transferring agents from one tree to another. The pollen of those flowers which are not endowed with bright-coloured petals is usually carried by the wind, as happens with the Scots Pine, Spanish Chestnut, Yew, and Oak. Lubbock has pointed out that flowers are the most susceptible to fertilisation from the pollen of the flower of another tree. Cross-fertilisation, it seems, is beneficial ; and is the rule rather than the exception. The bearing on the forms of flowers leads to great diversity of construction. (Figs. 269-289, pp. 266-8.)

The flowers on some species of tree are " complete," as we have described. In other species the flowers on individual trees contain either the male organs or the female organs, but not both, though they may carry calyx and corolla. In other cases the flowers on all the individual trees of a species consist of nothing but the simple functionary organs.

Again, in some species, individual trees bear both " complete" and unisexual flowers—sometimes separately on distinct branches, at other times grouped together in the same flower-cluster. Instances even have been noticed in which a branch would bear one type of flower one year, and another type in the following year, but this is exceptional.

In some flowers the calyx and corolla are missing (example, Ash, Fig. 290) ; in some units of a flower-cluster it is the stamens and pistil that are missing, as in the outer circle of the Guelder-Rose (when the flower is called neuter). On many trees the flowers have

Fig. 290 Fig. 291 Fig. 292 Fig. 293 — Stamens only

neither calyx nor corolla, but consist of a scale and stamens (Figs. 291, 293), or a scale and pistil (Figs. 292, 294). This is the rule in the

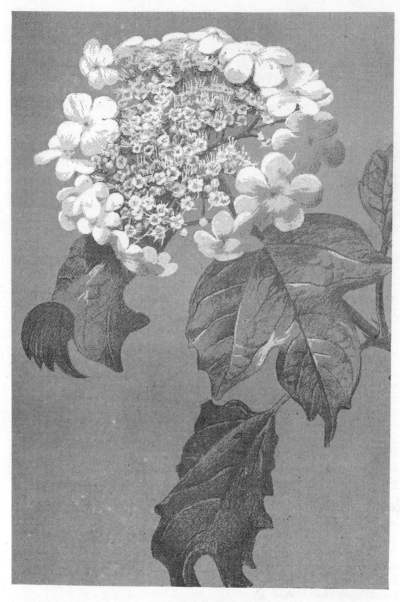

ILLUS. 128. FLOWERS OF THE GUELDER-ROSE "NEUTER" FLOWER
IN CIRCLE ENCLOSING "COMPLETE FLOWERS"—EXAMPLE OF
TWO TYPES CONTAINED IN ONE CLUSTER

Willows and Poplars; and a still more elementary form is shown in the Pines and Firs—either of a scale bearing a pair of anther lobes, or a scale carrying two naked ovules without any style or stigma.

The terms given to these different forms are (1) Complete —when the calyx, corolla, stamens, and pistils are present; (2) Incomplete—when either calyx or corolla, or both, are missing, but stamens and pistil are present; (3) Male—when the stamens are present, but not the pistil; (4) Female— when the pistil is present but not the stamens; (5) Bisexual —when both the stamens and pistil are present.

Fig. 294

When the individual tree bears both " Male " and " Female " blossoms, it is said to be Monœcious (examples, Birch, Hazel, Alder, Oak). The male organs must be in one flower, the female organs in another, but not both combined in the same flower.

If the individual tree bears either " Male " or " Female " blossoms, but not both, it is Diœcious (examples, Buckthorn, Poplars, Willows).

(When Bisexual, Male, and Female blossoms are on distinct trees; the term used is Triœcious, as in the Spindle tree.)

(4) More rarely the tree bears Bisexual flowers as well as unisexual flowers, so that some florets have the organs of both sexes and other florets the organ of one sex only; this is described as Polygamous. Sometimes the bisexual florets will be on one tree, and the unisexual florets on another tree of the same species. The Ash is a good example; one individual tree may bear only male flowers, another individual tree may carry only female flowers, while a third may carry both bisexual and unisexual flowers. It is said that the same branch on an Ash tree may produce different types of flowers in different years. Holly trees are usually diœcious, but sometimes polygamous. The individual florets of many flowers are themselves inconspicuous, though the flower-cluster may make a brave show.

The appearance of some tree flowers bears so little resemblance to our notion of a flower that it is difficult to recognise them as such. The complete flowers of the delicate Apple blossom; the swagger pyramids of florets on the Horse Chestnut; even the little star-shaped flowers of the Spindle with petals of humble green, we immediately recognise as flowers. Other examples are Hawthorn, Cornel, Wayfaring tree, Elder, Whitebeam, Cherry, Bird Cherry, Mountain Ash, Pear, Lime.

Some of the incomplete flowers also remind us of the flowers of our garden, since they have petals, though other parts are missing; for instance, the Buckthorn and Holly, where the male and female organs are on separate flowers. In others we see little resemblance; such as in the catkins of the Birch, Willow, Oak, Sweet Chestnut, the Alder,

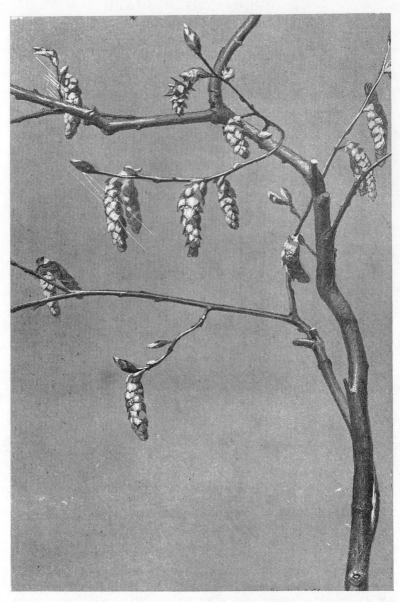

ILLUS. 129. CATKINS OF THE HORNBEAM

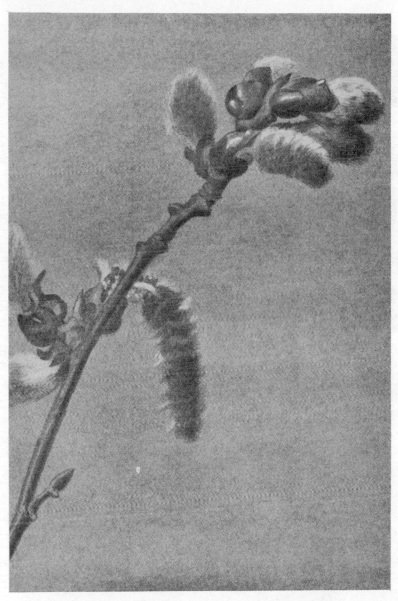

ILLUS. 130. THE HAIRY CATKINS OF THE ASPEN

ILLUS. 131. MALE AND FEMALE FLOWERS OF THE ALDER—EXAMPLE OF A "MONŒCIOUS" TREE

ILLUS. 132. EXAMPLE OF MALE CATKINS ON A " DIŒCIOUS " TREE

ILLUS. 133. FEMALE FLOWERS OF WALNUT—EXAMPLE
OF A "MONŒCIOUS" TREE

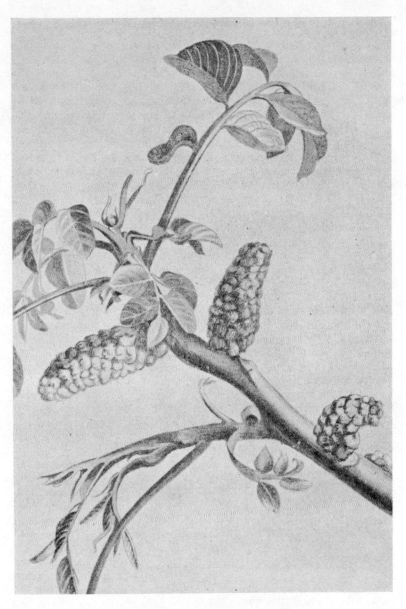

ILLUS. 134. MALE CATKINS OF WALNUT

Hazel, and Hornbeam, or in the tassels of the Beech and budlike clusters of the Ash. Many of these flowers, however, from their colour, or profusion, affect the appearance of the tree as a whole. The Alder and Hazel "lambstails," and the clothing of purple-red flowers on the Elms, that come to the call of Spring, the sulphur catkins that cover the Birch ; and the gilded balls of the Goat Willow, sweet in scent and musical with the sound of countless bees before winter has waned, are each in their turn landmarks of the country. The crimson catkins of the Black Poplar give colour to the trees and the earth below, and the tiny ruby gems of the female Hazel flower, and the rose and white stigmas on the Walnut, are worth the seeking. The Scots Pine, prolific with its pollen, dusts all around with its sulphur-coloured clouds.

Individual trees of the following species bear either male or female flowers (not both)—the Willow, Poplar, and Aspen.

Individual trees of the following bear separate flowers of both sexes—Beech, Oak, Alder, Hazel, Hornbeam, Birch, Walnut, Holm Oak, Sweet Chestnut (male and female flowers on the same catkin), Spruce, Plane, Yew (sometimes), Box, Spindle (occasionally). The flowers of the Box are in clusters in the axils of the leaves. The male flowers are below the female on the same cluster. The Guelder-Rose has a flower-cluster composed of a number of complete flowers encircled by a row of neuter flowers (illustration, p. 270) (*i.e.* no pistil nor stamens). The Holly bears complete male and female flowers on the same tree, or bears only male or female flowers. Neuter flowers are also to be found.

We will now consider the shapes of flowers. The flower is " regular,"when all the parts of the calyx or corolla respectively are shaped alike ; of this the Apple or Blackthorn flower is a good example. It is " irregular " when the parts of either of these circles are dissimilar (examples, Horse Chestnut, Laburnum, Acacia).

The construction of flowers is various ; but three forms may be taken as types : (1) Normal construction, in which the receptacle is a dome supporting the central pistil while the calyx, corolla, and stamens are arranged in circles, each circle in the above order from the base (Fig. 295). (2) The receptacle no longer a dome, but cup-shaped, with the pistil arising from the bottom of the cup, and the calyx, corolla and stamens carried on the rim of the cup (Fig. 296).

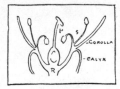

Fig. 295 Fig. 296

(3) The receptacle planned as in No. 2 ; but enclosing the ovary, leaving only the stigmas, or the stigmas and style, projecting from its adherent walls (Fig. 297). In the first and second plans the ovary is quite free, and consists of the carpels only. In the third plan the wall of the ovary is formed by the receptacle. It may be sufficient if we describe the ovary in (1) and (2) as " free," to distinguish it from (3), where it is " adnate." The purpose of such a definition will be seen in the following chapter in reference to the construction of fruits. In most flowers the sepals, petals, and stamens fall off after the fertilisation, leaving only the pistil ; or the ovary alone may be left. Often the calyx remains, and in some cases the bracts also. All the cells, or the ovules they contain, do not always come to maturity. Some persistently fail (example, Oak, Hazel, Birch).

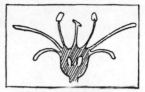

Fig. 297

Flowers not only give a new colour to trees, but for the time being alter their appearance in other ways. We see the twigs of the Elm, that through the winter have formed delicate tracery against the sky, become in March suddenly thickened and by comparison clumsy ; though the loss of pattern is atoned for at a distance by the changing colour. Birches, too, whose twigs were but a haze of lovely tone against the light, have their sky spaces filled in by a multitude of catkins far denser than the opening leaves.

All these matters are common knowledge to the country man ; but less obvious, though of greater importance, is the fact that the growth of the tree is stopped at those points where flowers are produced, and the new shoots starting from other points give the branches a new direction. But this is explained in the chapter dealing with Twigs.

CHAPTER XX

In full Summer-time the ground under the Elms is carpeted as with fallen green leaves: these are the winged fruits that have hung in clusters, unnoticed except on the leafless twigs in Spring, when one might have mistaken them for foliage. In Winter, Ash "keys" (often retained throughout the cold months), as well as the cones of the Alder and the threaded balls of the Plane, are conspicuous among the naked boughs. In Spring the curious leaf-like bracts protecting the seed of the Hornbeam give an added fulness to the young foliage. These, in their way, change the trees as much as do the gay colours of the fruits on Holly, Hawthorn, Rowan, Apple or Yew. Some trees one can hardly name without thinking of their fruitage—Walnut, Horse Chestnut, Spanish Chestnut, Hazel, Cherry, Oak, and the Larch, the Scots Pine and the Spruce with their cones. The fruits of trees may be remembered by separating them into two divisions : (1) Those that have wings or have the seed attached to hairs or tufts of down, as a means of dispersal by the wind ; (2) those sought for as food by birds and animals, and thus carried away. The fruits of these two divisions envelop their seeds in various outward forms. Some of the winged seeds are protected by cones ; others merely by the wing itself, or are attached to a bract. Some have a hard shell or husk ; but the greater number have a more or less fleshy covering. In the latter, the seed itself is protected by a strong wall embedded in the centre of the flesh.

(1) *Winged fruits.*—Winged fruits are noticeable features on six of the forest trees—the Maple, Sycamore, Ash, Elm, Hornbeam, and Lime. The seeds of the Pine and Fir are also attached to wings, but they remain hidden in the cones up to the time of their dispersal ; and the winged seed of the Birch forms part of a catkin. A winged fruit is called a Samara, and each membranous wing encloses one seed. Some of these fruits have very similar forms, notably that of the Sycamore and Maple (Illus. 136 and 137). In these, a rounded seed is enclosed by the membrane at the base of a flat semi-transparent wing. One fruit stalk supports two of such winged fruits, which are

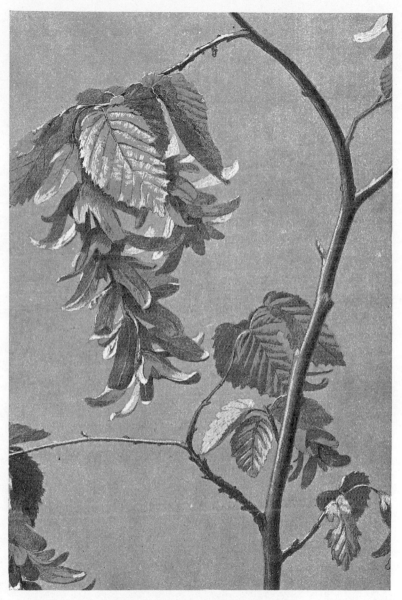

ILLUS. 135. EXAMPLE OF WINGED FRUITS—FEMALE CATKINS
(FRUITS) OF HORNBEAM

(See Chap. XIX, Illus. 129, of male catkins)

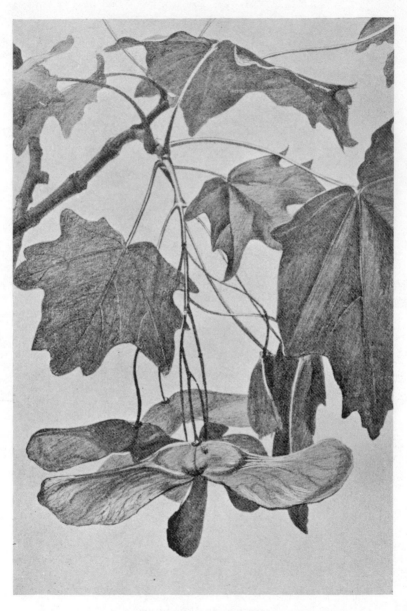

ILLUS. 136. WINGED FRUIT (SAMARA) OF THE FIELD MAPLE

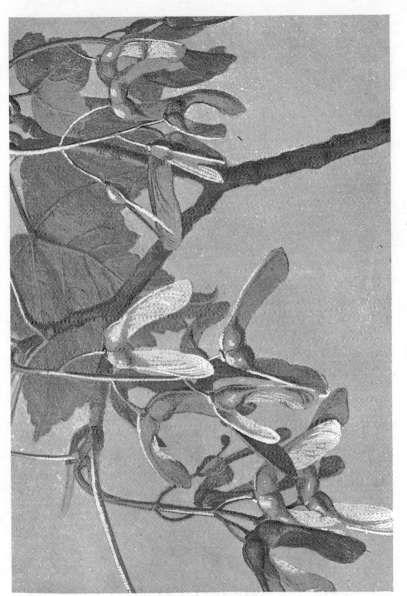

ILLUS. 137. WINGED FRUIT OF THE SYCAMORE

detachable at their junction. They spread out from the stalk after the fashion of a butterfly wing. Those of the Field Maple are the most outspread, and have their junction more completely covered by the base of the wing. Occasionally we find three fruits, instead of a pair, supported by one stalk. Their green colour changes, before they ripen, to beautiful tints of pink and crimson. The pointed Ash seed is carried singly at the base of a twisted wing to spin it on its way : the Birch by a pair that resemble a horse shoe in form. The Elm seed lies in the centre of a nearly circular plate (Illus. 138). The seed of the Hornbeam is carried by a three-lobed serrated bract of leafy texture. The fruits of the Lime (Illus. 139), in small clusters, have their pedicels united to a long pendent stalk to which a thin yellow-green entire bract is attached for nearly half its length ; this wing—unlike those of the other trees—has to carry the whole bunch of fruits.

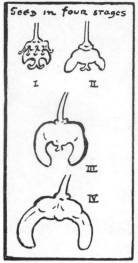

Fig. 298.—Sycamore

Seeds provided with hairs.—All the species of Willows (botanists enumerate about thirty, I believe) and Poplars have the female flowers collected together in catkins. The seeds are

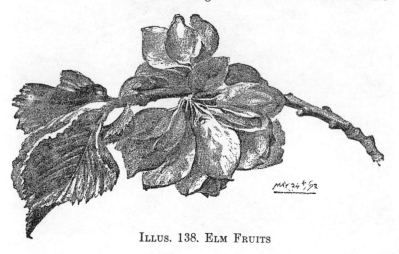

ILLUS. 138. ELM FRUITS

provided with a tuft of silky hair enabling them, when set free, to be caught by the breeze. One of these trees, bearing female catkins, will

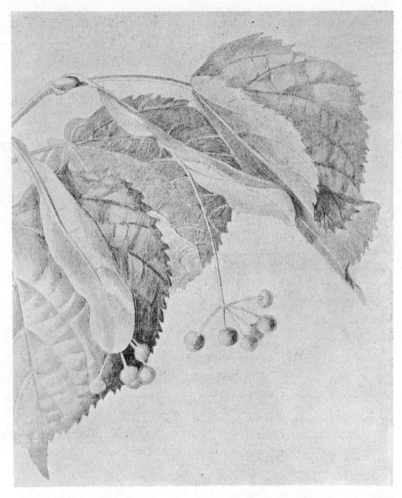

ILLUS. 139. EXAMPLE OF WINGED FRUIT—LIME TREE
A drawing of the flower is given Chap. XVIII, p. 259

cover everything around it with the down that envelops the seed.[1]

[1] Illustration, Chap. XV, p. 206.

The drawing of one of the small Willow trees shows how the stigmas curl back ; also how the style splits when the seeds are liberated.

Cones.—The female flower-cones of the Scots Pine, Spruce, and Larch, though differing in appearance, are all constructed on the same plan—that of a number of over-lapping scales in spiral order

ILLUS. 140. CATKIN (FEMALE) OF A LESSER WILLOW SHOWING HOW THE STYLE SPLITS AND THE STIGMAS CURL BACK THAT THE SEED WITH ITS TUFT OF HAIRS MAY BE SET FREE

attached to a central axis. On the inner side, at the base of each scale, are the ovules, and on these the pollen falls. These young cones stand stiffly out from the branches, and are beautiful in colouring (Illus. 141). Those of the Spruce are waxen in texture and soft, tinted green and bronze pink ; the scales at first stand out or droop towards the base to facilitate fertilisation ; they soon become

harder, however, and point to the tip of the cone. The mature cone reaches six inches in length, and becomes pendent. The mature cones differ in many respects in the different species. Those of the Silver Fir are held upright, while those of the Spruce and Hemlock Firs hang (Illustration 142). The latter are only one inch in length to the five or six inches of the Spruce, and their cones drop to pieces

ILLUS. 141. YOUNG CONES OF SCOTS PINE

after the seeds are dispersed, while Spruce cones fall unbroken. The tips of the scales in the Scots Pines become knobby—making an embossed pattern over the cone, and finally woody—in texture before the scales drop apart. Spruce cones, on the other hand, have smooth scales, and taper to a blunt end. The cone of the Silver Fir has the most cylindrical form. That of the Spruce tapers gently to bluntness at both ends, while that of the Scots Pine is more egg-shaped. It

ILLUS. 142. EXAMPLE OF CONE—SPRUCE FIR

ILLUS. 143. OLD LARCH CONES IN WINTER

should be remembered that the scales of cones are furnished with bracts at the base on the outer side. These are often hidden by the overlapping of the scales, but in some of ornamental conifers they are longer than the scales themselves. The wing to which Pine seeds are attached is a part of the carpel scale on which the ovules grew. The Alder also has the female flowers clustered in a small cone. The bracts become woody, and remain on the tree after the seed has dropped.

(2) *Fruits which have no wings.*—We have accounted for six species that have noticeable winged fruits ; also for two genera (Pines and Firs) and one species (Alder) whose winged fruits are hidden in cones ; two genera (Willows and Poplars) that congregate fruit provided with hairs ; and one (Birch) with wings in catkins. The remaining sixteen species bear fruit in which the seed is enclosed in an edible covering, or the germ is enclosed by edible seed leaves that constitute the fruit. It adds to our interest in these fruits if we follow their transformation from a flower. These fruits have been named " Drupe " ; Pome ; Nut ; Berry.

The Drupe (Illus. 144, 145, 147, pp. 291, 292, 294) is a stone fruit constructed from a single carpel. The original layers of the ovary walls—enlarged after fertilisation—form the skin, flesh, and stone respectively, the kernel being the seed ; these normally contain one seed, sometimes two. Examples are Cherry, Blackthorn, Plum, Peach, Walnut, and Yew. Fruits formed of a compound pistil are also included —example, Buckthorn and Cornel.

The Pome (Illus. 149, 150, 151, pp. 296–98) is made up of a large body of flesh, that in the flower was the receptacle that has overgrown the carpels, these carpels remaining in the fruit and forming the core, inside which are the pips or seeds, as in the Apple, Pear, and Hawthorn. In some cases the remains of the calyx tips protrude from the end of the fruit farthest from the stalk. The illustration shows this, in the formation of a pear. The lobes of the calyx are a conspicuous feature also on the Medlar fruit.

The Nut (Illus. 153, 154, pp. 300, 301)—examples, Acorn, Beech nut, Hazel nut, Spanish Chestnut—has one cell and seed, though it is usually formed from an ovary that contained two or more cells with one or more ovules in each. For instance, the flowers of the Oak, Beech, and Spanish Chestnut have a three-celled ovary constructed by three united carpels, and each cell contains two ovules—only one of the seeds, however, comes to maturity. The cup enclosing the base of the acorn is made up of the scales that surrounded the base of the flower united into one form. The leafy cup of the Hazel nut is also formed by the union of the bracts that supported the flower. The

ILLUS. 144. EXAMPLE OF DRUPE—THE CHERRY

ILLUS. 145. EXAMPLE OF DRUPE—FRUIT OF THE CORNEL (2 CELLS) FORMED FROM A FLOWER WITH A COMPOUND PISTIL

ILLUS. 146. FRUIT OF THE WALNUT

ILLUS. 147. EXAMPLE OF DRUPE—FRUIT OF THE ALDER BUCKTHORN

prickly covering of the Beech fruit, which usually encloses two (sometimes more) nuts, is made up of the inner and outer scales of the catkin. The Spanish Chestnut bears the female flowers in groups of

ILLUS. 148. THE YOUNG PEAR FRUIT BEING FORMED ROUND THE FLOWER. THE SEPALS, STAMENS, AND STYLE ARE SEEN PROTRUDING

two or three; the fruit consists of two or three nuts enclosed in a prickly covering formed out of the four bracts that enveloped the flowers.

The berry is a fruit in which the matured ovary is fleshy through-

ILLUS. 149. EXAMPLE OF POME—FRUITS OF THE ROWAN

ILLUS. 150. EXAMPLE OF POME—FRUIT OF THE THORN-TREE

ILLUS. 151. BRANCH OF THE CRAB-APPLE TREE
EXAMPLE OF POME

ILLUS. 152. FRUIT OF THE SPINDLE TREE.

Notice the shape of the rose-coloured capsules that enclose the seed
membrane of a brilliant orange colour

Aug. 30 ft.

ILLUS 153. HAZEL NUT

Illus. 154. Spanish Chestnut

out, the seeds being embedded in the pulp. The fruits of the Guelder-Rose and Elder are examples.

The transition from the types of flowers that we have explained in the last chapter is shown in some of these fruits. The Cherry consists of the carpels ; the skin is the outer layer of the carpel, the flesh is the middle layer, and the stone is the inner layer, and the seed inside is the ripened ovule. The fruit was developed from a flower in which the pistil was free from the other forms. The Apple has the flesh formed of the receptacle, the core formed of the carpels, while the pips are the ripened ovules—the fruit, therefore, being developed from a flower in which the ovary was united to the receptacle. The Plum is formed of a single carpel, and the furrow down it corresponds to the junction of the margins of the carpellary leaf. The edible part in the Chestnut, Acorn, Walnut, and Hazel nut is provided by the seed-leaves, whose business later would have been to provide nourishment for the young plant, therefore they are protected by a hard or prickly covering. The edible part of some envelops the seed—as in the Apple and Pear ; in others, the edible portion surrounds the protecting shell of the seed.

ILLUS. 155. FRUIT OF THE YEW

A DESCRIPTIVE TABLE OF THE FRUITS ON TREES

	Nut	Cone	Catkin	Drupe	Berry	Pome	Winged Seed	Hairy Seed	Naked Seed	Colour of Seed Covering				
										Brown	Red	Black	Purple	Green
Alder	x ←→ x									x				
Apple						x				x ←→ x (Green)				
Ash							x							
Aspen		x						x						
Beech	x									x				
Birch		x						x						
Blackthorne				x								blue/black		
Box											x ←→ x (Green)			
Buckthorne		x (3 celled)										x		
„ Alder				x							x ←→ x			
Cherry, Wild				x							x			
„ Gean				x							x ←→ x			
„ Bird				x								x		
Chestnut Spanish	x									x ←→ x				husk x
„ Horse	x									x ←→ x				x
Cornel			x (2 cell)								x ←→ x			
Elder			x (3 feels)									x		
Elm							x							x
Fir, Spruce		x					x			yellow brown				
„ Silver		x					x			x				
GueldarRose					x						x			
Hawthorne				x						x	x			
Hazel	x									x				
Holly			x								x			
Hornbeam	x ←→ x						x						x	green x
Larch		x					x	x	x					
Lime							x							x
Maple							x				x ←→ x (Green)			
Medlar						x				x				
Oak	x ←→ x									x				
„ Holm	x ←→ x									x				
Pear						x				x				
Pine		x					x	x						
Plum				x									x	
Poplar		x						x						
Privet				x									x	
Rowan						x				x				
SpindleTree	Capsule 3 celled pink. Aril orange													
Sycamore							x				x ←→ x (Green)			
Walnut	x ←→ x													x
WayfaringTree				x							x ←→ x			
White Beam					x					x				
Wild Service Tree									x					
Willow		x						x						x
Yew			x							x				

CHAPTER XXI

Stipules.— In a Beech wood in Spring, when the limp young leaves
are losing their silver fringe, the ground beneath is strewn with the
brown, shrivelled, leaf-like forms that have protected them as they
came out of the bud. These are the stipules ; they fall as soon as
the leaves develop. Those of the Beech are not remarkable for beau-
tiful colour or interesting form ; but in some other cases they are of
larger size and are brightly coloured ; in fact, they play a very orna-
mental part in the Spring-time gala. The Norway Maple plays first
fiddle with its scarlet stipules, and is well supported by the Sycamore
and Field Maple with theirs of pink and rose, and the Hornbeam and
Wych Elm with shades of purple ; those of the Beech, Elm, and Lime
are brown in colour and membranous. On some trees, entertaining
shapes replace gay colouring, and we see the stipules mimicking leaves,
it may be only as far as showing a notched tip ; or, in other cases,
the stipular forms are really leaf-like in colour, form, and texture.
Those on the Walnut tree, Guelder-Rose, Hawthorn, and Plane (Illus. 158,
p. 307) are interesting for the various formations they illustrate. Holly
stipules are minute, and take the unusual colour of black. Stipules may
be divided roughly into two divisions : (1) Those acting like the scales
in protecting the young leaves in the bud ; and either falling when
the bud bursts or in early life lengthening with the leaves and falling
after they are developed. (2) Leaf-like persistent appendages at the
base of the leaf-stalks of matured leaves. These last are usually green
in colour ; they differ in shape on individual—and even the same—
trees, though the same forms will be found repeated on other indi-
viduals of the same species. The stipules at the base of the leaf-stalk
are usually in pairs—one on either side of the stalk—or are united
so that they form a cup round the stalk. Stipules formed on the
latter plan are conspicuous in the young growth of a Plane tree ; making
a sort of vase with a frilled recurved lip, from which the young leaves
spring. On some trees there are no stipules.

Bracts.—The dictionary definition of a bract is " any leaf which bears

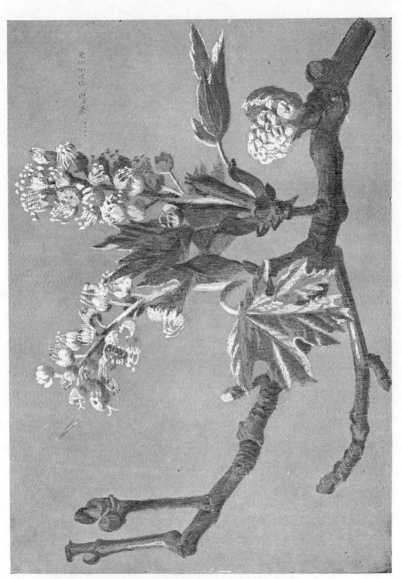

PALE GREEN

ILLUS. 156. THE FLOWERS ON A SPECIES OF SYCAMORE

Notice the notched leaf-like scales at the base of the stalks

ILLUS. 157. BUD SCALES AT BASE OF INFLORESCENCE—MAPLE

in its axil (the angle between itself and the stem from which it arises) a flower, or a branch which terminates in a flower." If we add that leaves in these positions are usually modified leaves (generally smaller than the real leaves and with an entire margin), and sometimes like scales, we get quite a good idea of what a bract is. The circle of bracts which enclose the stalks of the flower-cluster termed an Umbel, is a noticeable feature of the inflorescence. In a compound inflorescence there should be a bract at the base of the main flower axis and also at

ILLUS. 158. VASE-SHAPED STIPULES OF THE PLANE TREE

each junction where other stalks branch. Bracts must not be confused with the leaf-like forms that commonly constitute the outer circle of the flower itself. In catkins—where the flowers are crowded on a short axis—each flower arises from the axil of a bract, just as it would do in an inflorescence built of longer axes; but unless the construction of the floret is understood, the bracts from their closeness to the florets might be mistaken for a part of them. It follows that the bracts will be in pairs when the branching is in pairs, and single where the flowers are produced alternately. In cones the bracts are

usually hidden between the scales (each bract is on the side of the scale farthest from the axis) ; but in some species they protrude beyond the scales, as in the Douglas Fir and some species of the Silver Fir.

Buds and Scales.—We have carefully followed the arrangement of the buds, and have seen that they arise from the axils of the leaf-stalks, where they lie protected by stipules and leaf-stalks, sometimes even hidden by the swollen or hollowed form of the stalk (Walnut) ; and in the case. of the Plane actually enclosed inside the base of the stalk until its fall. It will be also understood that a bud contains the rudimentary stem, leaves, and in some cases flowers. Buds act, as it were, like a greenhouse, keeping all these parts under cover and pushing forward their growth, to save time during the growing season. Early in summer we see the buds getting ready for the following Spring.

The protection of the young leaves from frost while in the bud, by wool, hairs, and stipules, has been mentioned, but not the bud scales, that form the outer tiles, as it were. These are arranged in the same order as the leaves—if the leaves are in pairs, so will be the bud scales (Horse Chestnut, Illus. 159), or the scales will follow the leaves in being alternate (Beech). The scales may be considered as undeveloped leaves ; nevertheless they sometimes prove their analogy by producing the leaf-like tips that we occasionally see on the Horse Chestnut and varieties of Walnut. Some scales are covered with gum (Horse Chestnut), others with a sort of resin (Poplar), as a protection against wet. The buds of the Plane have a cap of fur over them. Some scales may also be considered as undeveloped stipules ; the form of a pair of stipules sometimes being represented by a double-tipped edge. Bud scales are often very numerous : Lubbock, in his *Buds and Stipules*, minutely describes thirteen on an Elm bud. Generally the scales are not long enough to cover the bud, but overlap one another like inverted tiles. The colour of the scales varies, from purple-brown to yellow or green or even black, as in the Ash. The Alder-Buckthorn is remarkable for having no scales to protect the bud. Buds containing flowers can usually be recognised by their larger size, and in most case by their rounder form.

Spines.—On the Hawthorn, Sloe, Wild Pear, and some other trees, there are a number of sharp-pointed spines. These are twigs arrested in growth, a fact that is shown by their being produced from one of the usual side buds in the axils of the leaves ; sometimes they bear stunted leaves and rudiments of flowers, and additional buds may spring up at their junction with the shoot. The spines on the Acacia, on the other hand, are transformed stipules. The change from leaves to spines is not shown by our forest trees, though

it occurs in shrubs ; the nearest approach to it being in the difference
between the smooth-leaved and prickly-leaved Holly. Prickles such
as those on the wild Rose are additional outgrowths from the bark

ILLUS. 159. BUD SCALES AND REMAINS OF THE PACKING WOOL ON THE
NEW SHOOT OF A HORSE CHESTNUT

only, and are easily broken off ; their origin being so distinct, they must
not be confused with spines. The metamorphosis of organs is quite
outside the scope of this book, but we might mention the curious ex-
ample of the Butcher's Broom, which in some localities is a common

bush in the coverts ; the "leaves" are dark green, sharply pointed, and bear half-way up on their "central rib," or the under side of the "leaf," the blossom and subsequent fruit. These so-called "leaves" are actually transformed flattened branches, each springing from the axil of a real leaf which has the appearance of a bract. At the junction of the flower and the "leaf," there is also a bract, just as there would have been if the "leaf" were a branch.

Leaves of seedlings.—While in the woods, we come across seedlings of most of the trees growing there, and of others whose seed has been dropped by birds or carried by the wind. In my book *British Trees*, I have described the leaves of the Hornbeam seedling and some others. "The seedling of the Hornbeam is a striking example of the dissimilarity which so often exists between the seed-leaves of a tree and the true leaves which are afterwards produced. In this case the seed-leaves have a disc-like form, a flat surface, an even, uncut edge ; while the blades of the true leaves are fluted and their outlines are notched. In making the comparison many points must be taken into consideration. For example, some cotyledons (seed-leaves) have no footstalks, while the true leaves possess long ones ; or, again, the cotyledons may be arranged in a pair, the one opposite the other on either side of the stem, while their successors show no such arrangement, and spring from different points on the stem. Seed-leaves also differ from the true in colour, in texture, and in size. Sometimes the transition from the pattern of the cotyledon to that of the leaf is a gradual process, and the leaves that immediately follow the cotyledon rarely show the type of its completion. Often there are many stages to be passed through, and the disguise in each is scarcely less complete than it was in the case of the first seed-leaves. But little by little the type emerges as each leaf, or pair of leaves, follows in the procession of development, until perfection is attained. Even in individual seedlings from trees of the same species, there is variety in the stages of transition."

The seed leaves of the Beech are fan-shaped ; the first pair of true leaves are correct in form, but appear (from being on a short axis) to be a pair instead of set alternately. Ash seed-leaves are long, narrow, and tapering at both ends. The first pair of leaves have serrated edges, but consist of two single leaves instead of a series of leaflets —occasionally they bear three leaflets each. Sycamore seed-leaves resemble two pieces of narrow, green, pointed ribbon. The first leaves are heart-shaped, with a long tapering point and serrated edges, and possess only the rudiments of the lobes of the perfect leaf. The seed-leaves of the Scots Pine resemble true leaves. They are arranged in a bundle, and radiate from the stem after the fashion of a vase. The

cotyledons of the Oak have little resemblance to leaves; and still less those of the Chestnut. In the former, the acorn is split in half, and carried on either side of the growing stem; so the position at least of leaves is assumed. In the latter, the nut entire has not outwardly the faintest resemblance to a leaf.

The Bark.—The bark on a Beech or a Plane is as noticeable for its smoothness as that of an Oak or Scots Pine is for its roughness. This difference in texture is accounted for by three distinct methods of growth, examples of which are seen in the former and latter trees respectively. The rind of the younger parts of a tree is made up of three layers—an inner layer or " cambium," a middle layer, the " bast," and an outer green layer or " epidermis." Each of these is provided with cells, and grows by the addition of new cells on its inner surface. The epidermis or outer skin does not increase after a year or perhaps two years, when it is replaced by cork formed by its underlying tissue ; while each year the cambium forms a new ring of wood to add to the girth of the trunk. This cork or bark is made up of cells for the passage of air and moisture. The outer cells live only a short time, and lose their elasticity ; consequently the bark cracks, and the dead pieces become separated by grooves from the increase in diameter of the trunk within. The pieces of dead bark, thickened by new layers formed inside it, in some species remain on the trees many years (Cork-Oak) ; in other species, they merely form thin papery layers (Birch, Plane), and scale off. The fibrous layer of bast continues to grow by additions every year from the cambium layer. The bast is in some cases strongly developed—as in the Lime ; or it may be produced only in the first year—as in the Birch, Beech, and Maple. Young shoots are covered with smooth green epidermis ; but during the season the green colour disappears, being usually replaced by some shade of ash-grey or brown-grey of the newly formed bark. As the twigs get older, the colour is less

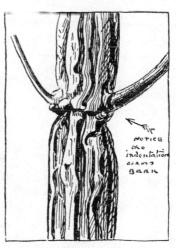

Fig. 299.—Field Maple

conspicuous and a corresponding difference in loss of smoothness occurs. The delicate gradations in the colour of the twigs to the greys of the older branches adds much to the harmony of the woods in winter.

ILLUS. 160. TRUNK OF SPANISH CHESTNUT

Notice the spiral twist of the bark

ILLUS. 161. ANOTHER TRUNK OF A SPANISH CHESTNUT

ILLUS. 162. BARK OF LARCH

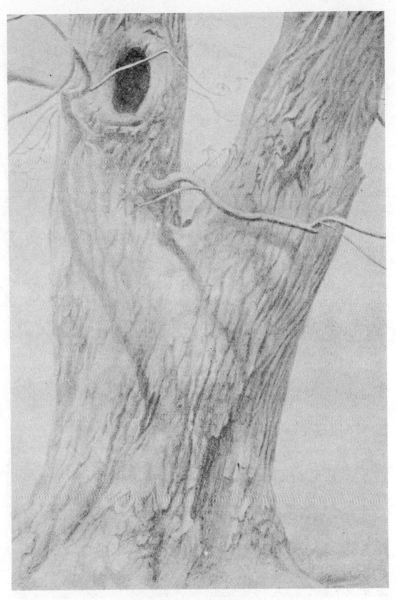

ILLUS. 163. THE BARK ON A WALNUT TREE

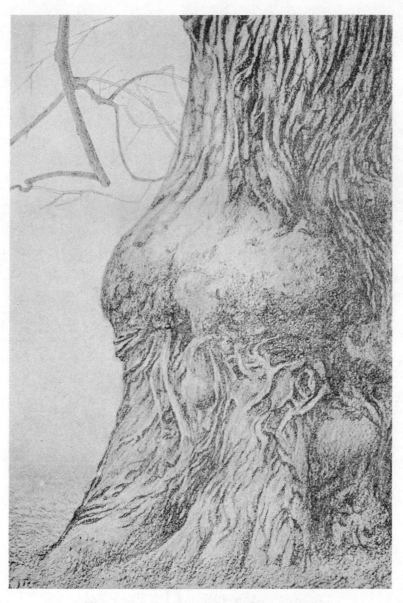

ILLUS. 164. THE BARK ON A LIME TREE

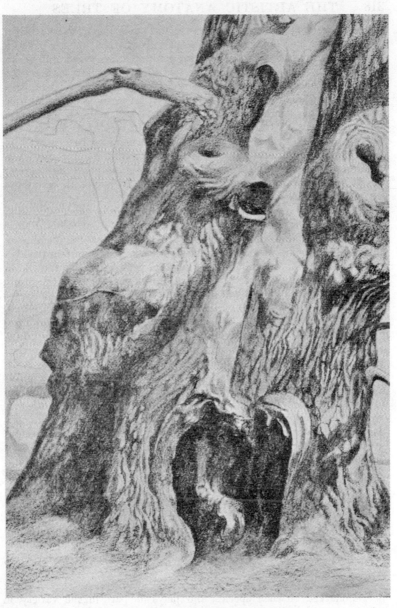

ILLUS. 165. BOLE OF AN OAK TREE

There are shining silver-greys on young Oak trees and Rowans : varied grey tints on Ash saplings and the fully grown tree : purple-grey on Alder twigs : chestnut and red-brown on Birch : grey and nut-brown on Hazel : red and purple on Maple and Cherry : yellow tints on the Elder : and mealy-white stems on the Wayfaring tree. The Cornel takes crimson, as also do some species of Withies, while others assume yellow or orange or red ; some are smooth and shining, others are woolly. The shoots from the Spanish Chestnut stools are purple ; the Spindle alone is green. The change in colouring may be observed on the Plane, where the twigs of one year's growth are olive-green, the older ones dark brown tinged with red, and the branches dark grey ; the thin bark of the trunk flakes off annually, exposing a smooth surface where the grey is tinged with yellow.

The ultimate bark on the tree trunks varies in construction, as in colour, in the different species. In the Spanish Chestnut (Illus. 160) it forms vertical spirally twisted keels, hardly at all cross-sectioned ; on the Acacia these keels have an interlacing appearance ; and on the Ash they form a sort of elongated diamond pattern. The Rowan has a smooth rind split by lines that form broken rings round the stem. The Sycamore is covered with slight patternless fissures. The projecting bark of the Hornbeam is smooth, and lighter in colour than the wide gaps between it. The bark of the Pear divides into little blocks. There is much in common in the Oak and Elm in the rough covering of their trunks. A still more cork-like bark, split in vertical layers, covers the base of a Birch stem ; in the upper part there is the extreme of silky smoothness, gleaming silver white, with papery layers unwinding in circular strips and disclosing new shades of pinks and greys of the layers underneath. The bark of a young Larch is smooth and greenish-brown with vertical stripes of a lighter shade ; later in life it is fissured and becomes scaly, bearing some resemblance in colour to the red-grey of the Scots Pine, though usually more mauve in colour (Illus. 162). The bark of the Black Poplar is rough and dark, while that of the White Poplar is smooth, pale, and grey, pitted with lozenge-shaped marks that are divided vertically by a slight red-brown incision. These marks are grouped in patches and horizontal rows, and form rings, which accentuate the roundness of the trunk. At the lower part of the bole the diamond-shaped marks disappear, the incisions become deeper, and the bark forms vertical cork-like ribs between them. The Grey Poplar has similar scars ; the bark is smooth and stone-coloured, with shades of green and yellow.

The difference in texture, colour, and arrangement of the bark is well-marked on each species, and plays its part in the variety in which nature delights.

APPENDIX

THE DISTRIBUTION OF TREES IN EUROPE

TREES INTRODUCED INTO ENGLAND, OR INDIGENOUS

WE know on indisputable authority that Britain, as well as the greater part of Europe, in early days was covered with dense forests ; it is also granted that only a few of the trees common with us now are indigenous. Most writers agree that Scotland was probably densely wooded, chiefly with Scots Pine, Birch, and Rowan : that great forests were formed of Oak, Beech, and Pine, and that the Ash, Aspen, Alder, Wych Elm, Oak, Yew, Willow, and Hawthorn were native trees of Britain. Nisbet has collected a fund of information concerning the distribution of the forests of Britain, and gives reasons for assuming that certain trees are indigenous while there are records of the introduction of many. Loudon's *Arboretum et Fruticetum Britannicum*, 1838, is a source of early information on the subject, while Manwood's *History of Forest Laws*, Holinshed's *Description of Britaine*, Evelyn's *Sylva, or a Discourse on Forest Trees*, are freely quoted by some writers, as well as references to the writings of Julius Cæsar and Pliny the Latin naturalist. The Rev. C. A. Johns in his *Forest Trees of Britain*, and Edward Step in *Wayside and Woodland Trees*, refer to other writers, amongst whom were H. C. Watson, Selby, Gilpin (*Forest Scenery*, 1834), Schönberg, and others. It is sufficient if we compile a table on the authority of Step and Nisbet (p. 320).

THE POPULAR NAMES OF SOME TREES

Scots Elm . . .	(A)	also called	Wych Elm, Mountain Elm.
Hornbeam . . .	(B)	„	Aller and Howler.
Birch	(C)	„	Birk.
Lime	(D)	„	Linden.
Sallow . . .	(E)	„	Saugh and Goat Willow.
Evergreen Oak .	(F)	„	Holm Oak, Holly Oak, and Ilex.
W. Poplar . . .	(G)	„	Abele
Mountain Ash .	(H)	„	Rowan.
Hawthorn . . .	(I)	„	May-bush, May-tree, Whitethorn, Quickthorn, Quick, formerly called Haythorn.
Holly	(J)	„	Hollen and Holm.
Scots Pine . . .	(K)	„	(erroneously) Scots Fir.
Sycamore . . .	(L)	„	(erroneously in the North " Plane ").
Acacia	(M)	(The popular name for Robinea, also called Locust).	
Spanish Chestnut	(N)	also called " Sweet " or " eating Chestnut."	
Elder	(O)	„	Eller, Bore-tree, Bottery.

319

Trees Introduced into Great Britain

Indigenous in prehistoric Ages	By the Romans	Before the 16th cent.	In the 16th cent.	In the 17th cent.	In the 18th cent.	In the 19th cent.
Oak	Plane	(B)Hornbeam	Spruce	Silver Fir	Weymouth Pine	Austrian Pine
Beech (not in Scotland)	(N)Chestnut Walnut	(L)Sycamore	Walnut	Maple	Maritime Pine	Yellow Pine
(K)Scots Pine	English Elm	White Willow Crack Willow	Laburnum Juniper	Plane	Cembran Pine	Jeffrey Pine
(C)Birch	(D)Lime Medlar	Grey Poplar	(J)Holly	Horse Chestnut	Pitch Pine	Nordman Fir
Ash		(G)White Poplar	(F)Evergreen Oak	Larch (England 1629)	Larch (Scotland 1727)	Douglas Fir
(O)Elder(?)						
(H)Mountain Ash	Poplar	(Walnut 15th.cent:Step)	Stone Pine	(M)Acacia (Robinia or Locust)	Service	Deodar
(A)Scots Elm	Box	(Maple 15th.cent:Step)	(Bay? Step)	Buckthorn	Cedar	(Lawson's Cypress.Step)
	†Mulberry Service		(Medlar Step)			(Chili Pine Step)
*(E)Sallow (White Poplar) Step	†Peach Hazel		Guelder Rose			
Aspen	†Apricot		†Mulberry			
	†Apple					
Alder	†Quince †Pear †Cherry*		(Horse Chestnut Step.)			
Yew (I)Hawthorn (Grey Poplar Step. S.E.England)						

The above lists are compiled from Nisbet (*British Forest Trees*), with the exception of those names placed in brackets. The authority for these is Edward Step.

* See *Wayside and Woodland Trees*, E. Step, p. 95.
† See *Arboretum et Fruticetum Britannicum*, London, 1838, vol. i. p. 15, &c.

DISTRIBUTION OF TREES IN EUROPE

Huge tracts of Europe are covered by forests, as will be seen by these figures :

Percentage of Land under Forest.—Bosnia and Herzegovina, 53 per cent. ; Bulgaria, 45 per cent. ; Sweden, 44 ; Russia, 40 ; Austria-Hungary and Luxembourg, 30 ; Germany, 26 ; Norway, 21 ; (Great Britain and Ireland, 3⅘ per cent. !) ; other countries, under 20 per cent. (*Harmsworth Encyclopædia*). The extent of these forests may be better appreciated by saying that in Great Britain there are roughly three million acres of woodland, and in Austria and Hungary, over forty-six millions of acres.

The tables and information following give a general idea of the distribution of European trees. The table on p. 322 shows the highest altitudes at which they are commonly found. The situations (whether on wet or dry land, on mountains or in valleys, &c.) that are favourable to each species (see table below) should, of course, be taken into consideration. The list following on pp. 323–5 gives the general habits.

TREES THAT GROW ON SOILS THAT ARE			
Wet	Moist	Dryer	Dry
Alder	Oak	Beech	Scots Pine
Ash	Hornbeam	Oak	Austrian Pine
Willow	Birch	Lime	Maritime Pine
Maple	Aspen	Silver fir	Cembran Pine
	Larch		
	Weymouth Pine		
	Spruce		

TABLE SHOWING THE HIGHEST ALTITUDES AT WHICH VARIOUS SPECIES OF TREES ARE FOUND IN EUROPE. THE FIGURES IN THE TABLE REPRESENT FEET

	SCOTS PINE	SPRUCE	SILVER FIR	LARCH	BEECH	ENGLISH OAK	BIRCH	ALDER	CEMBRAN PINE	PINUS MONTANA	WEYMOUTH PINE	ASH	SYCAMORE	NORWAY MAPLE	ELM MONTANA	HORNBEAM	SPANISH CHESTNUT	WHITE ALDER	LIME	HORSE CHESTNUT	ASPEN
SILESIAN MTS				1100 to 2700						550											
HARZ MTS		3300			2150			2170				3500	2000 2700	1650		1200					
THÜRINGERWALD			2700		2600																
ERZGEBIRGE					2700																
BLACK FOREST		4000	3250		2600																
VOSGES MTS			4000																		
NORTH GREECE THESSALY EPIRUS											4000	4000		2350		2600	2000				
BAVARIAN ALPS		6000	5000	3000 to 6000	5000	OAK 2500 / L.& RIVER INN 3050 / W.& F. INN		2800					5000	4000		2900	1800	4500		3300	
TYROLESE ALPS					5125	3300		4100													
CENTRAL ALPS		6600							2300 to 7500						3300	3300	2900	5100	3900		4400
N. ITALY										9000											
PYRENEES	7000																				
SIERRA NEVADA	5400																				

This table has been compiled from information distributed in Nisbet's *Forest Trees*.

DISTRIBUTION OF THE CHIEF SPECIES OF TREES IN EUROPE

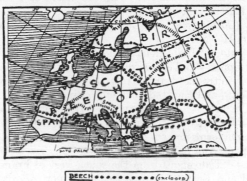

BEECH ●●●●●●●●●● (enclosed)
OAK ●—●—●—●—● N. LIMIT
SPRUCE ııııuıııuıııııııııı(enclosed)
SCOTS PINE ———— —N LIMIT

Fig. 300. —Map of Europe

Alder.—"The Alder is found in moist situations throughout nearly the whole of Europe from Asia Minor and the Caucasus up to the 62° of latitude on the average ; . . . on fen soil in the Baltic provinces of Northern Germany it is often found in pure forests of scores of square miles in extent, and at other times in extensive mixed forests along with Birch, Aspen, Ash, &c.

Ash.—"The Ash is to be found over nearly the whole of Europe and the Caucasus, southwards from 63° 41′ in Norway, 62° in Sweden, and 60° in Finland."

Aspen (and Poplars).—"Is found over the greater part of Europe. On the low tracts south of the Baltic it covers large forest areas with the Lime as its chief associate."

Beech.—"Throughout the western, the central, and most of the southern portion of Europe, also in the Caucasus. Its north-eastern limit is in Scotland, lat. 56°–57°, in Scandinavia, 61½° on the western, and 57° on the eastern side, 54½° on the East Prussian sea coast, thence across Eastern Poland, Bessarabia, and the Crimea, towards the Caucasus. It is essentially a tree belonging to the hilly and the lower mountainous tracts of Central and South Germany, and North-Western Austria, but it also forms pure forests on the plains within the Baltic region, in Upper Silesia, and in that portion of Alsace drained by the Rhine."

Birch.—" The southern limit of the Birch extends from North-west Spain, across the Pyrenees and along the southern slopes of the Alps, to Croatia, Servia, and Thrace." In the north it stretches across Scandinavia, Russia, and Siberia.

Buckthorn (Cartharticus).—" Europe, Russian Asia. Not Arctic." (Bentham and Hooker.)

Horse Chestnut.—"Indigenous to the mountains of Northern Greece, Thessaly, and Epirus—and eastwards to Persia, Afghanistan, and Upper India. It was introduced into Italy 1569, and Austria 1576, and into France 1613, and England 629 (according to Hess)."

Spanish Chestnut.—" Throughout the whole of Southern Europe. It is found as a forest tree in the outlying ranges of Southern Switzerland and France, and forms forests of considerable extent and importance throughout Spain, Austria, Italy, and Greece."

Hornbeam.—" Indigenous from the south-west of France eastwards across Central and Eastern Europe to Persia, northwards to England and Ireland (but not Scotland) and the southern portion of Sweden, and southwards to Lower Italy and Greece."

Larch.—" Is indigenous to the Alps and Carpathians, the lower portion of the Silesian and Moravian mountain ranges, and the southern edge of the woodland area of Bohemia and Moravia ; outside of these limits its growth is due to artificial measures."

Lime.—" The small-leaved Lime extends from Central and Northern Russia, where it forms forests westwards towards the north of Spain, northwards to Finland and Scandinavia, southwards to Southern Italy, and eastwards to Western Siberia. The larger-leaved species is indigenous throughout Southern Europe up to Central Germany, and eastwards to the Caucasus."

Norway Maple.—" Extends from 61°–62° in Scandinavia throughout Central Europe eastwards to the Caucasus, Armenia, and Northern Persia, and southwards to the Balkan Peninsula, Dalmatia, Central Italy, the Cevennes, and the Central Pyrenees."

Elm.—" Throughout the greater part of Europe, Algiers, Asia Minor, and Siberia as far as the drainage of the Amur, but is characteristic rather of Southern than of Northern Europe."

Oak.—" The English Oak is found over the greatest portion of Europe, Asia Minor, and the Caucasus, its northern limit being about 58° in Scotland, 61°–63° in Scandinavia, 57½° in Russia, thence eastwards to the Ural ; its southern limit through Spain, Sicily, and Greece is not fixed."

Poplars.—See *Aspens.*

Pines (Black, Austrian, or Corsican Pine).—" Extends from Spain across Southern Europe to Asia Minor, and in the specially recognised

former variety (Austrian) forms extensive pine forests in Lower Austria, and south-east towards Bosnia and Herzegovina."

Maritime Pine (including *Pinaster*).—" Is cultivated at Bordeaux and along the shores of the Bay of Biscay."

Cembran Pine.—" On Alps and Carpathians and in Russia and Siberia."

Mountain Pine.—" Native of mountains of Central and Southern Europe."

Scots Pine.—" Nearly all Europe, greater part of Northern Asia from 71° N. latitude in Scandinavia, south to the Sierra Nevada and the Pyrenees. Covers more than 81 per cent. of the wooded area of the great North German plain, and forms forests of enormous extent in Russia."

Silver Fir.—" Central and South Europe from Pyrenees eastwards to the Caucasus, northwards to the Vosges, Luxembourg, the southern edge of the Harz, Silesia, and Galicia, and southwards to Navarre, Corsica, Sicily, Macedonia, and Bithynia."

Spruce.—Extends from 69° N. Lat. southwards to the Alps. Cevennes, and Pyrenees. " It forms extensive forests in Scandinavia, Finland, Lapland, and Russia. In Germany and Switzerland the Spruce is the principal forest tree on all mountain ranges and hilly tracts."

Rowan (Mountain Ash).—" Is found throughout nearly the whole of Europe and of Northern Asia."

White Alder.—" Is distributed throughout Central and Northern Europe, and in the greater portion of Western and Northern Asia."

Willows.—" Have a wide distribution throughout Europe and Asia."

Yew.—" Indigenous throughout the whole of Central and Northern Europe and Asia but occurring most frequently in Southern France, Italy, and Algiers."

NOTE.—The descriptions in inverted commas are extracts from *British Forest Trees* by John Nisbet (Macmillan, 1893), a book crowded with information about trees from the forester's point of view. The map is more or less a rough copy from the *Harmsworth Encyclopædia*.

BIBLIOGRAPHY

SYNOPSIS OF LIST

ABBREVIATIONS AND NOTES

Fully illus. details = a volume in which the plates are confined to figures of leaves, flowers, fruits, seeds, &c., and do not show general habit of growth.

n.s.d. = natural-size diagrams.

g.h. = general habit of growth.

The date of publication is some guide to the style of illustration that may be expected.

Many books under heading GENERAL contain interesting, but only incidental, references to flora, unless otherwise stated.

The term " scenery, &c.," is used in a general sense to indicate that the book is illustrated with views of characteristic scenery, architecture native life, and so forth.

327

BRITISH

Botanical

Arboretum et Fruticetum Britannicum, Loudon. 1838. (8 vols.) English text. Descriptive ; historical. Includes 4 vols. of plates of a very conventional type.

Encyclopædia of Trees and Shrubs of Great Britain, Loudon. 1842. Diagrams in text.

A History of British Forest Trees, P. J. Selby. 1842. " Indigenous and Introduced." Small steel engravings, g.h.

Trees and Shrubs of the British Isles, Cooper and Westell. 1909. Fully illus. details (n.s.d.).

The Trees of Great Britain and Ireland, Elwes and Henry. Issue of parts just completed. 6 vols. letterpress, 6 vols. photogravures. The plates are magnificent. *N.B.*—A large number of foreign trees are shown in their natural surroundings. This book is the latest and best of its kind.

Handbook of the British Flora, Bentham and Hooker.

Structural Botany, Asa Gray.

Elements of Botany, M. Adrien de Jussieu. Translated by Hewetson Wilson.

Elementary Botany, Joseph W. Oliver.

Structural Botany, Thomé.

Popular Botanical

British Trees, R. Vicat Cole. (2 vols., royal 4to.) Trees and all their parts described. Illus. with 500 drawings of whole trees and details.

How to Know the Trees, H. Irving. 1911. Descriptive text. Illus. with good photos. (g.h.), and details.

Woodland Heaths and Hedges, W. S. Coleman. Details only (woodcuts).

Our Woodland Trees, Francis S. Heath. Coloured reproductions of leaves only.

British Forest Trees, John Nisbet. Not illus. Mainly forestry. Gives details of distribution and management of trees.

Flowering Plants of Great Britain, Anne Pratt. Coloured illus. of flowers and fruits, arranged under the orders of the genera.

Trees : A Handbook of Forest Botany for the Woodlands and the Laboratory, H. Marshall Ward. 1909. (5 vols.) Cambridge Biological Series. Illus., g.h. and details.

Familiar Trees, G. S. Boulger. 1907. (3 vols.) Good photos. and coloured plates (g.h.).

Wayside and Woodland Trees, Edward Step. 1904. A pocket guide. Good photos. (g.h.).

The Forest Trees of Britain, Rev. C. A. Johns. 1849. (2 vols.) Anecdotal. Conventional engravings (g.h.).

Trees and Their Life Histories, Percy Groom. 1907. 517 very fine photos. (g.h. and n.s.d.).

Trees in Landscape, E. Kennion. 1815. An early specimen of " Artists' Handbook." 50 engravings (about $5\frac{1}{2}'' \times 8''$) of a very conventional nature.

Trees, Foreign and Indigenous, H. W. Burgess. 1827. Descriptive and anecdotal text. 54 lithos. (about 12″ × 16″) of trees in association with picturesque scenery.

Sylva Britannica ; or, Portraits of Forest Trees Distinguished for their Antiquity, Magnitude, or Beauty, J. G. Strutt. 1822. English Anecdotal text. 46 etchings (about 12″ × 15″).

Sylva Britannica. A supplement to the above. 1830. 50 small etchings.

The Forests of England, and the Management of Them in Bygone Times, J. C. Brown. 1880. Descriptive ; technical. Not illus.

SPECIAL

The Yew-Trees of Great Britain and Ireland, John Lowe. 1897. Descriptive and anecdotal text. Good photos. (g.h.) and historical plates.

The New Forest : Its History and Scenery, J. R. Wise. 1863. Anecdotal. Many vignettes in text, and some full plates.

The New Forestry : The Continental System adapted to British Woodlands, J. Simpson. 1900. Technical. 8 photos. of woods.

On Buds and Stipules, Sir John Lubbock.

Flowers, Fruits, and Leaves, Sir John Lubbock.

On Seedlings, Sir John Lubbock.

Hand-List of Trees and Shrubs grown in Arboretum, Kew Gardens.

EUROPE

BOTANICAL

Fremdländische Wald- und Parkbäume für Europa, Heinrich Mayr. 1906. Good photos. (g.h.).

Die Bäume und Sträucher des Waldes, Hempel and Wilhelm. 1889–99. Text figures (g.h.), and details ; also fine coloured plates (n.s.d.).

Flora Forestal Española, D. M. Laguna. 1883–90. Accompanied by folio *Atlas* of excellent coloured plates (n.s.d.).

Forests and Forestry of Finland, J. C. Brown. 1882. Technical manual. Not illus.

Forests and Forestry of Northern Russia, J. C. Brown. 1880. Technical manual. Not illus.

GENERAL

Rambles on the Riviera, E. Strasburger. 1906. Popular descriptive text. No useful plates.

The Parks, Promenades, and Gardens of Paris, W. Robinson. 1869. Many various wood engravings.

The Land of the Midnight Sun : Summer and Winter Journeys through Sweden, Norway, Lapland, and Northern Finland, P. B. du Chaillu. 1881. Slight ref. to flora. Wood engravings of general scenery.

French Forest Ordinance of 1669, J. C. Brown. 1830. Technical ; historical. Not illus.

NORTH AMERICA AND CANADA

BOTANICAL

Manual of the Trees of North America, C. S. Sargent. 1905. Illus.,
details in text.
North American Trees, N. L. Britton. 1908. " Descriptions and
Illustrations of Trees growing Independently of Cultivation in
N.A., North of Mexico, and the West Indies." Numerous photos.
(g.h.) and diagrams.
Handbook of the Trees of the Northern States and Canada, Hough. 1907.
" Photo.-descriptive." Good photos. of trunks, leaves, and fruits,
&c., but not g.h.
The Sylva of North America (12 folios), C. S. Sargent. 1898. Fully
illus. details (n.s.d.).
Flora Boreali-Americana (2 vols.), W. S. Hooker. 1840. Fully illus.
details (n.s.d.).
Trees and Shrubs of Massachusetts (2 vols.), G. B. Emerson. 1887.
Many excellent engravings of trees in natural surroundings.
Minnesota Plant Life, C. MacMillan. 1899. Popularly written.
Many good photos. (g.h.).
Trees of California, W. L. Jepson. 1909. Good photos. (g.h.) and
line drawings.
Botany of Mexican Boundary. Government Survey. 1859. Fully illus.
details (n.s.d.).
Botany Railroad Reports : Mississippi to Pacific. 1855–60. Contains
a number of lithographs (g.h.) of trees.
Plant Life of Maryland. Report. 1910. Many good photos. of trees
and scenery.

GENERAL

Forest Life in Acadie, Capt. C. Hardy. 1869. Sketches of sport and
nat. hist. in Lower Provinces of Canada. Engravings of scenery, &c.
Field and Forest Rambles in Eastern Canada, A. L. Adams. 1873.
No useful illus.
Alaska, Burroughs, Muir, Grinnell, &c. 1902. (2 vols.) Many good
photos. and some wa.er-colours of scenery.
The Mountains of California, J. Muir. 1894. Descriptive text ; a
large section on the " Forests." Photos. and steel engs. of scenery.
Mexico as I Saw It, Mrs. A. Tweedie. Descriptive travel. Many
photos. of scenery, &c.
Through Southern Mexico : The Travels of a Naturalist, H. Gadow.
1908. Good photos. of scenery.
Canadian Scenery Illustrated, N. P. Willis. 1842. (2 vols.) A large
number of engravings by Bartlett, conventional and somewhat
inaccurate.

SOUTH AMERICA

BOTANICAL

Flora Brasiliensis. (15 folio vols.) 1840–1906. Latin text. Fully illus. details (n.s.d.). Authors—specialists responsible for their own particular group of plants. Edited by C. F. P. von Martin and (afterwards) by E. C. Eichler and J. Urban.

Floræ Peruvianæ, et Chilensis Prodromus, Ruiz and Pavon. (5 folio vols.) Spanish text. Fully illus. details (n.s.d.).

GENERAL

Notes of a Naturalist in South America, J. Ball. 1887. Descriptive travel. Not illus.

The Great Mountains and Forests of South America, P. Fountain. 1902. Descriptive travel. A few plates of scenery.

Rough Notes of a Journey through the Wilderness, from Trinidad to Par⁴, Brazil, H. A. Wickham. 1872. Drawings of scenery, &c., by the author.

In the Guiana Forests : Studies of Nature in Relation to the Struggle for Life, J. Rodney. 1901. 16 photos.

A Naturalist in the Guianas, E. André. 1901. Narrative travel. Photos. of native life chiefly.

The Naturalist on the Amazons, H. W. Bates. 1879. Small various steel engravings.

Notes of a Botanist in the Amazons and Andes, R. Spruce. Ed. by A. R. Wallace. 1908. Large sections on " Forests." Some photos., trees, g.h. and various.

WEST INDIES

GENERAL

The British West Indies, A. E. Aspinall. 1912. General descriptive, good photos. of scenery, &c.

At Last, Rev. C. Kingsley. 1872. Descriptive travel. Various engravings of scenery, trees, fruits, &c.

Bermuda Islands, A. E. Verrill. 1902. Narrative ; scientific. Photos. and steel engravings of scenery.

The Natural History of Jamaica, H. Sloane. 1707. A book chiefly of antiquarian interest. A section on " Flora." Fully illus. details (n.s.d.).

Through Jamaica with a Kodak, A. Leader. 1907. General descriptive. Many small photos. of scenery, &c.

ASIA

GENERAL

Scientific Results of a Journey in Central Asia, Sven Hedin. 1907.
(5 tomes.) Narrative. Many fine photos., scenery, &c., diagrams,
maps.
Through Asia, S. Hedin. 1898. (2 vols.) Descriptive travel. Nearly
300 photos. and drawings of scenery, &c., some in colours.
Central Asia and Thibet : Towards the Holy City of Lassa, S. He in.
1903. (2 vols.) Descriptive travel. 420 photos. and drawings of
scenery, &c., some in colours.
Adventures in Thibet, S. Hedin. 1904. Narrative travel. Numerous
photos. of scenery, &c.
Expedition for the Survey of the Rivers Euphrates and Tigris, Lieut.-Col.
Chesney. 1850. Numerous good tinted lithos. of scenery, &c.

INDIA

BOTANICAL

Indian Trees, D. Brandis. 1906. Small plates of details in text.

GENERAL

Jungle Life in India, V. Ball. 1880. Diary of travel. A few illus.
of scenery.
The Forests of Upper India, and their Inhabitants, T. W. Webber.
1902. Descriptive narrative. Not illus.
Himalayan Journals, J. D. Hooker. 1854. (2 vols.) Scientific travel.
Lithos. and wood engravings of scenery.
Trans-Himalaya, Sven Hedin. 1909. (2 vols.) Narrative travel.
388 photos. and sketches of scenery, &c.
India and Its Native Princes, L. Rousselet. 1876. Narrative travel.
A few excellent wood engravings of scenery, many of architecture.
Burma, M. and B. Ferrars. 1901. General descriptive. Many good
photos. of scenery, &c.
Kashmir, P. Pirie. 1909. Descriptive travel. Many coloured plates
and drawings of scenery, &c.

CEYLON

GENERAL

Ceylon : Natural Resources, Indigenous Productions, &c., J. W. Bennett
1843. A few illus., coloured, n.s.d.
Eight Years in Ceylon, Sir S. Baker. 1874. Treats of jungle, &c.
No useful illus.

COCHIN-CHINA

BOTANICAL

Flore Forestière de la Cochinchine, L. Pierre. 1838–88. (5 folios.) French text. Litho. plates, n.s.d.

JAPAN

BOTANICAL

Forest Flora of Japan, C. S. Sargent. 1894. Good photos. of trees in natural surroundings.

GENERAL

Japan : Travels and Researches, J. J. Rein. 1884. A section on " Flora." A few general photos.
Japan : A Record in Colour, M. Mempes. 1901. Descriptive travel. Many sketches of native life, scenery, &c.

PALESTINE

GENERAL

Palestine : Physical History, J. Kitto. 1841. Small illus. in text.
The Holy Land, Robert Hitchens. 1910. Descriptive ; historical. Coloured illus. and photos. of scenery, &c.
The Natural History of the Bible, H. B. Tristram. 1880. A few small illus. in text.

AUSTRALASIA

BOTANICAL

Australian Plants, W. R. Guilfoyle. 1911. Many photos. of tree forms.
The Forest Flora of New South Wales, J. H. Maiden. (Still being issued in parts.) Good photos. (g.h.) and scenery, and details (n.s.d.).
South Australia. Ed. by W. Harcus. 1876. A large section on " Flora." No useful illus.
The Forest Flora of New Zealand, T. Kirk. 1889. (n.s.d.)
Observations of a Naturalist in the Pacific, H. B. Guppy. 1906. Plant-dispersal. Not illus.
The Indigenous Plants of the Hawaiian Islands, J. F. Rock. 1913. Fully illus., fine photos. (g.h., n.s.d.), &c.
Flora Australiensis, Bentham and Mueller. 1863–78.

GENERAL

Sunny Australia, A. Marshall. 1911. Descriptive. A section on
" Timber." Good photos. of scenery.
In the Australian Bush, and on the Coast of the Coral Sea, R. Semon.
1899. Observations of a naturalist. Descriptive. Various general
illus.
Through South Westland : A Journey to the Haast and Mount Aspiring,
A. M. Moreland. 1911. Light narrative travel in New Zealand.
Many photos. of scenery.
A Naturalist in Tasmania, G. Smith. 1909. Good photos., forest
and other scenery.
Gatherings of a Naturalist in Australasia, G. Bennett. 1890. Various
coloured plates of trees, plants, &c.
The Savage South Seas. Painted by N. H. Hardy. Described by E.
W. Elkington. 1907. 68 reproductions from water-colours of
scenery and native life.
Life in the Forests of the Far East, S. St. John. 1843. (2 vols.) Anec-
dotal travel. Tinted lithos. of scenery, &c.
Wanderings in the Great Forests of Borneo, O. Beccari. Good photos.,
general scenery ; diagrams, maps.
Through New Guinea and other Cannibal Countries, Capt. Webster.
1898. Many good photos., general scenery, &c.
Across Papua, Col. Kenneth Mackay. 1909. Narrative travel. Good
photos. of scenery, &c.
A Naturalist's Wanderings in the Eastern Archipelago, H. O. Forbes.
1885. Descriptive travel. Various illus. and diagrams in text.
In Strange South Seas, B. Grimshaw. 1907. Narrative ; anecdotal.
Good photos. of scenery, &c.
My Tropic Isle, E. J. Banfield. 1911. Narrative of a South Sea natu-
ralist. Many good photos. of scenery, trees (g.h.), &c.

AFRICA

BOTANICAL

The Forests and Forest Fauna of Cape Colony, T. R. Sim. 1907. 158
n.s.d.

GENERAL

Morocco and the Great Atlas, Hooker and Ball. 1878. Descriptive
travel. Appendices D, E, F, G, " Flora." No useful illus.
Liberia, Sir H. Johnston, K.C.M.G. (2 vols.) 1906. A section on
" Flora " by Dr. Otto Stapf, fully illus. with photos. (g.h.) and
diagrams (n.s.d.). There are also many photos. of scenery.
A Naturalist in Mid-Africa, G. F. Scott-Elliot. 1896. Good photos.
of scenery.
To the Mountains of the Moon, J. E. S. Moore. 1901. An account of
the modern aspect of Central Africa. Good photos. and sketches
of scenery.

Travels and Discoveries in North and Central Africa, H. Barth. 1858. (5 vols.) Many good tinted lithos. of scenery.
Across Africa, V. L. Cameron. 1877. (2 vols.) Desscriptive travel. Many engravings of scenery.
In Darkest Africa, H. M. Stanley. 1890. (2 vols.) Descriptive travel. Sundry engravings of scenery.
Explorations and Adventures in Equatorial Africa, P. B. du Chaillu. 1861. Slight reference to flora. No useful illus.
Sahara und Sudan, G. Nachtigal. 1879. German text. Scientific descriptive travel. A few plates of scenery and trees (g.h.).

VARIOUS

BOTANICAL

The Forester, J. Nisbet. 1905. (2 vols.) Bot., industrial, and commercial. Numerous various photos., diagrams, &c.
Timber : A Comprehensive Study of Wood in all its Aspects, P. Charpentier. 1912. Commercial and botanical. A few illus. in text (g.h.), and some details.
Manual of Forestry, S. W. Schlich. (5 vols.) Scientific and technical. Numerous photos. (g.h.), &c.
Principal Species of Wood : Their Characteristic Properties, Snow. 1903. Good photos. (g.h.).
Natural History of Plants, Kerner and Oliver. 1895. Many photos. of trees and plants in natural surroundings.
Botany of To-day, G. F. Scott-Elliot. 1910. Section on " Forestry." General photos.
Plant-Geography upon a Physiological Basis, Dr. A. F. W. Schimper. 1903. Eng. trans. Popular botanical. Characteristic photos. of vegetation in all parts of the world (g.h.), forests, &c., diagrams, details, &c. The most useful and comprehensive work of its kind.

GENERAL

The Elements of Picturesque Scenery, H. Twining. 1853. (2 vols.) In the nature of an " artists' handbook." Section descriptive of trees. A few wood engravings and lithos.
The Wonders of the World. Various writers. 1913. Articles on curious and particular trees. Photos.
The Forest. G. D. Harding.

SPECIAL

Manual of Coniferæ, J. Veitch. 1900. Photos. (g.h.).
Historia Naturalis Palmarum, C. F. P. de Martino. 1823–50. Latin text. (Folio.) Accompanied by folio " Atlas " of coloured plates (g.h.) and details.

The Myoporinous Plants of Australia, Baron F. von Mueller, K.C.M.G. 1886. Vol. I. Descriptions. Vol. II. Atlas (n.s.d.).
The Yew-Trees of Great Britain and Ireland. (See British : Special.)
Popular History of the Palms, and Their Allies, B. Seemann. 1856. Numerous tinted lithos. (g.h.).
Palms of the Amazon, and Their Uses, A. R. Wallace. 1853. Popular treatise. Line engravings (g.h.).
The Larch, C. Y. Michie. 1885. Culture and management. 4 plates (g.h.).
Genera Plantarum, Bentham and Hooker.

INDEX TO DRAWINGS BY THE AUTHOR

The numbers in this Index refer to the numbers placed beneath the Illustrations (not to the pages). References to the Diagrams are marked "Fig."

338 THE ARTISTIC ANATOMY OF TREES

INDEX TO THE PICTURES REPRODUCED
IN THIS VOLUME

The names of the Painters are in alphabetical order. (A Chronological
List is given on pp. 32–34.)

INDEX TO LETTERPRESS

(*See also Index to Illustrations, p.* 341; *and to Drawings by the Author, p.* 337)

The subjects referred to have been grouped, thus a painter's name will be found under "Artists," and the title of a picture under "Pictures." A particular tree will be found under that part of it mentioned, such as "Bough," "Flower." In the same way the organs of flowers are in alphabetical order under "Flowers," e.g. petals, 261, stigma, 279; and the descriptive names of fruits under "Fruits," e.g. kernel, 290, samana, 280.

343

A CATALOGUE OF SELECTED DOVER BOOKS
IN ALL FIELDS OF INTEREST

A CATALOGUE OF SELECTED DOVER
BOOKS IN ALL FIELDS OF INTEREST

CELESTIAL OBJECTS FOR COMMON TELESCOPES, T. W. Webb. The most used book in amateur astronomy: inestimable aid for locating and identifying nearly 4,000 celestial objects. Edited, updated by Margaret W. Mayall. 77 illustrations. Total of 645pp. 5⅜ x 8½.
20917-2, 20918-0 Pa., Two-vol. set $8.00

HISTORICAL STUDIES IN THE LANGUAGE OF CHEMISTRY, M. P. Crosland. The important part language has played in the development of chemistry from the symbolism of alchemy to the adoption of systematic nomenclature in 1892. ". . . wholeheartedly recommended,"—Science. 15 illustrations. 416pp. of text. 5⅝ x 8¼. 63702-6 Pa. $6.00

BURNHAM'S CELESTIAL HANDBOOK, Robert Burnham, Jr. Thorough, readable guide to the stars beyond our solar system. Exhaustive treatment, fully illustrated. Breakdown is alphabetical by constellation: Andromeda to Cetus in Vol. 1; Chamaeleon to Orion in Vol. 2; and Pavo to Vulpecula in Vol. 3. Hundreds of illustrations. Total of about 2000pp. 6⅛ x 9¼.
23567-X, 23568-8, 23673-0 Pa., Three-vol. set $26.85

THEORY OF WING SECTIONS: INCLUDING A SUMMARY OF AIR-FOIL DATA, Ira H. Abbott and A. E. von Doenhoff. Concise compilation of subatomic aerodynamic characteristics of modern NASA wing sections, plus description of theory. 350pp. of tables. 693pp. 5⅜ x 8½.
60586-8 Pa. $6.50

DE RE METALLICA, Georgius Agricola. Translated by Herbert C. Hoover and Lou H. Hoover. The famous Hoover translation of greatest treatise on technological chemistry, engineering, geology, mining of early modern times (1556). All 289 original woodcuts. 638pp. 6¾ x 11.
60006-8 Clothbd. $17.50

THE ORIGIN OF CONTINENTS AND OCEANS, Alfred Wegener. One of the most influential, most controversial books in science, the classic statement for continental drift. Full 1966 translation of Wegener's final (1929) version. 64 illustrations. 246pp. 5⅜ x 8½. 61708-4 Pa. $3.00

THE PRINCIPLES OF PSYCHOLOGY, William James. Famous long course complete, unabridged. Stream of thought, time perception, memory, experimental methods; great work decades ahead of its time. Still valid, useful; read in many classes. 94 figures. Total of 1391pp. 5⅜ x 8½.
20381-6, 20382-4 Pa., Two-vol. set $13.00

THE COMPLETE BOOK OF DOLL MAKING AND COLLECTING, Catherine Christopher. Instructions, patterns for dozens of dolls, from rag doll on up to elaborate, historically accurate figures. Mould faces, sew clothing, make doll houses, etc. Also collecting information. Many illustrations. 288pp. 6 x 9. 22066-4 Pa. $4.00

THE DAGUERREOTYPE IN AMERICA, Beaumont Newhall. Wonderful portraits, 1850's townscapes, landscapes; full text plus 104 photographs. The basic book. Enlarged 1976 edition. 272pp. 8¼ x 11¼. 23322-7 Pa. $6.00

CRAFTSMAN HOMES, Gustav Stickley. 296 architectural drawings, floor plans, and photographs illustrate 40 different kinds of "Mission-style" homes from The Craftsman (1901-16), voice of American style of simplicity and organic harmony. Thorough coverage of Craftsman idea in text and picture, now collector's item. 224pp. 8⅛ x 11. 23791-5 Pa. $6.00

PEWTER-WORKING: INSTRUCTIONS AND PROJECTS, Burl N. Osborn. & Gordon O. Wilber. Introduction to pewter-working for amateur craftsman. History and characteristics of pewter; tools, materials, step-by-step instructions. Photos, line drawings, diagrams. Total of 160pp. 7⅞ x 10¾. 23786-9 Pa. $3.50

THE GREAT CHICAGO FIRE, edited by David Lowe. 10 dramatic, eyewitness accounts of the 1871 disaster, including one of the aftermath and rebuilding, plus 70 contemporary photographs and illustrations of the ruins—courthouse, Palmer House, Great Central Depot, etc. Introduction by David Lowe. 87pp. 8¼ x 11. 23771-0 Pa. $4.00

SILHOUETTES: A PICTORIAL ARCHIVE OF VARIED ILLUSTRATIONS, edited by Carol Belanger Grafton. Over 600 silhouettes from the 18th to 20th centuries include profiles and full figures of men and women, children, birds and animals, groups and scenes, nature, ships, an alphabet. Dozens of uses for commercial artists and craftspeople. 144pp. 8⅜ x 11¼. 23781-8 Pa. $4.00

ANIMALS: 1,419 COPYRIGHT-FREE ILLUSTRATIONS OF MAMMALS, BIRDS, FISH, INSECTS, ETC., edited by Jim Harter. Clear wood engravings present, in extremely lifelike poses, over 1,000 species of animals. One of the most extensive copyright-free pictorial sourcebooks of its kind. Captions. Index. 284pp. 9 x 12. 23766-4 Pa. $7.50

INDIAN DESIGNS FROM ANCIENT ECUADOR, Frederick W. Shaffer. 282 original designs by pre-Columbian Indians of Ecuador (500-1500 A.D.). Designs include people, mammals, birds, reptiles, fish, plants, heads, geometric designs. Use as is or alter for advertising, textiles, leathercraft, etc. Introduction. 95pp. 8¾ x 11¼. 23764-8 Pa. $3.50

SZIGETI ON THE VIOLIN, Joseph Szigeti. Genial, loosely structured tour by premier violinist, featuring a pleasant mixture of reminiscenes, insights into great music and musicians, innumerable tips for practicing violinists. 385 musical passages. 256pp. 5⅝ x 8¼. 23763-X Pa. $3.50

THE AMERICAN SENATOR, Anthony Trollope. Little known, long unavailable Trollope novel on a grand scale. Here are humorous comment on American vs. English culture, and stunning portrayal of a heroine/villainess. Superb evocation of Victorian village life. 561pp. 5⅜ x 8½.
23801-6 Pa. $6.00

WAS IT MURDER? James Hilton. The author of *Lost Horizon* and *Goodbye, Mr. Chips* wrote one detective novel (under a pen-name) which was quickly forgotten and virtually lost, even at the height of Hilton's fame. This edition brings it back—a finely crafted public school puzzle resplendent with Hilton's stylish atmosphere. A thoroughly English thriller by the creator of Shangri-la. 252pp. 5⅜ x 8. (Available in U.S. only)
23774-5 Pa. $3.00

CENTRAL PARK: A PHOTOGRAPHIC GUIDE, Victor Laredo and Henry Hope Reed. 121 superb photographs show dramatic views of Central Park: Bethesda Fountain, Cleopatra's Needle, Sheep Meadow, the Blockhouse, plus people engaged in many park activities: ice skating, bike riding, etc. Captions by former Curator of Central Park, Henry Hope Reed, provide historical view, changes, etc. Also photos of N.Y. landmarks on park's periphery. 96pp. 8½ x 11. 23750-8 Pa. $4.50

NANTUCKET IN THE NINETEENTH CENTURY, Clay Lancaster. 180 rare photographs, stereographs, maps, drawings and floor plans recreate unique American island society. Authentic scenes of shipwreck, lighthouses, streets, homes are arranged in geographic sequence to provide walking-tour guide to old Nantucket existing today. Introduction, captions. 160pp. 8⅞ x 11¾. 23747-8 Pa. $6.95

STONE AND MAN: A PHOTOGRAPHIC EXPLORATION, Andreas Feininger. 106 photographs by *Life* photographer Feininger portray man's deep passion for stone through the ages. Stonehenge-like megaliths, fortified towns, sculpted marble and crumbling tenements show textures, beauties, fascination. 128pp. 9¼ x 10¾. 23756-7 Pa. $5.95

CIRCLES, A MATHEMATICAL VIEW, D. Pedoe. Fundamental aspects of college geometry, non-Euclidean geometry, and other branches of mathematics: representing circle by point. Poincare model, isoperimetric property, etc. Stimulating recreational reading. 66 figures. 96pp. 5⅜ x 8¼.
63698-4 Pa. $2.75

THE DISCOVERY OF NEPTUNE, Morton Grosser. Dramatic scientific history of the investigations leading up to the actual discovery of the eighth planet of our solar system. Lucid, well-researched book by well-known historian of science. 172pp. 5⅜ x 8½. 23726-5 Pa. $3.00

THE DEVIL'S DICTIONARY. Ambrose Bierce. Barbed, bitter, brilliant witticisms in the form of a dictionary. Best, most ferocious satire America has produced. 145pp. 5⅜ x 8½. 20487-1 Pa. $1.75

HISTORY OF BACTERIOLOGY, William Bulloch. The only comprehensive history of bacteriology from the beginnings through the 19th century. Special emphasis is given to biography-Leeuwenhoek, etc. Brief accounts of 350 bacteriologists form a separate section. No clearer, fuller study, suitable to scientists and general readers, has yet been written. 52 illustrations. 448pp. 5⅝ x 8¼. 23761-3 Pa. $6.50

THE COMPLETE NONSENSE OF EDWARD LEAR, Edward Lear. All nonsense limericks, zany alphabets, Owl and Pussycat, songs, nonsense botany, etc., illustrated by Lear. Total of 321pp. 5⅜ x 8½. (Available in U.S. only) 20167-8 Pa. $3.00

INGENIOUS MATHEMATICAL PROBLEMS AND METHODS, Louis A. Graham. Sophisticated material from Graham Dial, applied and pure; stresses solution methods. Logic, number theory, networks, inversions, etc. 237pp. 5⅜ x 8½. 20545-2 Pa. $3.50

BEST MATHEMATICAL PUZZLES OF SAM LOYD, edited by Martin Gardner. Bizarre, original, whimsical puzzles by America's greatest puzzler. From fabulously rare Cyclopedia, including famous 14-15 puzzles, the Horse of a Different Color, 115 more. Elementary math. 150 illustrations. 167pp. 5⅜ x 8½. 20498-7 Pa. $2.50

THE BASIS OF COMBINATION IN CHESS, J. du Mont. Easy-to-follow, instructive book on elements of combination play, with chapters on each piece and every powerful combination team—two knights, bishop and knight, rook and bishop, etc. 250 diagrams. 218pp. 5⅜ x 8½. (Available in U.S. only) 23644-7 Pa. $3.50

MODERN CHESS STRATEGY, Ludek Pachman. The use of the queen, the active king, exchanges, pawn play, the center, weak squares, etc. Section on rook alone worth price of the book. Stress on the moderns. Often considered the most important book on strategy. 314pp. 5⅜ x 8½. 20290-9 Pa. $3.50

LASKER'S MANUAL OF CHESS, Dr. Emanuel Lasker. Great world champion offers very thorough coverage of all aspects of chess. Combinations, position play, openings, end game, aesthetics of chess, philosophy of struggle, much more. Filled with analyzed games. 390pp. 5⅜ x 8½. 20640-8 Pa. $4.00

500 MASTER GAMES OF CHESS, S. Tartakower, J. du Mont. Vast collection of great chess games from 1798-1938, with much material nowhere else readily available. Fully annotated, arranged by opening for easier study. 664pp. 5⅜ x 8½. 23208-5 Pa. $6.00

A GUIDE TO CHESS ENDINGS, Dr. Max Euwe, David Hooper. One of the finest modern works on chess endings. Thorough analysis of the most frequently encountered endings by former world champion. 331 examples, each with diagram. 248pp. 5⅜ x 8½. 23332-4 Pa. $3.50

SECOND PIATIGORSKY CUP, edited by Isaac Kashdan. One of the greatest tournament books ever produced in the English language. All 90 games of the 1966 tournament, annotated by players, most annotated by both players. Features Petrosian, Spassky, Fischer, Larsen, six others. 228pp. 5⅜ x 8½. 23572-6 Pa. $3.50

ENCYCLOPEDIA OF CARD TRICKS, revised and edited by Jean Hugard. How to perform over 600 card tricks, devised by the world's greatest magicians: impromptus, spelling tricks, key cards, using special packs, much, much more. Additional chapter on card technique. 66 illustrations. 402pp. 5⅜ x 8½. (Available in U.S. only) 21252-1 Pa. $3.95

MAGIC: STAGE ILLUSIONS, SPECIAL EFFECTS AND TRICK PHOTOGRAPHY, Albert A. Hopkins, Henry R. Evans. One of the great classics; fullest, most authorative explanation of vanishing lady, levitations, scores of other great stage effects. Also small magic, automata, stunts. 446 illustrations. 556pp. 5⅜ x 8½. 23344-8 Pa. $5.00

THE SECRETS OF HOUDINI, J. C. Cannell. Classic study of Houdini's incredible magic, exposing closely-kept professional secrets and revealing, in general terms, the whole art of stage magic. 67 illustrations. 279pp. 5⅜ x 8½. 22913-0 Pa. $3.00

HOFFMANN'S MODERN MAGIC, Professor Hoffmann. One of the best, and best-known, magicians' manuals of the past century. Hundreds of tricks from card tricks and simple sleight of hand to elaborate illusions involving construction of complicated machinery. 332 illustrations. 563pp. 5⅜ x 8½. 23623-4 Pa. $6.00

MADAME PRUNIER'S FISH COOKERY BOOK, Mme. S. B. Prunier. More than 1000 recipes from world famous Prunier's of Paris and London, specially adapted here for American kitchen. Grilled tournedos with anchovy butter, Lobster a la Bordelaise, Prunier's prized desserts, more. Glossary. 340pp. 5⅜ x 8½. (Available in U.S. only) 22679-4 Pa. $3.00

FRENCH COUNTRY COOKING FOR AMERICANS, Louis Diat. 500 easy-to-make, authentic provincial recipes compiled by former head chef at New York's Fitz-Carlton Hotel: onion soup, lamb stew, potato pie, more. 309pp. 5⅜ x 8½. 23665-X Pa. $3.95

SAUCES, FRENCH AND FAMOUS, Louis Diat. Complete book gives over 200 specific recipes: bechamel, Bordelaise, hollandaise, Cumberland, apricot, etc. Author was one of this century's finest chefs, originator of vichyssoise and many other dishes. Index. 156pp. 5⅜ x 8. 23663-3 Pa. $2.50

TOLL HOUSE TRIED AND TRUE RECIPES, Ruth Graves Wakefield. Authentic recipes from the famous Mass. restaurant: popovers, veal and ham loaf, Toll House baked beans, chocolate cake crumb pudding, much more. Many helpful hints. Nearly 700 recipes. Index. 376pp. 5⅜ x 8½. 23560-2 Pa. $4.00

"OSCAR" OF THE WALDORF'S COOKBOOK, Oscar Tschirky. Famous American chef reveals 3455 recipes that made Waldorf great; cream of French, German, American cooking, in all categories. Full instructions, easy home use. 1896 edition. 907pp. 6⅝ x 9⅜. 20790-0 Clothbd. $15.00

COOKING WITH BEER, Carole Fahy. Beer has as superb an effect on food as wine, and at fraction of cost. Over 250 recipes for appetizers, soups, main dishes, desserts, breads, etc. Index. 144pp. 5⅜ x 8½. (Available in U.S. only) 23661-7 Pa. $2.50

STEWS AND RAGOUTS, Kay Shaw Nelson. This international cookbook offers wide range of 108 recipes perfect for everyday, special occasions, meals-in-themselves, main dishes. Economical, nutritious, easy-to-prepare: goulash, Irish stew, boeuf bourguignon, etc. Index. 134pp. 5⅜ x 8½. 23662-5 Pa. $2.50

DELICIOUS MAIN COURSE DISHES, Marian Tracy. Main courses are the most important part of any meal. These 200 nutritious, economical recipes from around the world make every meal a delight. "I . . . have found it so useful in my own household,"—*N.Y. Times.* Index. 219pp. 5⅜ x 8½. 23664-1 Pa. $3.00

FIVE ACRES AND INDEPENDENCE, Maurice G. Kains. Great back-to-the-land classic explains basics of self-sufficient farming: economics, plants, crops, animals, orchards, soils, land selection, host of other necessary things. Do not confuse with skimpy faddist literature; Kains was one of America's greatest agriculturalists. 95 illustrations. 397pp. 5⅜ x 8½. 20974-1 Pa. $3.50

A PRACTICAL GUIDE FOR THE BEGINNING FARMER, Herbert Jacobs. Basic, extremely useful first book for anyone thinking about moving to the country and starting a farm. Simpler than Kains, with greater emphasis on country living in general. 246pp. 5⅜ x 8½. 23675-7 Pa. $3.50

HARDY BULBS, Louise Beebe Wilder. Fullest, most thorough book on plants grown from bulbs, corms, rhizomes and tubers. 40 genera and 335 species covered: selecting, cultivating, naturalizing; name, origins, blooming season, when to plant, special requirements. 127 illustrations. 432pp. 5⅜ x 8½. 23102-X Pa. $4.50

A GARDEN OF PLEASANT FLOWERS (PARADISI IN SOLE: PARADISUS TERRESTRIS), John Parkinson. Complete, unabridged reprint of first (1629) edition of earliest great English book on gardens and gardening. More than 1000 plants & flowers of Elizabethan, Jacobean garden fully described, most with woodcut illustrations. Botanically very reliable, a "speaking garden" of exceeding charm. 812 illustrations. 628pp. 8½ x 12¼. 23392-8 Clothbd. $25.00

CATALOGUE OF DOVER BOOKS

MUSHROOMS, EDIBLE AND OTHERWISE, Miron E. Hard. Profusely illustrated, very useful guide to over 500 species of mushrooms growing in the Midwest and East. Nomenclature updated to 1976. 505 illustrations. 628pp. 6½ x 9¼. 23309-X Pa. $7.95

AN ILLUSTRATED FLORA OF THE NORTHERN UNITED STATES AND CANADA, Nathaniel L. Britton, Addison Brown. Encyclopedic work covers 4666 species, ferns on up. Everything. Full botanical information, illustration for each. This earlier edition is preferred by many to more recent revisions. 1913 edition. Over 4000 illustrations, total of 2087pp. 6⅛ x 9¼. 22642-5, 22643-3, 22644-1 Pa., Three-vol. set $24.00

MANUAL OF THE GRASSES OF THE UNITED STATES, A. S. Hitchcock, U.S. Dept. of Agriculture. The basic study of American grasses, both indigenous and escapes, cultivated and wild. Over 1400 species. Full descriptions, information. Over 1100 maps, illustrations. Total of 1051pp. 5⅜ x 8½. 22717-0, 22718-9 Pa., Two-vol. set $12.00

THE CACTACEAE,, Nathaniel L. Britton, John N. Rose. Exhaustive, definitive. Every cactus in the world. Full botanical descriptions. Thorough statement of nomenclatures, habitat, detailed finding keys. The one book needed by every cactus enthusiast. Over 1275 illustrations. Total of 1080pp. 8 x 10¼. 21191-6, 21192-4 Clothbd., Two-vol. set $35.00

AMERICAN MEDICINAL PLANTS, Charles F. Millspaugh. Full descriptions, 180 plants covered: history; physical description; methods of preparation with all chemical constituents extracted; all claimed curative or adverse effects. 180 full-page plates. Classification table. 804pp. 6½ x 9¼.
23034-1 Pa. $10.00

A MODERN HERBAL, Margaret Grieve. Much the fullest, most exact, most useful compilation of herbal material. Gigantic alphabetical encyclopedia, from aconite to zedoary, gives botanical information, medical properties, folklore, economic uses, and much else. Indispensable to serious reader. 161 illustrations. 888pp. 6½ x 9¼. (Available in U.S. only)
22798-7, 22799-5 Pa., Two-vol. set $11.00

THE HERBAL or GENERAL HISTORY OF PLANTS, John Gerard. The 1633 edition revised and enlarged by Thomas Johnson. Containing almost 2850 plant descriptions and 2705 superb illustrations, Gerard's Herbal is a monumental work, the book all modern English herbals are derived from, the one herbal every serious enthusiast should have in its entirety. Original editions are worth perhaps $750. 1678pp. 8½ x 12¼.
23147-X Clothbd. $50.00

MANUAL OF THE TREES OF NORTH AMERICA, Charles S. Sargent. The basic survey of every native tree and tree-like shrub, 717 species in all. Extremely full descriptions, information on habitat, growth, locales, economics, etc. Necessary to every serious tree lover. Over 100 finding keys. 783 illustrations. Total of 986pp. 5⅜ x 8½.
20277-1, 20278-X Pa., Two-vol. set $10.00

CATALOGUE OF DOVER BOOKS

THE STANDARD BOOK OF QUILT MAKING AND COLLECTING, Marguerite Ickis. Full information, full-sized patterns for making 46 traditional quilts, also 150 other patterns. Quilted cloths, lame, satin quilts, etc. 483 illustrations. 273pp. 6⅞ x 9⅝. 20582-7 Pa. $3.95

ENCYCLOPEDIA OF VICTORIAN NEEDLEWORK, S. Caulfield, Blanche Saward. Simply inexhaustible gigantic alphabetical coverage of every traditional needlecraft—stitches, materials, methods, tools, types of work; definitions, many projects to be made. 1200 illustrations; double-columned text. 697pp. 8⅛ x 11. 22800-2, 22801-0 Pa., Two-vol. set $12.00

MECHANICK EXERCISES ON THE WHOLE ART OF PRINTING, Joseph Moxon. First complete book (1683-4) ever written about typography, a compendium of everything known about printing at the latter part of 17th century. Reprint of 2nd (1962) Oxford Univ. Press edition. 74 illustrations. Total of 550pp. 6⅛ x 9¼. 23617-X Pa. $7.95

PAPERMAKING, Dard Hunter. Definitive book on the subject by the foremost authority in the field. Chapters dealing with every aspect of history of craft in every part of the world. Over 320 illustrations. 2nd, revised and enlarged (1947) edition. 672pp. 5⅜ x 8½. 23619-6 Pa. $7.95

THE ART DECO STYLE, edited by Theodore Menten. Furniture, jewelry, metalwork, ceramics, fabrics, lighting fixtures, interior decors, exteriors, graphics from pure French sources. Best sampling around. Over 400 photographs. 183pp. 8⅜ x 11¼. 22824-X Pa $5.00

Prices subject to change without notice.

Available at your book dealer or write for free catalogue to Dept. GI, Dover Publications, Inc., 180 Varick St., N.Y., N.Y. 10014. Dover publishes more than 175 books each year on science, elementary and advanced mathematics, biology, music, art, literary history, social sciences and other areas.